The Voice of
PISTOLETTO

The Voice of
PISTOLETTO

MICHELANGELO PISTOLETTO
ALAIN ELKANN

Translated from the Italian by Huw Evans

Rizzoli
ex libris

Published in the United States of America in 2014
By Rizzoli Ex Libris, an imprint of
Rizzoli International Publications, Inc.
300 Park Avenue South
New York, NY 10010
www.rizzoliusa.com

Originally published in Italy as *La Voce di Pistoletto*
Copyright © 2013 Bompiani/RCS Libri S.p.A. - Milano
This edition published by arrangement with
Luigi Bernabò Associates Srl., Italy.

2014 2015 2016 2017 / 10 9 8 7 6 5 4 3 2 1

Distributed in the U.S. trade by Random House, New York
Printed in China

ISBN-13: 978-0-8478-4387-9
Library of Congress Catalog Control Number: 2014935633

The interviews in this book
were conducted between
July and September 2012
at Maria Pioppi and
Michelangelo Pistoletto's
homes in Biella and Sansicario.

Alain Elkann
Michelangelo Pistoletto

A.E.: *There are some very strong facets of your personality, Pistoletto, key points that are sources for your work, your art, your thinking, your raison d'être. The one that strikes me first is the religious aspect. I've noticed that your life and your work are pervaded by continual references to religion: personal references, art references, and references to the creation of your work itself. Are you a religious man?*

M.P.: Not under the terms set by religions up to now. Instead, I'd say that my interest is in spiritual roots, in the idea of the spirit that then turns into spirituality; and for religions, spirituality is clearly pivotal.

Do you believe in God?

No. Once I was asked this question officially and I answered, "I don't believe, but I think." I would put the word *think* in place of the term *believe*. To "believe" is to set a fixed point, but to "think" is to create movable points.

So you're not religious, but what influence does religion have on your life and your work?

Religion has a fundamental influence on every area of social life and affects everyone. In a way it was the primary element in my education. So I experienced religion as something I absorbed, something that was fed into my mind.

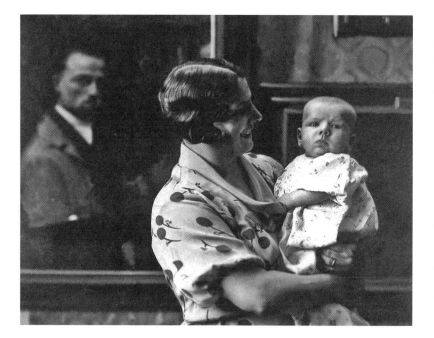

M.P. at the age of three months, in the arms of his mother, Livia Fila. In the background, a self-portrait painted by his father, Ettore Olivero-Pistoletto. Biella, 1933.

Bottom: M.P. with his parents. Turin, June 1937.

Facing page: M.P. on the day of his First Communion. Turin, March 31, 1940.

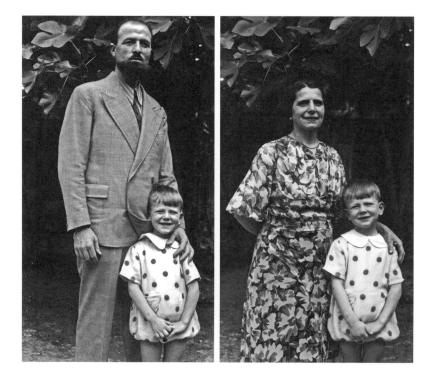

Were your parents religious?
My mother was religious. I couldn't say what the real meaning of her devotion was, but she placed her trust in religion. With my parents it was Mass every Sunday.

So she had faith.
Yes, but her trust in religion took her into the realm of superstition. She gave me some lessons in superstition. She didn't talk to me about the fundamental tenets of Christianity; she talked to me about black cats. But then on Sundays, in Turin, we sometimes took a long walk to a church that had an altar dedicated to the Black Virgin of Oropa. It was inevitable that my mother, who came from Biella, would be devoted to the Black Virgin, patron of the sanctuary of Oropa, situated on the mountain above Biella and one of the largest and most important in Italy. She perhaps wouldn't have known exactly what to say to any old Virgin Mary, whereas she felt protected by the Virgin of Oropa.

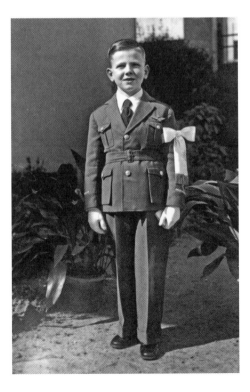

Do you have any brothers or sisters?
No, I'm an only child.

Did you grow up in a superstitious environment?
It wasn't a superstitious environment. I said my mother was superstitious, but perhaps on the sly we all are a little bit. They taught me to say my prayers—those were my first exercises in memory training. Then they sent me to Sunday school.

Did they send you to Catholic school?
Yes, at the age of eleven, when the war was over, in my second year of middle school. A school run by the Christian Brothers.

Did you finish your studies there?
No, I was there for a year and it was the worst year of my life.

Why?
Because I saw that some boys were
favored over others. Perhaps they
were the most attractive, and I wasn't
cute enough. That favoritism made
me an object of derision. Derision
and scorn. After the first few days
I shut myself off completely. I
never missed a day of school, but
I attended with my books closed,
my mouth closed, and for much of
the time my ears closed, too. So I
flunked that year with an average
grade of zero.

Did your parents know? What did they say?
Yes, of course they knew. They thought it was my fault. But by
then I didn't tell them much about myself.

M.P. in a 1944
portrait photo.

And what did you do afterward?
After that I did two years in one, the second and the third, at
a private school, and I passed the exam with an average grade
of seven.

At a secular school?
Yes.

Was your father secular?
No, I'd say not, though as I said he went to church. In my family
we followed the typical ritual of Sunday Mass.

But you didn't rebel against religion? You went to Mass?
No, I didn't rebel. I went to Mass like a little doggy, a puppy that
didn't know what it was doing. I went to church and kept still.
I didn't move. When it was time to make the sign of the cross, I
did it. I was obedient.

So you weren't a rebellious child?
No.

Did you become so later?
No, I don't think I'm a rebel even today. It's the world that creates problems for me; I don't create problems for the world.

Was your father a Christian Democrat?
No, I think—since he never showed me a card—that my father supported the Liberal party. He certainly wasn't a Christian Democrat, and he wasn't a Fascist or a Communist, either. He had a truly libertarian outlook; rather than being a member of a political party, I'd say he held a libertarian view of life.

Was he middle class?
You could say so, about him and his family. My grandfather had a lumber business in Susa. At the end of the nineteenth century I'd say that buildings were constructed 50 percent of wood and 50 percent of stone and brick, so he made much of his profit from the building industry. What left the deepest mark on my father in his childhood, and consequently throughout his life, was a bout of meningitis that he had when he was eight, as a result of which he lost his hearing. He was a man of extreme intelligence and extreme sensitivity. I say extreme because, in spite of his deafness, he was able to lead the same life as a hearing person, perhaps partly because he was lucky enough to hear until he was eight, to have known his voice as a child. The interesting thing is that, being deaf, he favored his eyes totally. He told me that when he was a child he went to school in the tiny village of Arnodera in the municipality of Gravere, near Susa, where he lived with his family. The school had just one room that housed all five classes. The teacher spoke and he couldn't hear. He used to look out of the window and stare for hours at a lunette on the chapel that stood in front of the school, a small fresco that I believe, from what he told me, depicted the Annunciation. There was a Virgin Mary. He looked at this image and copied it. He killed time by copying that icon.

Was he a good painter?
He was very good in the sense of the classical realism of the late nineteenth century. His ideal was Giacomo Grosso, who painted in a realistic style on a dark background.

Was he influenced by the Impressionists?
He was slightly influenced by them when he started to paint "with the palette knife," as people used to say at the time. But always with an extreme realism. He wanted me to learn that painting technique from him. He taught me drawing, anatomy, the use of chiaroscuro and color. He even taught me some essential elements of architecture. At home I received an old-style academic education from him, in part because at the age of fourteen I started to work with him on the restoration of old pictures. My father used to restore old pictures.

What did you restore?
It was a very interesting time, because after the war there was a shift from an economy in the hands of the nobility to an industrial economy. The Piedmontese aristocracy had to sell their jewels, pictures, estates, palaces, and castles, in order to survive after the advent of the industrial revolution. The big dealers—at the time there was Accorsi in Turin—bought everything and then, after having the works restored, transferred them to the homes of wealthy industrialists. I experienced the transition from one economic and political phase to another through the restoration of the work that passed through my father's studio.

But what kind of child were you? Shy, well-behaved, imaginative?
Normal.

Loved?
Yes, of course. I was an only child. Loved, obviously.

Were there grandparents, uncles, and aunts around?
I only knew one of my grandparents, my father's elderly mother who lived in Susa, where we went when we were evacuated

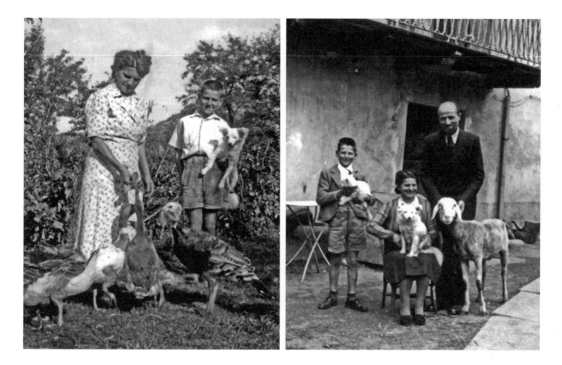

M.P. with his mother, above, and on the right with both of his parents at the home of his paternal grandmother, where the family was evacuated during the war. Susa, August 1944.

during the war. One of my father's sisters had also taken refuge there, and we lived in adjoining apartments. My aunt Maria had lived in Paris and then come back to Italy, to Turin, with her daughter, Arlette; I remember they spoke to each other in French. Today many people ask me why I speak French so well: it's because I became familiar with the language then.

Were you afraid during the war?
I wasn't terrified, but I felt a continual fear provoked by daily events, what with American bombs and German roundups. Both Fascist and German squads would come into our home, looking for men and arms. And then around our house there were absurd partisan actions and insane Nazi reprisals.

And you saw those things?
Unfortunately, yes.

Was your father drafted?
No, he was exempt because of his deafness. I was exempt, too, because I was the son of a father who was deemed "unfit for work," so neither he nor I ever did military service.

Did you have a complex about the fact that your father was deaf?
No, not at all. To me it was normal. At most people thought my father was foreign because he had an unusual accent. But he didn't speak like a deaf man since, as I told you, he could hear his own voice as a child and he always remembered how to talk. And he was good at reading the lips of people in front of him and understood what they said, so he was able to hold a normal conversation.

Did he have friends? Who were they?
His friends were architects, antiquarians, and doctors, as well as a lot of people who came to his studio regularly.

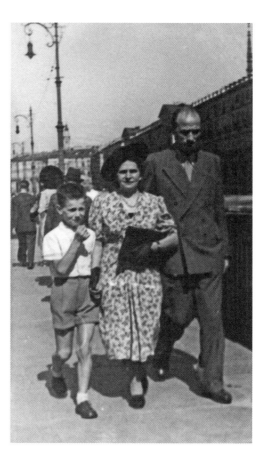

And your mother?
My mother met my father in Biella. She wanted to learn to paint and my father was in town for a job that lasted almost three years. That's how they met.

Was she a middle-class woman?
Yes, she came from a middle-class Biella family. My mother's surname is Fila, a well-known name in Biella.

Was it after the war that you went back to Turin?
No, long before. In 1934, when I was a year old, the family had already moved there from Biella, where my father, who was working on big graffito designs for Ermenegildo Zegna, had met my mother and where I was born.

Second grade class photo. (M.P. is the fourth from the right at the top.) Turin, 1941.

Facing page: M.P. with his mother and father on the Ponte Vittorio Emanuele. Turin, September 1941.

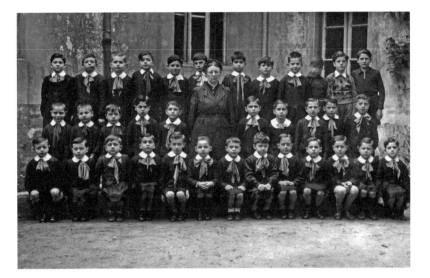

Where?
For several years at the beginning on Via Rubiana, a street off Corso Francia. Then, immediately after the war, on the corner of Lungo Po Cadorna and Corso San Maurizio. My father had his studio over the apartment, one of those typical painter's studios on the top floor, with large expanses of glass.

It sounds as though you led a rather bohemian life as a child.
No, very normal, very bourgeois.

With a serene religious faith?
Not serene, especially as time passed. I'd already had an early moment of crisis in elementary school, when I had to wear the Fascist uniform and say *I believe in God* along with *I believe in Mussolini.* Gradually I started to question things. I saw things during the war and its aftermath, the secret weapon of the Germans that turned into the atomic bomb of the Americans, communism, the Cold War, and above all the Holocaust. All these things coming one after the other led to my growing lack of confidence in society in both its ethical and its political manifestations.

What did they say at home about the racial laws, the declaration of war, and everything that was going on at that time?
My father was very scared by what was happening, though he recognized that he was lucky to have a handicap that allowed him to survive. Survival was the only thing that mattered. Above all there was an attachment to life. The situation was desperate: at my aunt's house we tried to pick up Radio London, in order to find out what was happening in the world, but we were completely in the dark about the Holocaust. Death was part of everyday existence, something we expected to happen at any moment. When there was a big Allied bombing raid on Turin, in 1943, a bomb landed on my father's studio. It ended up in the cellar and didn't explode. We were in the basement, flung against the walls by the blasts of the explosions, but we survived. I think we would have died if the bomb had gone off. Those raids were indescribable.

Did your family hope the Americans would win?
Certainly. But there was a great contradiction: the Americans were killing us by dropping bombs on us, while the enemy at home was the SS of Nazi Germany. I spent twelve hours a day hiding on the terrace, keeping a lookout for the German patrols that were rounding up and deporting non-Fascists, and if I saw them coming I ran to tell my father, who had made himself a hideout and would shut himself inside. I ran no risk because I was twelve years old. I was saved because I was just a boy, but at the age of twelve you're aware, you understand very well what is going on.

What did you think of the partisans?
The Fascists called them "rebels," whereas we all called them "partisans." Then absurd things happened. I'm thinking of an episode in which a partisan arrived secretly, alone, near our house, saw a German passing, and killed him without thinking about the consequences. This was the really idiotic part of the mentality of that time: they didn't understand that the Germans reacted ruthlessly. Because of that partisan, ten

people were hanged and a farmhouse was burned down. An example of true stupidity.

How did you deal with that as a child?
In 1940, immediately after war was declared, there were the first French bombing raids on Turin. I remember that for the first time, one night, I was overcome with fear, my teeth chattering with terror. My parents stared out of the window and saw lots of beautiful lights in the sky. They looked like fireworks, but they were flares fired from the antiaircraft artillery so they could see the planes. My parents' recklessness only increased my fear. In the end all that was destroyed was the corner of a house. The day after the raid everyone went to take a look—there was a crowd gathered to see that bit of collapsed wall. They had no notion of what could come from the sky. People still had the idea that war was fought on the ground, between opposing armies.

Has this thing you experienced as a child stayed with you all your life?
It's stayed, like many other difficult experiences, but it didn't have traumatic aftereffects.

Has it influenced your work?
All this, together with the upbringing I received, made me grow up, maturing day by day.

Were your parents quiet people?
Very.

Did the war years introduce you to the concept of death?
No.

At that time people lived in a schizophrenic atmosphere.
There were the most terrible contradictions.

But a moderate Catholic education, a negative experience at school, being forced to wear the Fascist uniform, the war, the bombing, the

evacuation—all this must have combined to shape
your character. I'd like to know what that character is.
I couldn't say. I can tell you that at the time of
the evacuation to Susa we lived off farming.
We even had hens, turkeys, rabbits, sheep.

So you didn't go hungry?
No, things were tight, but we grew what we
needed. If I were to show you the photos,
you'd see that we were a bit like peasants.

Were you cold in the winter?
No, we had wood to burn. We cut down trees
that were already dead and kept ourselves
warm with those. I remember that an old man
used to come to saw up that wood and then
we stacked it in great piles, divided them up,
and then each took some, half for us and half
for my aunt. There was also a human side, in
the sense that our home life was good.

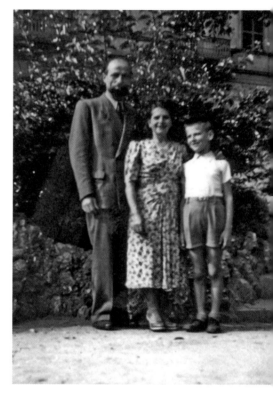

M.P. with his
mother and father.
Turin, 1942.

Did you feel at ease in your family?
Very much so. My mother was a person of extraordinary
kindness and unselfishness. Many times she was even hated
for her unselfishness.

Was she pushy with you?
Not at all. She was always very understanding. Like my father,
for that matter. They were very understanding and very open
people.

Did they talk about money?
I knew what my father earned, how much money they had, how
we had to economize, what needed to be done in periods when
there was no kind of income, like during the war. Another thing
I have to tell you is that, despite everything that was happen-
ing, I've never responded to provocation nor used violence. I

discovered I had this capacity for forbearance in Susa. Every day, coming out of school, a boy, seeing me so quiet and passive, used to grab my satchel and throw it on the ground. I would pick it up and carry on, while he kept doing it, perhaps to see how long I'd be able to resist or if he could make me mad. But I didn't react. Then one day another schoolmate, who'd seen this behavior, gave him such a slap that he broke three of his front teeth and the boy, who as luck would have it was the son of the best dentist in Susa, went home without those teeth.

Has it been the same all of your life? Have you continued not reacting?
Yes.

Are you really calm or do you hide your anxiety well?
I'm anything but calm, but my life is one of activity, of active tension that has gradually grown ever since I became involved in modern art. But, seeing that we're talking about my adolescence, there is another interesting thing worth mentioning: my relationship with the media. We didn't have a radio at home until I was eighteen. As a child I didn't listen to music. We didn't have a radio in the house because my father was deaf.

Did you read?
No. I never read books and I still don't read them.

You've never read?
No.

Not even newspapers?
Yes. Newspapers, yes.

You haven't even read the classics?
No. The books that I didn't read but whose pictures I looked at almost obsessively were those of my father's *Enciclopedia Treccani*.

And did you read the Bible?
To me the Bible doesn't exist. It was never written.

Did your mother read?
I don't remember. If she did, not often.

And your father?
My father did. He gave himself an education with books.

*But there are quotations in some of your writings. So you've
read something.*
No, nothing. I've been told all of it.

You don't own even one book?
Personally, no.

Because you don't like reading?
I don't know. I can't give you an answer.

Well, have you listened to music?
I listened to pop music a little, but I have to say that I haven't
paid much attention to music, either. At home the eye was
favored, owing to the fact that my father couldn't hear. The
image was given precedence.

Why were you named Michelangelo? After Michelangelo Buonarroti?
My paternal grandfather was named Michele, but my parents
were probably not satisfied with Michele and wanted an angel,
too. I wasn't present when they decided on my name, so that's
just my thought.

Did your family have artistic preferences, or did you not discuss that?
My father loved every aspect of the art of the past, not just paint-
ing, and he passed that interest down to me. If I look at an old
picture I can recognize the school and analyze the work in its
entirety: you start from the material used to make it, which is
typical of a certain historical period or a specific country. The
preparation of the surface in eighteenth-century Piedmontese
painting was very different from the priming used in Naples in
the seventeenth century. The canvas and the fabric, the pigment

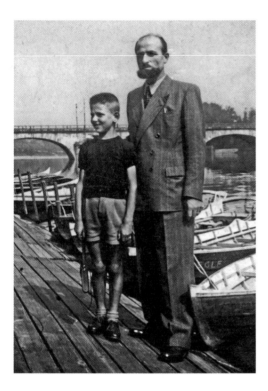

M.P. with his father on the River Po. Turin, 1942.

or wooden panel were different, too. From the character of the painting you can identify the workshop and see whether it was done by the master or a follower.

But what did you see? Did your father show you photographs, or did you go to museums together?
Every Sunday morning, from when I was very small, my father used to take me to the Galleria Sabauda and the Egyptian Museum of Turin and show me the works on display.

And you didn't object to being forced to do that?
I wasn't forced to do it. I was following my father's teaching. I knew he was giving me an education.

Did you play sports?
Yes, skiing in Susa. And then rowing. We lived on the Po and every day, at noon, my father made me get down from the jetty and row to a point in the river where the old seaplane departure station was located. I went back and forth, from twelve till one and built up my muscles. My father used to say that I needed exercise, as sitting in front of an easel all day wasn't good for me.

So a bit of sports and a lot of museums.
Yes. We also had my grandparents' house in the Losa area, high up in the mountains of the Susa Valley, and we went up there very often, by train up to a certain point and then on foot. The three of us were always together.

I take it you didn't have much of a social life.
There were my cousins. One of my mother's sisters had two sons and another sister had a daughter, all three of them more

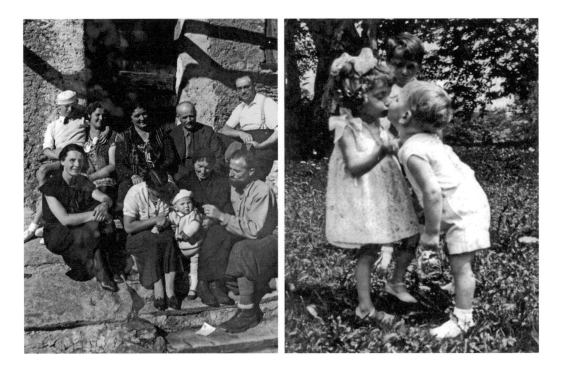

or less my age. We used to go to the beach together. We went
to Alassio and Noli. I preferred Alassio over Noli, because there
was fine sand there, whereas at Noli there were pebbles, so I
didn't like it. The grownups preferred Noli because of the
ancient ruins, while I liked the sand better.

Did you speak Piedmontese or Italian at home?
We spoke Italian. My mother also knew the Biella dialect, which
is a mixture of Piedmontese and Lombard. You can tell people
from Biella by the slight accent that they're usually not able to
conceal, even if they speak only Italian.

What about your studies?
Working with my father, I didn't study much. I started going
to the school for surveyors, which I attended for two years. I
worked all day with my father and went to school in the evening.
Then I stopped. I didn't want to do it any longer. Until one day

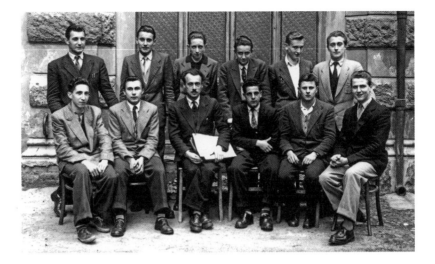

Group photo with fellow students in the second-year surveyors section of the Istituto Tecnico San Massimo. (M.P. is on the right in the first row.) Turin, 1948–49.

Facing page: Left, M.P. with, from top left, his cousin Fulvio, cousin Ida, aunt Emilia, uncle Michele, cousin Paolo, and, bottom, aunt Beatrice, mother Livia, grandmother Maria, and father Ettore. La Losa near Susa, 1934.

M.P. with his cousin Elda. Biella, 1935.

my mother said, "Restoration is a fine thing, but the future is in advertising," and she enrolled me in Armando Testa's advertising school.

Did you always go along without arguing?
Without arguing.

It sounds as if your parents were very modern, very open-minded.
It's true. I think very highly of my parents.

They brought you up by example.
Yes. My father always told me that your choice of friends was very important. He'd say, "It can have terrible consequences if you choose your friends badly." I remember those were his exact words. At last I reached the age of eighteen. My father bought a Fiat Topolino from his brother just before I was old enough to apply for a driver's license, and on my eighteenth birthday he took me to driving school. I have to thank him for this, too, because if he hadn't pushed me to get a license I might still not have one. But you know why he did it? Because he couldn't get a license and was waiting for me to be able to drive the car and take him where he wanted to go.

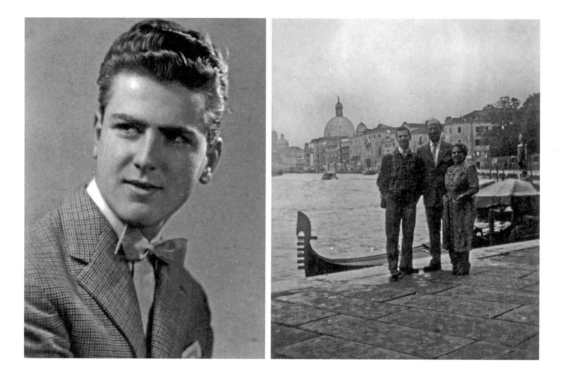

Did you drive him around?
Sure. I remember my first trip to Venice with my father
and mother.

What did you do in Venice?
We went to visit the museums, to see the monuments, certainly
not the Biennale. Modern art was the opposite of what my father
had always aspired to. There is another important factor to con-
sider: being deaf, he couldn't follow the debate over art that went
on in those years. To do so he'd have had to hang around with
other artists, he'd have had to talk to them, because modern art
was rooted in discussion and debate.

*We were saying that in your life it is possible to discern an interest in
religion that is found in your art, too. Another thing that strikes me,
and that I think is important, is your attachment to the region. You're
known all over the world, you've held exhibits and traveled, but your*

Top: M.P. and his mother with their first family car, a Fiat Topolino. Val di Susa, October 25, 1951.

Bottom: M.P. with his parents. Piazza Duomo, Milan, 1951.

Facing page: M.P. in a portrait taken in 1951, and with his parents in Venice in September 1951.

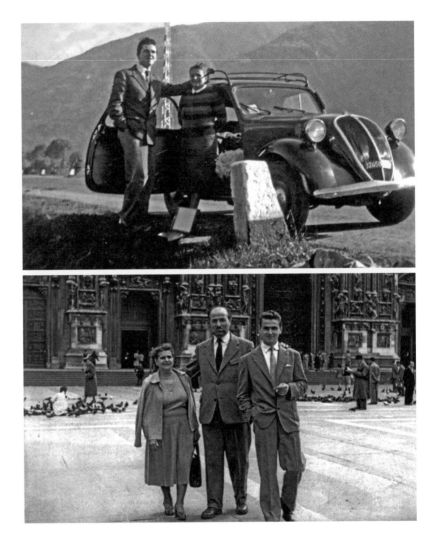

places are Turin, Biella, Sansicario, Susa, Corniglia. You have deep ties to your region, like an artist of the past. On the other hand, you don't have ties to a specific studio, as I see that you've changed houses and studios many times.

Turin has an important history. I'm still trying to understand it now. First of all, the aristocracy fostered crafts, and out of the development of the crafts came industry. There was a lot of ambition. Turin has inherited the pride and ambition of the House of Savoy, which came from the city of Chambéry. When I

visited it, I was amazed at how small the place that gave birth to
Turin was.

Was your family monarchist?
I don't remember. I think after the war my father was in favor of
the republic, and my mother went along with his ideas.

Were you sorry when the king left?
No, I thought Victor Emmanuel III had betrayed the great Savoy
ambition. He was a great failure. I wasn't sorry that he went
away. I thought it was really time for a change. My father did
some restoration for the royal family, in particular for the Duke
of Bergamo, who often came to his studio, I remember him
well. My father had custody of much of the duke's art. During
the war, when he realized that things were coming to a head, he
asked my father to look after some of it; a few things were there
being restored, and others were added. My father took care of
them. He took them with us when we were evacuated during
the war and brought them back to Turin in perfect condition.
A couple of years after the war, the Duke of Bergamo turned up
again and asked if we had managed to save any of his art. My
father told him, "It's all here."

What art did the Duke of Bergamo have?
A lot of it consisted of portraits of the members of the House
of Savoy. Some were good and some less good. Then there were
landscapes by Cignaroli and some still lifes by Rapous. They
were the pictures that hung on the walls and above the doors of
Savoy palaces in Piedmont.

*Going back to politics, what impression did seeing pictures of Mussolini
hanging in Piazzale Loreto have on you?*
Even though I didn't like violence, I thought that he'd asked for it.

What did you children think of Hitler?
I was terrified. Even the German language has always sounded
harsh to me. I taught in Vienna for ten years without learning

German, speaking to the students in English. That language had done me so much violence during the war that for me it represented violence, even though I didn't understand it. That feeling of rejection was visceral.

But later you had German friends.
Yes, of course. But that has nothing to do with it.

When you were a boy, did you have friends in Turin?
I had friends who were the children of my parents' friends, and then the cousins in Biella who used to come to Turin and had become friends of my friends in Turin. After the war we all went skiing together.

When did you discover sex?
I don't know. I was very small when I discovered it. I was sitting on the potty and realized I had something sticking out between my legs, and I set out to explore this thing. I remember my father scolding me a lot, telling me that if I touched himself I would get ill. Clearly this was a legacy of his Catholic upbringing, but sex has always been exciting partly because it is forbid-

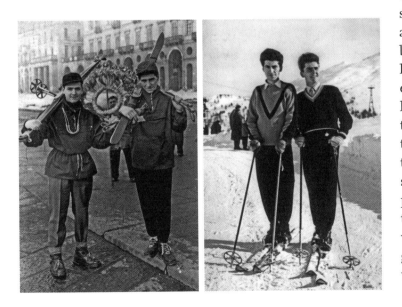

den. During the war I saw German soldiers asking where the brothel was; everyone knew the address, even me, but I didn't know much more than that. Let's say that making advances toward the opposite sex was a very slow process. At a certain time you'd go dancing with friends and ask a girl, "Excuse me, miss, would you dance with

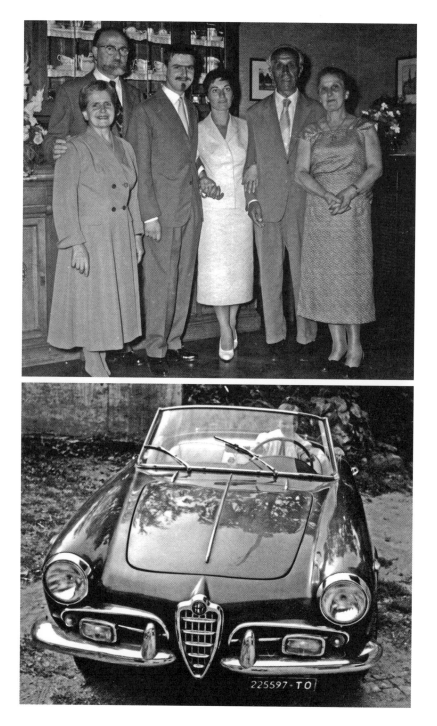

M.P. and Marzia Calleri with their parents on their wedding day at the home of Calleri's parents. Turin, 1955.

Cristina Pistoletto in her father's Giulietta. Susa, summer 1961.

Facing page: M.P. with his daughter Cristina in Turin in 1961, and with Marzia Calleri, his sister-in-law Federica, and daughter Cristina at Montgenèvre, in February 1962.

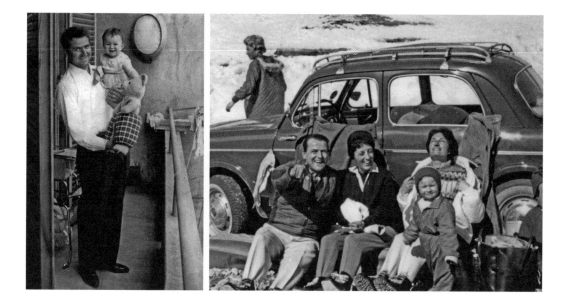

me?" And if during the slow parts you held her a little closer, the girl would immediately say, "Excuse me, what do you think you're doing?" She would be there with her mother or sister. The relationship was very prudish. And it was a bit like that for everybody. The first person with whom I had a real relationship I met going skiing in the mountains, and she became my wife. We had a beautiful, happy, complete, ideal relationship.

Who was she?
Marzia Calleri. We had a daughter, Cristina, born in 1960.

Were you married for a long time?
Ten years. I got married in 1955, when I was very young. Then, in 1965, I went to live by myself in my studio.

Have you been with a lot of women?
Only to a very limited degree. I'm something of a monogamist. I knew it was important to have affairs because it was necessary to try things out, to experiment, but often I got no real satisfaction out of it. I've always desired intense and complete emotional

relationships. If I'd applied myself I perhaps could have been a womanizer, but I'm not naturally like that, even though I've always been attracted to beautiful women. Just think that when I was teaching at the Academy of Fine Arts in Vienna, from 1991 to 2000, everyone said that I chose my female students not on the basis of their portfolios, but based on their appearance. It seemed like a school for beauties: I chose them because they were good and, by sheer chance, apart from a few cases, they were good-looking, too. But I never approached any of them in anything but professional terms.

M.P., around 1960.

Why?
Because I see the complications more clearly than the pleasure.

In the end you're a practical man.
Yes, I'd say so.

Do you dream of another life?
Oh, no. This life is wonderful, the finest I can imagine.

Why?
Because I'm doing what I want to do. My life is a hive of activity.

You are a serious man, but not in the sense of being boring. You come from a serious family, you have serious values, but without being tedious.

Yes. Dignity has always had great importance in my life. My father lived his life according to the contingencies of the time. Personally, I'm aware of being a continuation of my father. Indeed, I really am my father. I'm as my father would have wanted to be, perhaps without knowing it. Even though he would never consciously have imagined wanting to be what I am. But I know it for him.

But you make contemporary art.

Later my father understood what I was doing. And he always appreciated and thought highly of me. At the end, when he was seventy-five, he did some work following my suggestions. He became my pupil, as far as that was possible. He certainly didn't start doing abstract painting.

Coming back to you, you got married when you were very young, but certainly not because you lacked affection, given that you always had a loving and trusting relationship with your parents. Has it been the same with your children?

I think so.

How many children do you have?

I have three daughters. Cristina, born to my first wife Marzia in 1960, and the twins Pietra and Armona, born to Maria in 1971. Armona is the name of a village in the Susa Valley near where my father was born, while Pietra recalls the land owned by my grandfather, which was at Castelpietra, near Susa. In the 1970s Cristina came to live with us at Sansicario, where she also became a skiing instructor. It was great, as we were all together for several years. Then in 1978, Maria and I moved with the twins from Sansicario to Berlin for a year, and we spent the following two years in Corniglia and the United States. In the meantime, Cristina went back to Turin to live with Marzia, but we've always been very close.

Maria Pioppi with her daughters Armona and Pietra Pistoletto. Sansicario, 1975.

Are you a strict father?
I don't think so.

What kind of relationship have you had with your daughters?
I think my relationship with them has been like the one between me and my parents. Perhaps their upbringing has been less traditional and I have tried to help them develop their personal freedom.

Did you help them with their studies?
I've been involved in their education since they were small, even in little day-to-day things. I've always looked after them and always been close to them. More than keeping an eye on their schoolwork, I kept an eye on their overall development.

When they were in school did you go and talk to their teachers?
No.

Were you strict with them about their grades?
No, but they had a good attitude. I think it's partly due to their being girls. They were fairly sensible, although with the vivacity typical of children, of course. Cristina had a stronger personality than the twins, something I believe she got from her mother.

Did Cristina take your separation badly?
I think my leaving caused her a lot of distress. When I went to live by myself in my studio, she was always waiting for me to come back and I think that was really traumatic for her, partly because relations in the family gave her no grounds for thinking that Marzia and I were going to separate. There was no tension, so Cristina couldn't understand what was happening. But she did understand that the art I was doing was an expression of freedom of action and that fascinated her, and she began to do things with me on the level of performance from a very early age. Cristina has always had a strong attachment to me and I to her. The same thing is true for the twins.

Was she jealous when the twins arrived?
She never showed any sign of it, but I think so; she must have felt something of the kind. There's an age difference of eleven years between her and the twins. When the twins arrived we paid them a lot of attention, obviously.

Are the twins different?
Physically no, but in character I would say they are. It's hard to define their characters clearly, but they have different

personalities. I have to say that family has always been my main
point of reference.

*What kind of relationship did you have with your daughters when they
started to have boyfriends?*
The curious thing is that Cristina's boyfriends all belonged in
one way or another to artistic circles. I've always maintained ties
with the ones with whom she had significant relationships. One
of them became my assistant after they split up. As for the twins,
Paolo, Armona's husband, is the director of Cittadellarte and
Andrea, Pietra's husband, is the lawyer for our foundation.

Does Cristina have children?
She has a daughter named Elettra.

What does Cristina do?
She took singing lessons. She has a beau-
tiful voice, but she wasn't interested in
a career as an opera singer and has fol-
lowed her own creative path. We've done
many performances together, including
at the Documenta in Kassel in 1992.

Does she still do that?
No. Since she became a mother she's
devoted her time to her daughter. She
has had her study music since she was
small, and now she's following her in
this commitment to music. Elettra plays
the cello and piano and sings.

*And the twins? For starters, where is
Armona now?*
Armona currently lives in Biella. She
earned a degree in architecture in
Turin and works at Cittadellarte. She
married Paolo Naldini who, as well as

Top: M.P.'s granddaughter Elettra imitating his sculpture *Dietrofront* (1981–84) with her doll. Turin, 2002.

Dietrofront, 1981–84. Marble, 600 x 400 x 180 cm. Installation at Forte di Belvedere, Florence, 1984. Later permanently installed at Porta Romana, Florence.

Bottom: M.P.'s granddaughter Elettra reflected in *Gabbia specchio* (Cage Mirror), 1973–92, on the occasion of M.P.'s solo exhibition *Io sono l'altro. Michelangelo Pistoletto* (I Am the Other: Michelangelo Pistoletto) at the GAM, in the Società Promotrice delle Belle Arti in Turin, 2000.

Facing page: M.P. with his granddaughter Elettra, the daughter of Cristina Pistoletto and Giuseppe Vecchi. Turin, 1999.

M.P. with his grand-
daughter Ginevra,
the daughter of
Armona Pistoletto
and Paolo Naldini.
Sherborne, England,
1998.

M.P.'s grandson
Eugenio at the age
of five. Cittadellarte,
Biella, December
2012.

Facing page: M.P.'s
exhibition space at
Documenta IX.

Bottom: *Mouthpiece*,
performance by
Cristina Pistoletto
at Documenta IX.
Kassel, 1992.

being director of the foundation, has a passion for art
and literature.

Do they have children?
They have three children, a girl and two boys: Ginevra, Mauro,
and Eugenio.

Do you have a good relationship with Armona?
Marvelous.

And Pietra?
Pietra went to a fashion school in Florence, the Polimoda, and
since then has worked on integrating fashion and art through
clothing, with extraordinary brilliance. Naturally, she hasn't
followed the typical seasonal system of production of fashion.
She has made only one-off pieces, but they have anticipated
general trends.

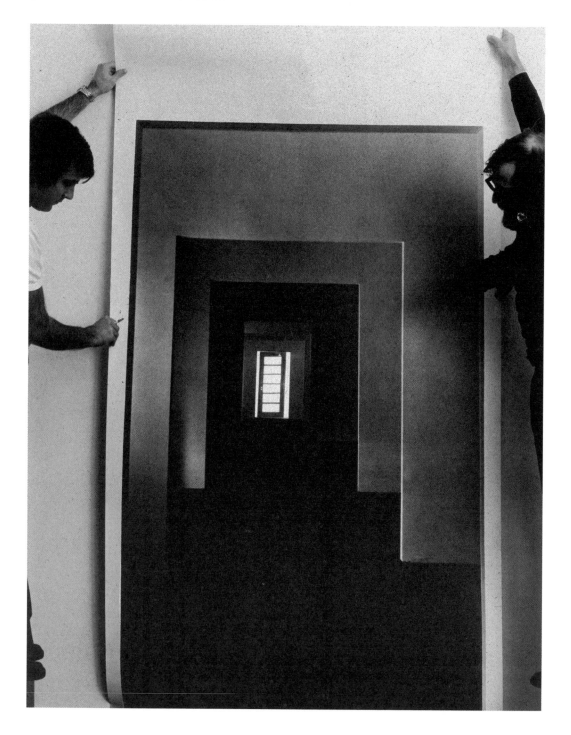

Where does Pietra live?
Now she lives in Lugano with her husband, Andrea, and their two sons, Amedeo and Ettore.

What sort of grandfather are you?
I'd like to know what my grandchildren think of me. We see each other only rarely. Ginevra, Mauro, and Eugenio live at the foundation with my daughter and my son-in-law, but sometimes months go by without my seeing them.

Why? Aren't you interested in them?
Of course I am. It's just that I'm so busy and they are doing their own thing. The relationship you have with grandchildren is different from the one you have with your children, and I'm not a retired grandfather. But I have to say that I have a strange attitude toward affection. For example, I didn't accompany either my mother or my father to the cemetery and I've never visited their graves. My relationship with the end of life is not a conventional one. Between 1975 and 1976 I held an exhibit that lasted for a year and was subdivided into twelve shows, one a month, entitled *Le Stanze* (The Rooms) at the Galleria Christian Stein in Turin. In the ninth show, which represented

the afterlife, I showed a marble tombstone with the image of
my mother. I've never gone to the cemetery, but I brought my
mother onto the art scene instead. Recently, on the other hand,
I did an exhibition of works by my father and myself. When
people die they go away, but I reactivate their presence in the
space of art. Just as in the *Mirror Paintings* I bring a photo
of the past into a mirroring of the present. For me, art is
really the location of all forms of thought, of reason, emotion,
understanding, and meeting.

Aren't your grandchildren curious about a grandfather like you?
I wouldn't know. They experience a bit of the atmosphere that
circulates around me, rather than myself.

M.P.'s
grandchildren
Ettore and Amedeo,
the sons of Pietra
Pistoletto and
Andrea Ciurcina,
Ginevra and Mauro,
the children of
Armona Pistoletto
and Paolo Naldini,
and Elettra, the
daughter of Cristina
Pistoletto and
Giuseppe Vecchi.
Cittadellarte, Biella,
2003.

Facing page:
M.P., Maria
Pioppi, Cristina,
Armona, and Pietra
Pistoletto and the
photographer Nini
Mulas, reflected in
the work *Macchina
fotografica* (Camera),
125x125 cm, (1962–
75). Sansicario, 1975.

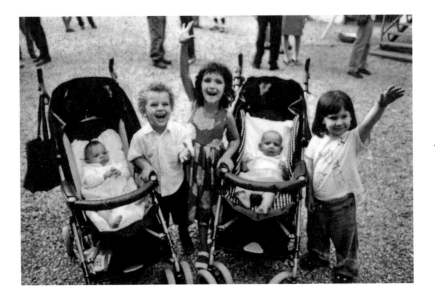

*Many artists of the past have done portraits of their families. Have you
ever done a portrait of them all?*
Rather than doing portraits, I've put images of members of my
family, in some cases, in my work. There are *Mirror Paintings*
with images of my daughters and sons-in-law, but it hasn't
happened with the grandchildren yet. I was thinking of doing

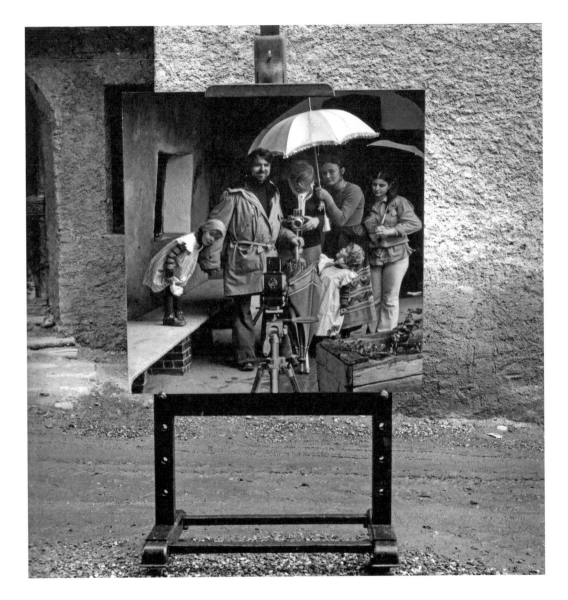

exactly that. With Cristina I talked about art from the time she
was a small child, while with the twins I behaved differently.
I've never explained my art to them. The times were different.
Armona and Pietra went to design school in Turin and oppo-
site it was the agency run by Armando Testa, who was a legend
to them. One evening I told the twins Armando was coming to

dinner, and I urged them to behave well and lend a hand. The girls couldn't believe Armando Testa was coming to dinner and Pietra said, "I can't help, because this is my first business dinner!" I value a sense of humor highly and there's never been a lack of it at home.

So you had good relationships with all three of your daughters?
Not just good, very good.

You've never fought or had problems?
No, I'd say not. The occasional squabble is inevitable, but love gets you through it. I think I've always been there when I was needed. For example, when Armona was studying architecture she met a young man who was studying the humanities. Maria and I were abroad. She called us and told us she wanted to change from architecture to humanities. I told her, "Listen, do what you want, but remember that if you change at this point, you may never be sure about what you'll be doing in the future." And she carried on, successfully, with architecture. I've always been very attentive. Pietra had to submit some fashion sketches when she applied to Polimoda. I saw what she was doing and told her, "If you submit these sketches they won't accept you. If you want to be accepted, you have to do it like this." She immediately did what I suggested and was accepted.

How do the twins relate to your work? Were they bothered by the fact that you and Maria were always together and traveling continually?
We've always had a good understanding about that. As there were two of them, the twins constituted a small but fairly self-sufficient community. In addition, I never forced my art on them. I always wanted to make them feel they had a place in the world of art, but maintain the possibility for them to be as independent as possible.

Do they come to your exhibitions?
Yes, almost always.

Have you ever taken your grandchildren skiing?
My daughters and grandchildren always. One thing I can be
sure about is that in their eyes I'm the grandfather who skis.
I taught my daughters and grandchildren to ski. Technically
speaking, I taught them more about skiing than about art.

How long have you been with Maria?
We've been together since 1967.

Is Maria Roman?
She was born in Rome. Her father was an antiques dealer.

How did you meet her?
On a trip I made to Rome with Pino Pascali when, with his first
exhibition in Turin, he was starting to do Arte Povera. We were
in Turin together and he was about to drive back to Rome by
car. On the spot I decided to go to Rome with him, and as soon
as we got there I met Maria.

Pino Pascali and
Efi Kounellis
during the opening
performance
of M.P.'s solo
exhibition at the
Galleria L'Attico,
Rome, 1968.
Reflected in the
mirror painting
behind them,
standing, the critic
Alberto Boatto.

You went to Rome with Pascali the year before his death? He was killed in a motorbike accident, wasn't he?
Yes, Maria and I were at his bedside for three days before
he died.

Did you and Maria fall in love at first sight?
Immediately. Maria was very beautiful, and I wasn't bad-looking either. She was twenty-nine and I was thirty-four.

Where did you meet?
That evening, right after we arrived in Rome, we went to the Pollarolo, a trattoria next to the Piazza del Popolo where artists often used to go. A very small trattoria. I went in and Maria was there with a girlfriend. I paid her a compliment and she paid me one back.

You were a good-looking man, tall, with a beard.
At that time I didn't have a beard but long sideburns. I changed my look often. I was quite slim, and I've always been one meter and seventy-five centimeters [five foot nine inches] tall.

Were you dressed in an eccentric way?
I was wearing white cotton pants, a blue and gray ribbed turtle-neck sweater, and black ankle boots.

What year was it?
November 1967.

And how was Maria dressed?
In black, with a turtleneck sweater and a fairly long, I'd say three-quarter-length, straight skirt that left her ankles barely visible. Her body could only be guessed at, but her face was beautiful.

Did you make love right away that evening?
Right away.

Where?
At Maria's house.

Did she live alone?
She lived by herself in a garret on the sixth and top floor of an apartment building. We went up the back stairs and on a landing we found a sack of potatoes. Maria took some of them and fried them, and that was all it took to make me fall head over heels in love, obviously.

What did Maria do?
She'd been to the Accademia di Belle Arti and was working at a gallery.

Where was she working?
She'd been working with Plinio De Martiis at La Tartaruga until a short time before. At that time she had a job at a gallery called Arco d'Alibert, near the Piazza del Popolo.

Was she aware that you were a well-known artist?
Yes, when I paid her a compliment she said, "I admire your work a lot." She'd seen my works at the San Marino Biennale that year.

How many days did you stay there without going out?
She had to work the next day. In the morning she accompanied me to the station. I had to go back to Turin because I had a lot of appointments.

Were you sad?
No, I was very happy. A few days earlier I had bought a Fiat Spider, one of the very first. Back in Turin I took the Spider, went to the airport, got on a plane, and flew to Rome. I went to the Pollarolo, that little restaurant again. I knew Maria didn't earn much and went there as a rule because it was cheap. She earned 60,000 lire a month and out of that she had to pay the rent for the apartment, food, clothes, everything. But she liked

to go out to dinner with her girlfriends and her artist friends, and if she ate just a dish of broth with pasta she could afford it. So I got there, looked in the window, and recognized the back of Maria's head, and while I was looking she slowly turned around, saw me, and fainted. So obviously there was already something between us, right?

Have you been together ever since?
Yes. In those days I had made a public announcement that my studio in Turin was open to anyone who wanted to participate, to create things together. Just two days after my trip to Rome, some poets were coming to recite their work. So there was no choice—I had to go back the next morning. I went to the gallery where Maria was already at work and I told her, "Maria, I have an idea. Why don't you come with me?" She stood there think-ing, smiling a little, and I added, "Look, I can't wait. I'm going to walk out the door now and if you come, good; if not, when I close the door that's it." I went, opened the door, and when I was about to close it she said, "Wait, wait!" And she came.

Did she lose her job?
She quit.

Did you like movies?
Yes. I liked them so much that in Turin, between the restoration work and the advertising school, when I felt like it I went out and saw maybe four or five movies in a row, from afternoon until late eve-ning. In those days you could go into a movie theater at any time; you didn't have to wait for the film to start. As soon as a movie fin-ished in one theater, I rushed to another theater and watched another movie.

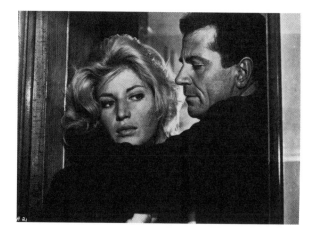

Monica Vitti and Gabriele Ferzetti in a scene from Michelangelo Antonioni's *L'Avventura*, 1960.

What did you watch?
Anything. Anything they showed, I watched.

You didn't have any particular preferences?
Not in the beginning. The first movie I really enjoyed was
Antonioni's *L'Avventura*. That made me realize cinema could
truly be art. But I still remember one of the few movies I saw as a
child, *The Hunchback of Notre Dame*. I was really touched by it. The
movie theater itself fascinated me, not so much because of what
was shown there but because of what it was: light, image, space.

Did you eat well in your family?
Very well. My mother cooked very well, in a traditional way, of
course. An interesting thing is that at home my father's work got
mixed up with my mother's cooking. My father used to paint
still lifes with mushrooms, fish, and game, and when he had
finished one part of the picture, my mother would take the food
that had already been painted and cook it.

Did you eat in the kitchen?
It was different in each house. We moved several times. When
the kitchen was big enough we ate there; if not, we ate in the
dining room.

What did your mother cook particularly well?
She was very good with game, and then she made agnolotti
filled with meat and vegetables, the way they do in Biella, with
a sauce of minced meat and chicken livers. Maria learned from
my mother how to make them.

Did you eat three times a day?
Yes, but not much at breakfast.

What did you eat for breakfast?
Everybody had hot milk with a splash of coffee, but I was
never really able to digest it, so I've always had some problems
with breakfast.

But they insisted on giving you milk and you drank it.
Yes, I took things as they were. I couldn't imagine alternatives.

Were you often sick as a child?
No. I had one ailment as a child, erysipelas, an infection that
makes your face swell up. But after that I was always well. I can
say that I was always in good health.

Did the doctor visit you?
My mother used to take me to the doctor every so often for
"a good checkup." And the doctor would say, "Your son is fine,
signora. Go, go."

Did you talk to your father at home?
My father told me stories of when he was a boy, about how he
lived and studied. We talked a lot. He also told me how he left
the Susa Valley to study in Turin and then went to work with a
Pre-Raphaelite painter named Bogino, a follower of Enrico Reffo.
He painted frescoes in churches with him. And he talked to
me about when he used to help my grandfather, telling me that
when he was very young he would go into the mountains to keep
an eye on the woodcutter, because his father, who had a lumber-
yard, used to buy large tracts of woodland. He only cut down the
trees he needed in those woods, to let new trees grow. That was
the essence of recycling. My father taught me about the process
of recycling through nature—perfect recycling. My grandfather
employed many woodcutters, and other people who would go
with carts to collect the trees that had been cut and bring them
down into the valley. Indeed, the stones of the Vittorio Emanuele
Bridge in Turin are supported by wooden piles. My father told
me the wood for those piles was supplied by my grandfather.

Did you drink wine?
Yes, my parents usually drank wine with meals. I started when
I was eighteen, at a party in Biella. I'd gone to Biella from Turin
with the Fiat Topolino, accompanying some girls I knew, to attend
the twentieth birthday party of one of my cousins, and I remember

making a great impression as a drinker on that occasion. My aunt Candida put jugs of red wine on the table. My friends, girls and boys, including my cousin, drank very little, almost nothing, even though they were a couple of years older than I was. I drank nonstop, I remember emptying several jugs. Then, when the party was over, I got in the Topolino and drove back to Turin with my friends. That was the first time I understood that I could hold my wine. I wasn't drunk at all, just in high spirits.

Have you drunk a lot all your life?
Always in moderation. The odd drinking spree with grappa in the Cinque Terre, with friends in the evening, but I've never exaggerated.

In Turin you, the son of an artist-craftsman, worked as an adman. You weren't an intellectual, were you?
No, perhaps because I hadn't yet found the practical means that would have allowed me to be one.

Did you want to be one?
Yes.

You didn't read books and didn't go to the theater, so what was it about intellectuals that attracted you?
I don't know. When I was young I let things happen around me. It was enough for me to live amid the complexity of the things that surrounded me. Then I did what I was able to do. I still remember the moment when I succeeded in standing up for the first time. I remember the sensation of changing my state, of going from crawling on all fours to standing upright. I thought, "I can do it, I can do it, I can do it. I did it." In a way that's the story of my whole life, succeeding in standing up.

But you wanted to become an artist.
You know, there are still some small pictures that I painted with my father in 1950, a bit Realist-Impressionist in style, that were stolen from my daughter's attic recently. Since they're

not signed, someone showed them to me to ask me whether I had painted them. I haven't tried to get them back. I let them go their own way. My father got me to paint those little pictures stored in the attic. I remember saying to myself, "If this is art, I'm never going to be an artist." But then in advertising school, modern art was seen as an inspiration for commercial art, and there I began to discover the wonder of modern art and the enormous possibilities it offered. At that point, I realized I would be able to develop, through art, my own mode of existence, my own way of thinking and acting, something that I would never have been able to do otherwise.

Did Armando Testa became your teacher after your father?
In a sense, yes.

What was he like? Was he Piedmontese like your father?
No, he was a different kind of person, a modern man. Armando Testa's greatest quality was an extraordinary feeling for synthesis. I liked very much one thing he said: "I can't paint. I don't know how to create refined effects of light and shade. In my commercial art, I try to produce essential images precisely because I don't know how to paint."

You did know how to paint, though.
Yes, of course. But I don't paint, I use other instruments and other techniques, outside of the painting tradition. As for drawing, I make sketches, studies to fix my ideas.

Did Armando Testa introduce you to art?
His dream was to be an artist. We became friends because, when I had begun to make a name for myself with my art, he used to invite me over fairly regularly to show me his abstract paintings, and he said to me, "You hit the mark, because you've succeeded in doing what I've never been able to do, that is, to be an artist." And I told him, "But you're a great commercial artist." Quite apart from this very strong friendship we had, Armando Testa was an extremely funny guy, and since I can claim to have a

M.P., gallery owner
Luciano Pistoi (next
to him), and from
the right at the
top the critic Carla
Lonzi, Carla Accardi,
and an unidentified
person, at the
Galleria Notizie
on the occasion of
the opening of an
exhibit of work by
Kenneth Noland
and Frank Stella.
Turin, November
1964.

Bottom: M.P. with
Carla Accardi.

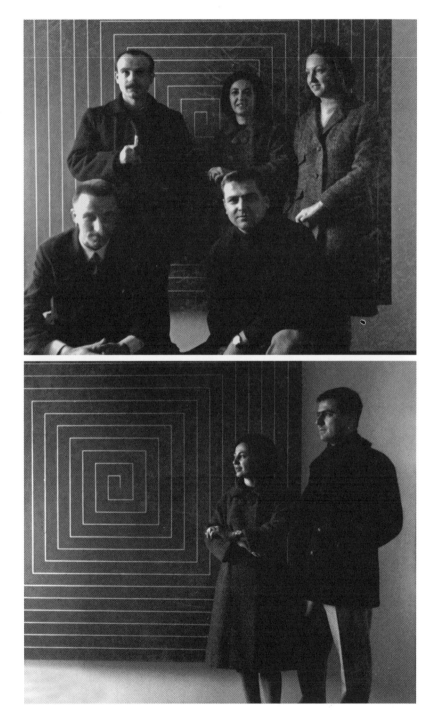

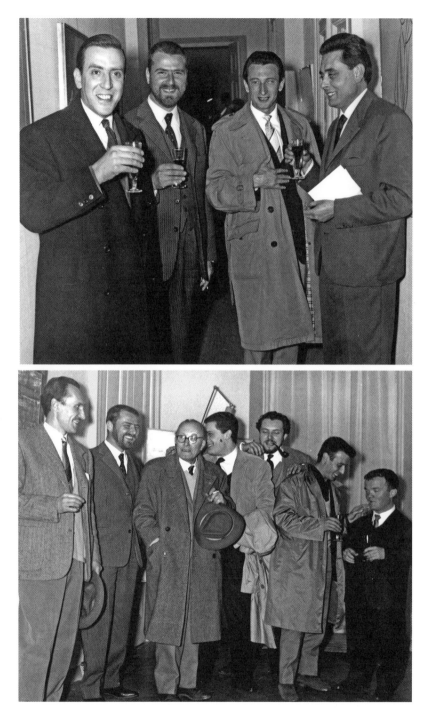

M.P. at the home of collector Aldo Buzzacchino with, from left, Giacomo Soffiantino, Piero Garino, and Achille del Piano. Turin, 1959.

Bottom, from left: Aldo Buzzacchino, M.P., Francesco Menzio (painter and founder, in 1928, of the Gruppo dei Sei), and the Turin painters Sergio Saroni, Francesco Casorati, Nino Aimone, and Francesco Tabusso.

Facing page: Lucio Fontana, *Spatial Concept: Expectations*, 1960. Museum of Modern Art, New York.

sense of humor, too, however immodest it may be to say so, we used to have some good laughs. We had fun together. But before that, at the time I was going to his school, and partly through his assistants, he urged me to go and see his exhibitions. And then we young students used to exchange ideas. In the space of six months I got to know all of modern and contemporary art. From the Impressionists to Picasso, Chagall, and Munch, and then the "isms": Cubism, Expressionism, Surrealism. I had a great thirst for knowledge and learned a lot in those few months. Keep in mind that in Turin in the 1950s there were exhibits of the most avant-garde art from America, France, Japan. Luigi Carluccio ran the Associazione Italia-Francia, which held annual exhibitions at the Galleria d'Arte Moderna, and Luciano Pistoi's Galleria Notizie showed the American exponents of Action Painting: Franz Kline, de Kooning, Rothko, Gottlieb, and other followers of Pollock. Thanks to that movement, I understood that art had made itself totally independent of anything to do with the real world.

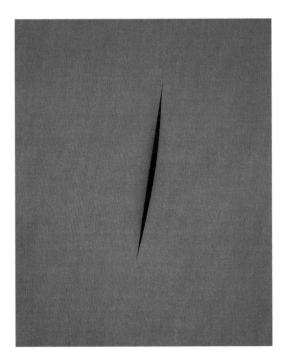

Did Turin feel small?
Turin was isolated, as were the other Italian cities for that matter, since there was no communication between them. But in the 1950s it was like being in Tokyo, New York, Paris, because art from those places was shown in Turin. Even in Rome it was like that. At that time there was minimal communication between Turin and Rome, but there was communication between Turin and the world, between Rome and the world, between Palermo and the world.

Who was in Turin in those years?
Casorati, of course, and then there were Spazzapan, Paolucci, Chessa, Menzio,

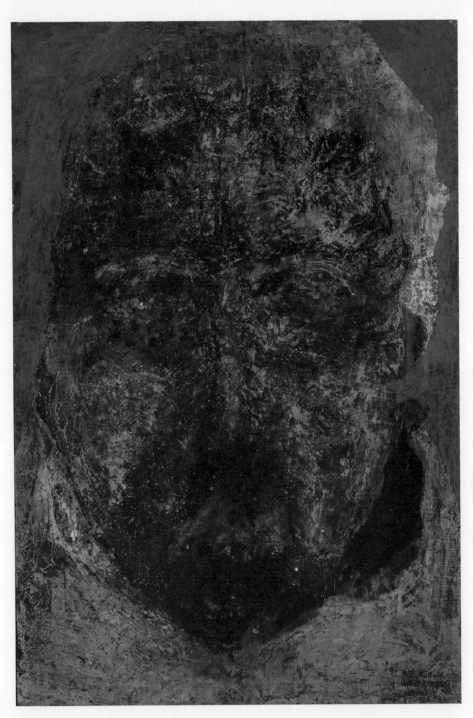

M.P. between two of his self-portraits created fifty years earlier: *Autoritratto* (Self-Portrait), 1960, and *Il presente— Uomo di fronte* (The Present—Man Seen From the Front), 1961, and, on the right, in front of the mirror painting *Autoritratto con quadro nero* (Self-Portrait with Black Square), 1962–76.

Facing page: *Autoritratto* (Self-Portrait), 1956. Oil and acrylic on canvas, 140 x 90 cm. All works, Cittadellarte-Fondazione Pistoletto Collection, Biella.

Galante. At the same time, though, international avant-garde work was arriving from outside.

Did you already see that you could become an artist?
I understood that I would be able to develop a vision of my own, just as others had done. I remember when I saw Fontana's pictures with holes in Turin for the first time, I said, "If Fontana did this, he must have his motivation. I don't know what that motivation is, but I realize that I myself, then, have to find my own." This was the school of freedom: finding one's own motivation.

And how did you find your motivation?
By working intensely on my personal research. We should bear in mind that at that time the art scene was engaged in a heated confrontation between abstract art and figurative art. There were artists working in both fields. For me, it was a question of choosing a field first.

When you began working as an artist, where did you start?
In the beginning I used paint as a means of liberation from descriptive content, clotting it in large lumps that, however, took on the character of a self-portrait. Through the self-portrait I sought my identity.

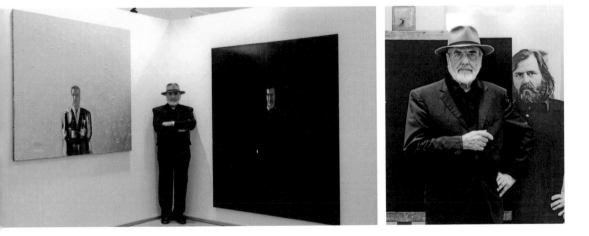

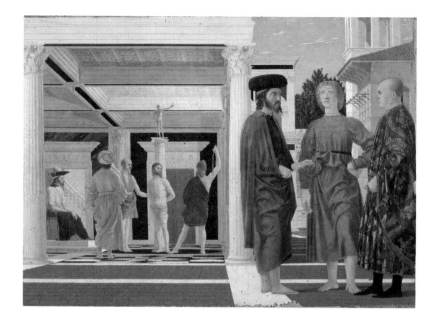

Piero della Francesca, *Flagellation of Christ*, c. 1455. Ducal Palace, Urbino.

Why a self-portrait? Were you vain?
Pictorial abstraction led to the creation of personal signs, but I felt the need to identify with the human image, starting with my own. In any case, though my training was modern, it came from the Italian school of representation. There is no abstraction in the Italian tradition. For me, Piero della Francesca was illuminating.

When did you discover Piero della Francesca?
When I was eighteen. I went to Urbino with my father and a friend of his, and in the Urbino ducal palace, I unexpectedly found myself in front of Piero della Francesca's *Flagellation of Christ*. I was dazzled. It was a religious subject, but the subject was a pretext. It was actually a phenomenological work, based on the essential definition of perspective. Perspective was the real protagonist of the picture. The narration of the religious story served only to position figurative elements that made the perspective evident. In addition, Piero had portrayed the three clients and placed them in the foreground to act as the wings of his perspective space, locating the scene of the flagellation

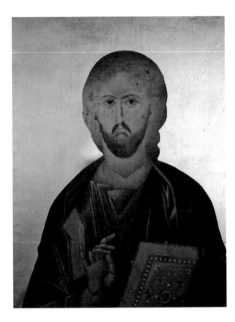

Byzantine icon,
fourteenth century.

on a plane further back. In the *Flagellation
of Christ*, Piero della Francesca totally leaves
aside the drama of the subject to focus
on a rigorous scientific and mathematical
formulation.

What about Caravaggio?
I like Caravaggio a lot, because he, too, in a
certain sense is a phenomenological artist.
He discovered the effect of photographic
chiaroscuro. It was a true milestone in the
history of painting. The dramatic character
of the image is due to the relationship that
the artist was able to establish between light
and shade.

Do you identify with the Italian tradition?
Yes. Much of the art that passed through my father's studio was
Italian, but obviously there was English, Dutch, French, and
Spanish work, too. Among these, the medieval icons became
very important points of reference for me. The icon came from
Byzantium and caught on in Italian painting. In Italy there
was a shift from the icon to Renaissance representation, to the
baroque, and then to nineteenth-century painting.

Which artists influenced you most?
One of my modern influences is Bacon. He became my guide
without being one in practical terms. He was a figurative
painter, but not an ordinary figurative painter. He reconsidered
the fundamental aspect of the human being, and that was
important to me. But he dramatized the image of the person,
and that's where we parted ways. I, too, turned back to the per-
son, but I sought to strip away any drama.

Did you see Bacon's work?
Not until an exhibition of his work was held at the Galleria
Galatea in Turin in 1958, the year I signed a contract with the

same gallery. His work confirmed the specific character
of what I was attempting to do, but at the same time it moti-
vated me to look for a way out of the existential drama that
he expressed.

What about Titian and Venetian painting?
Venetian painting was realized in part with light and shade in
white and black; the colors were then laid on in veils. Titian's
marvelous reds are vibrant in their transparency, as they are
laid on top of the impasto. *Techne* has always played a funda-
mental role in the history of Italian art, unfailingly figurative in
every era.

Is this figurative history of any use to you?
Certainly. I see the source of the cultural and religious issues
in it. The roots of figurative art are the opposite of those of
abstract art, which comes from the iconoclastic religions that
rejected and fought against representation: these include early
Christianity, Judaism, Islam, and later Protestantism. It was
in Italy that from Greece to ancient Rome, from Byzantium
to the Renaissance, from the baroque of Michelangelo to
modernity, representation followed the path of scientific prog-
ress up until the discovery of photography. The perspectives of
science are connected with the history of representation,
which has pre-Christian origins and was then adopted by
Catholic Christianity.

Were you influenced by the figurative?
I wasn't influenced by it, but I discovered the basis of scien-
tific development in representation. The fact is that Piero della
Francesca's discovery of perspective took place within repre-
sentation, which Catholicism adopted as its means of commu-
nication. Indeed it is through the image picked up by the eye,
in other words, through the representation of reality, that the
definition of perspective was achieved. Piero della Francesca's
Flagellation of Christ set in motion the process of scientific
development that led to photography. Science and technology

developed and completed what Piero started. Science, economics, politics, and social organization started to make their way toward modernity from the scientific perspective that was born out of representation. Caravaggio, too, was attracted by light and shade, as if his eye were a camera lens.

Have other artists interested you?
Looking at historical works of the past, I'm able to appreciate the specific qualities of any artistic expression. For me, though, what matters most is identifying through art a process of evolution that also concerns the various aspects of human history.

Is figurative art similar to cinema or photography in some ways?
Both cinema and photography are certainly similar to figurative art for one very important reason—they are not physical material but an image of reality. In addition, they are united by light. Total immersion in the light of the cinema is a marvelous thing. Cinema came after the discovery of photography. It is animated photography, photographs presented in sequence that reproduce motion and immerse us in the wonder of scientific and technical discoveries.

As Balla did with speed.
I've found Balla and Futurism very interesting, but while movement and speed are described in the work, it is in the form of sequences of images that recount a movement, but there is no real movement. Perhaps Balla aspired to cinema, but cinema gives me much more than Balla does.

You learned technique, first from your father and then from Armando Testa. When you talk about Titian, for example, you don't do it as an art historian. Instead, you speak of the paint, the colors, and the techniques he used in his work. Without realizing it, you learned the basics of art as an apprentice.
As I've already noted, all of that also trained me so that I could analyze artwork: the school, the period, the artist.

You're an art detective, a combination restorer, connoisseur, and artist. Could you have been an art dealer?
Oh, certainly.

Instead, Testa taught you to look at modernity, and you decided to make the leap. Did you do it on your own, or did you talk it over with your father?
I did it on my own and didn't talk to anyone about it. The commercial art course lasted for two years. After the first year of school, which was actually only one semester, Testa asked me to come and work in his studio. I was good at drawing and painting and had attracted his attention. At that time, though, I was already opening an advertising studio of my own, so I couldn't accept his invitation. A friend who had an advertising agency that was already a going concern had been appointed director of a much bigger agency, and had asked me if I was interested in taking over his business. From that day on I stopped doing restoration in order to work on advertising.

For whom did you do ads?
I worked for Necchi, Singer, Pibigas, and other companies.

When did you take the big step of becoming an artist?
Around the mid-1950s, I decided to rent a loft on Via Bava, in Turin, and it was there that I developed my "bent for art": it was a garret and I often used to bump my head. I painted pictures there that I've shown in recent retrospectives. At the outset I made large heads of a very tactile quality depicting my face. I called them self-portraits. Then I started to reduce the size of those enormous heads, and as they got smaller the body came out and around it the background appeared. At that point, the relationship to the Byzantine icon emerged.

So, you're an artist with Catholic-Byzantine roots. Is that the source of your inspiration?
You could put it that way: my inspiration comes from the relationship between the human figure and the gold background,

meaning an icon of Byzantine origin. The icon was born not as a work of art, but as an act of devotion.

You are figurative, but in the background of a Leonardo or Bellini painting, for example, there is always a landscape, something you don't do.
A landscape might also be the interior of a house.

As in a Vermeer.
Or a Giotto. In some of his pictures the backgrounds look like small or large rooms.

But you don't do that.
I don't do landscapes, because in my pictures the landscape is the reflection in the mirror.

None of your experiences as a youth in the Susa Valley, of the war, of the countryside, of the mountains have appeared in the background of your pictures?
No, and in discovering modern and contemporary art I discovered Yves Klein's monochromes—gold and blue monochromes.

Jean Fautrier, *Otage No. 17*, 1945. Private collection.

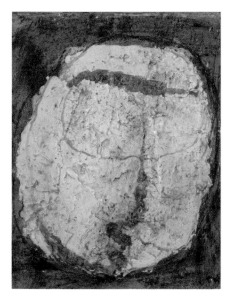

You were also inspired by Fautrier, who was not figurative. Why?
Fautrier interested me because he clotted lumps of paint on the canvas, magmatic excrescences that looked like mounds of lava. The paint itself, quite apart from any form, became the protagonist of the work. It was nonrepresentational art that led to the surface of the picture invading space physically. That was true of Fautrier's work, and Burri's, too.

Do you consider Burri a more important artist than Fautrier?
No, they're both important. I saw Burri's sacking in Turin, shortly before Fontana's holes.

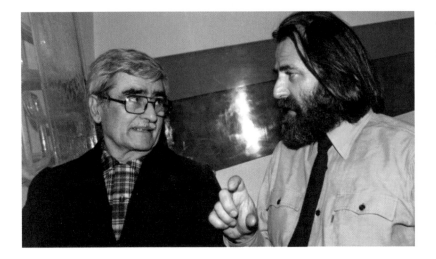

Alberto Burri and
M.P. Los Angeles,
1979.

Did you know Burri well?
Yes. Burri detested more or less all contemporary artists. I was
the only one he befriended.

Did you visit him in Città di Castello?
We met when I was already known as an artist, when he was
living in Los Angeles. There was an exhibit of my work there in
the late 1970s, and he came with his wife, an American dancer.
Then he invited me and Maria to his home, and later to Città di
Castello. We became friends, and I've heard that he spoke highly
of me on several occasions.

And what did you talk about?
I don't remember anything in particular. We certainly talked
about my *Minus Objects* that were being shown in Los Angeles,
about the logic of difference, about the dynamics of change,
something he appreciated, having experimented with it several
ways in his work. We talked about material differences. He was
attracted to my work with the mirror.

Do you think he was a true artist?
A great artist. He earned a degree in medicine, but he chose art,
and he had extraordinary powers of intuition. Without Burri,

Rauschenberg might not have existed, for one thing. He always had a strong aesthetic sense of formal composition, but he was able to overcome its limitations through the revolutionary use of materials: from sacking to burned plastic, sheet metal, and cracked concrete. He created work that substituted physicality for representation.

Had Rauschenberg seen Burri's work?
Yes, he'd certainly seen it and been inspired by it. He told me so himself. All things considered, people found Fontana more shocking. Burri literally sewed together pieces of color, while Fontana made holes in the canvas, and that was seen as pure provocation. Burri employed a physical technique, whereas Fontana developed a spatial concept.

Fontana tore the canvas. His work has a very strong identity.
Fontana punctured and cut the canvas as if he were breaking through the end wall of Renaissance perspective. He felt walled in by modernity. It was the wall created by Mondrian that had definitely blocked the spatial and temporal perspective from the past. By piercing the canvas, Fontana sought to open up a new space for perspective. Modern life seemed to satisfy every desire, but Fontana was not satisfied and showed it by trying to go beyond, even though this seemed impossible. It was a practical gesture, but it remained an intellectual exercise, since by puncturing the canvas, he broke only a few millimeters through the wall. At least, however, he had the sensation of not being shut up in the cage of modernity. He looked for new space and called his creations "spatial works."

Did you go to Milan to see Fontana?
He was very impressed with my work and told me to call him when I came to Milan and we would have lunch. He loved good food. We went to a restaurant on Via Senato famous for its fish. After Fontana saw my first mirror paintings, he told me I'd done something that hadn't occurred to him. Indeed, perspective had always been considered a view forward. A vision in perspective

could only be obtained by looking out a window or breaking through the wall of a room. When I turned the canvas into a mirror in 1961, perspective was turned back on itself. I didn't need to break through the wall; the wall was pierced automatically because an unlimited space opened up before the visitor's eyes, as if through a gap, without the violence and drama of Fontana's gesture. But why was this space created? Because it was the transfer of everything that lay behind the viewer, and so the perspective opened up forward by making us look backward. Perspective, through the mirror painting, became a two-way phenomenon. And the artist responsible for *Holes* looked at the mirror painting and realized that it was no longer necessary to continue the perspective by cutting through the wall. All that was needed to go beyond was to look backward. That was when Fontana created his *Teatrini* (Little Theaters), which inserted themselves in the real space represented in the reflection in the mirror, thereby escaping the obsession with the old perspective.

What was Fontana like? Was he a friend of yours?
Yes, but he was a friend to everybody, a man of great warmth, very open.

Were he and Burri friends?
I never saw them together. I don't even know what they thought of each other. Fontana started out as a sculptor, so he could be seen as a forerunner to artists like the American Flavin: he used neon directly as an aesthetic material. He arrived at painting through his search for perspective. One day he asked me if I wanted to exchange some work with him, but I didn't have anything at the moment, since my contract dictated that I had to give all my work to the gallery. Then, unfortunately, he died, and I was really sorry that I hadn't made a picture for him and hadn't gotten a piece of his in exchange.

Giuseppe Capogrossi, *Section 4*, 1953. Museum of Modern Art, New York.

What about Morandi?

Morandi represents a peremptory declaration of artistic individuality, made with figurative rather than abstract elements. Another artist I got to know during the six months in which I discovered modern art was Capogrossi. In my view, he defined the concept of the personal signature in a way few others have done, and he was an Italian abstractionist, not an American Abstract Expressionist. He wasn't expressionist, but he lucidly elevated the individual symbol of the artist to the highest degree. For the Americans, such a symbol was a gesture, while Capogrossi's was a calculation, not a gesture. Morandi did the same thing—he put his signature on his work, but figuratively. He found a characteristic feature and, instead of using symbols like Capogrossi did, he used bottles, and he did so with great control. Morandi's exhibit at the Guggenheim prompted me to look closely at the whole process of his work, and I realized that a war had taken place and he had shown no sign of noticing it. He had incredible staying power and did not modify his painting. Morandi's bottles hardly change color; they do not reflect the drama of the war.

Is that a good thing or a bad thing?

It's an extraordinarily good thing, because it allowed him to create a bridge of art that passes over the tragedy of human folly.

That's beautiful. But then, when Picasso painted Guernica *during the war in Spain, what did it mean? Was Morandi indifferent to what was happening?*

He was indifferent, because by then he had arrived at a minimal and inexpressive dimension very different from that of Picasso. Another artist springs to mind: the Polish painter Opalka. One day he decided to fill his canvases by painting the numbers in sequence in gray, starting from one and carrying on for as long as he lived. He didn't paint bottles, but numbers that were instants of life. Then one day he died. Before he died we did three exhibits together, and he showed those numbers, which marked his existence moment by moment.

He was no Pistoletto, though.

I represent life moment by moment through the mirror. But looking back to the abstract art of the 1950s, we should keep in mind that those artists eliminated all the symbols relating to society and kept only their own. With the mirror, I eliminated the individual symbol, too. The mirror painting turns subjectivity into objectivity. So it offers an objective view of the world. Art passes from the "I" to the "we" and includes society, but without representing the systems imposed by religious and political authorities. Having eliminated all symbols with the mirror, art has brought its autonomy to the center of social responsibility. Now new symbols are born from art, and no longer from politics, economics, or religion.

What about Giacometti?

I was fortunate to have a good relationship with him. But I should tell you how I met him and got to know him personally. In 1958, I took part in the Premio San Fedele competition for young artists and I won a prize. Luigi Carluccio was on the jury, and he took Mario Tazzoli, owner of the Galleria Galatea in Turin, to see what I'd done. Tazzoli bought it and asked me if I intended to carry on making commercial art and suggested that I could earn the same amount of money by signing a contract with him for acquisition of my works. I accepted, and my career as an artist began. The Galleria Galatea put on solo exhibits by Magritte, Bacon, Giacometti, Sutherland. The artists who showed in that gallery were all great masters. I was the only young artist. I met Giacometti at the gallery.

Did you get along with Giacometti?

Very well. He invited me to stay at his home at Stampa, in Switzerland, and showed me, along with the things he was working on, his father's pictures, and we talked about our fathers. Then we discussed the significance of the human figure. I talked to him about my icons and he talked about his. His icons were mostly from African art—typical elongated figures. Then he obsessively made those famous very small self-portraits drawn on gray paint. He liked the paintings I was doing at

Clockwise, from top left: Balthus, 1956; Alberto Giacometti in his studio, 1958; René Magritte photographed at the Museum of Modern Art, New York, 1965; Francis Bacon in his studio, London, 1962.

that time. They were not yet the mirror paintings, but figures steeped in paint.

Did you have the feeling of being with a great master when you were with him?
Oh, yes. I sincerely admired his work.

He was much older than you.
I was twenty-five then. He was thirty-two years older.

Which other great painters have you met?
At the Galatea I met Magritte. He was a courteous gentleman
with a bourgeois appearance. He could have been a bank clerk.
He was like his pictures, a surreal banality. He didn't talk much;
he was very reserved. Then I got to know Balthus, who at that
time had been appointed director of Villa Medici, the French
Academy in Rome. I used to see him in Turin, because he passed
through frequently on his way between Paris and Rome.

Did you know that I'm an adviser to the academy?
Oh, really? I've slept at the top of the tower, in the rooms deco-
rated in the Oriental style. Well, Balthus had to furnish his
studio and some of the rooms in Villa Medici, and since I knew
many antique dealers in Piedmont, I took him around to look
for original pieces of furniture from the fifteenth and sixteenth
centuries, which he bought and had sent to Rome.

What was Balthus like?
He was a very nice man.

Was he a great artist?
To me, yes. I was fascinated above all by the walls meticulously
reproduced in his paintings. They helped me develop the con-
cept of background with respect to figure.

Do you think he is an artist whose influence will be lasting?
Yes, definitely! He had a rather satanic side, the expression of a
libido stifled in mystery. I preferred his works to the brazenly
sexual ones of his brother Klossowski. Personally, I have to say
that I found the morbid side that the two brothers shared less
attractive. What interested me in Balthus was his ability to place
many elements of reality in suspense in the narration of a picture.

Did you work a lot when you were younger?
Yes, without letting up.

Did you work in your studio?

I moved my studio into the house. My father-in-law was our landlord. He let us have an apartment, and then I had asked him for another that I used as a studio. I made a passageway between them and connected my studio to the apartment. So, for all intents and purposes, I worked at home.

Left, M.P.'s parents. Right, Maria Pioppi and M.P. Pictures from the Buca Lapi restaurant's matchbox. Florence, 1970.

How did you work? Did you get up early in the morning? Did you work during the day or at night? Did you keep regular hours? Did you work every day?

I worked every day. Then, if I hadn't succeeded in doing something good by evening, I felt uneasy and thought I'd been wasting my time. I didn't feel the same unease when I went to the movies, though. There I would immerse myself blissfully in that luminous material. There was a story and I followed it, without having the sensation of wasting time.

Did you go with your wife or by yourself?

By myself. I stopped working and went to the movie theater.

Were your parents still alive?

Yes, they were alive. I was already with Maria when my mother died.

Were your mother and father unhappy about your separation?
I think so, but they never said anything to me. They always respected what I did.

Did you take your father to see your pictures? Did he come to see you?
At the beginning no, only later on, when I was already doing the mirror paintings.

Did he come to the exhibit at Galleria Galatea in 1960?
I don't remember.

Did you go to see them?
Yes, always. At a certain point they moved to Susa, to the second floor of the house they inherited from my grandmother, and on the ground floor I furnished an apartment for myself.

When did you go there?
Usually on weekends.

And did you still go to Mass with them?
No, I hadn't gone to Mass for many years. Perhaps I went with them at Christmas sometimes, but we always celebrated Christmas with great enthusiasm. My mother used to make agnolotti and I helped her. My first wife, Marzia, was there with our daughter, Cristina, and then Maria with the twins.

When you say you helped her, do you mean you made agnolotti?
Yes, I always made the pasta.

Are you a good cook?
Good, I don't know. I won't starve, let's put it that way.

M.P. with his father, mother, and the future gallery owner Annina Nosei, in the photography studio of Paolo Bressano, posing for creation of *Mirror Paintings*. Turin, 1963.

Do you still cook?
Yes, I cook something every now and then.

What do you cook?
I make vegetable flan, *peperonata*, *pappa al pomodoro*, which is a bread soup made with stale bread, rollatini, which my mother called *valigette*, or "little suitcases." And I make polenta, risotto.

Carlo Emilio Gadda and Pellegrino Artusi wrote recipes for risotto. What's yours?
To make risotto, you need to use a large flat pan. Slice an onion and sauté it briefly in olive oil with the right amount of salt. When the onion starts to cook, pour white wine over it, which adds liquid and helps it cook. Separately, prepare a stock with celery, garlic, and rosemary, which is a vital ingredient. The ideal would be to make it with a few pieces of chicken or beef, but you can use a bouillon cube instead. Put the rice in the pan, using two generous handfuls per person, and mix it with the cooked onion. Then you start pouring the stock into the rice—the Carnaroli variety, if possible—and let it simmer. There are two ways of making risotto. In the first the rice is stirred continually as the hot stock is added gradually, with a ladle. In this case, if you stir it once you have to keep stirring until the end, otherwise it sticks to the bottom of the pan. The result is a creamy risotto. The other way is to not stir it at all: you add the stock to the rice until it's covered by a couple of inches, and let it cook for twenty minutes. That way, the rice doesn't stick to the bottom and the grains remain more separate and not creamy. After twenty minutes the risotto shouldn't be too dry; it should still be fairly wet. You turn off the flame, cover the rice for a few seconds, and serve. Something I do every now and then is grate some Parmesan cheese and mix it with egg, then stir this mixture into the rice before serving it, as a last step in the process to make it creamy. The risotto acquires a pinkish yellow color and a delicious taste. But you have to be quick, so the rice doesn't overcook.

Do you make it often?
Occasionally, and with great pleasure.

I'd like to know what your homes were like.
I'd have to make a list of very different places and situations. I don't identify with a particular kind of house.

As a child, were you attached to your home or did you not care much? Seeing that your father spent his life surrounded by antiques dealers, how was it furnished? Did you have a beautiful house? Was there fine art on the walls?
There were my father's pictures. I remember that when I was a child the house was also a studio. It was always tidy. There were carpets, and I can recall the scent of the incense that my mother burned when friends came to see her. One thing that my mother made very well on special occasions was trifle with marsala. The only alcohol I had as a child was the marsala in my mother's trifle.

When did you leave your parents' house?
I was twenty-two when I got married and went to live with my wife on Via Cibrario in Turin.

Did you get married in church? Where?
Yes, in a church near home. I don't remember what it was called. I didn't know you could get married anywhere except in church.

Were you in love?
Yes, I was.

Were you faithful?
Yes.

Were you jealous?
I think I was in the beginning.

Why? Were you insecure?
I don't know, I'm not sure how to judge that feeling. In my view, jealousy stems from the fear that the magic circle that binds you to a person and binds that person to you can be broken. The fear of losing something that belongs to you creates the suspicion that, for some reason, it might happen. Two people who love each other, who plan to spend their lives together, cannot accept violation of the profound tie that unites them. Unfortunately, fear undermines even the greatest trust. Perhaps, though, jealousy is at bottom a phenomenon connected to the idea of possession of the person you love. As far as my own story is concerned, I discovered that a love affair could also come to an end.

How did you discover that?
I started to want to make myself independent and I rented a large space, a former printing works, a studio away from home, and I began to live there alone as well as use it for work.

Was it a traumatic separation?
No, no, it wasn't. We remained de facto separated until our daughter Cristina was eighteen, and then we got divorced. We had an untroubled relationship. Marzia and her partner sometimes came for Christmas lunch at Sansicario, where Cristina lived with me, Maria, and the twins for a while.

And you weren't jealous?
We had become good friends. I haven't seen her for a long time, but someone you've lived with in that way remains part of you. Like my mother has remained part of me. The people I've lived with stay a part of me.

Did you feel you were a handsome man?
I've never thought so.

Were you vain?
Who knows! I've always been interested in changing my image, in looking different.

Because you didn't like the way you looked or because you found it fun?
Because I found it fun. I changed my look to surprise myself, or perhaps to understand myself better.

Why is the Michelangelo Pistoletto of today always dressed in black? When did you start wearing black?
In 1969, when I wrote a book entitled *L'Uomo nero* (the Black Man, sometimes translated as the Minus Man), after working for several months at Corniglia with the Zoo on a specific theme: the search for the black man.

Who is the black man?
In cards he is a figure who has no double—he's the winner or the loser. He's the element that never pairs up. If, for example, there are twenty chairs and twenty-one people, when they change places the one who is left without a chair is the black man.

Why black?
Black for me has many meanings. My first mirror painting was black. Black is the sky at night, a black that contains everything. It contains the light of the stars, in other words, the universe. For me the black of the sky is the nothingness that contains everything, like the mirror.

Did you wear colorful clothes before 1969?
Yes. In fact, I'd say that in 1965 I joyfully started dressing in the hippie style that was fashionable then, which I really enjoyed. In that period I stopped wearing bourgeois clothes.

Lo Zoo scopre l'Uomo nero (The Zoo Discovers the Black Man), performance by the Zoo at Galleria Sperone, Turin, 1969. From left: M.P., Beppe Bergamasco, Maria Pioppi, Bill Hagans.

Up until then did you wear a necktie?
Yes, I used to wear a tie even when I went skiing. Although in the summer perhaps I didn't wear a tie.

Did you spend a lot of money on clothes?
No. My clothes have always lasted a long time. When Maria sees that they're getting worn out, she goes to Emerson's in Turin and has a black suit made for me. Lately they're in a larger size.

Did you have a lot of shoes?
No, certainly not.

And how did you spend your money? On cars?
Oh, I've always really liked cars and I've had many, but I didn't spend much money on them. When I started to earn money as a painter, I bought a metallic reddish purple Giulietta Spider. Since then I've had several very attractive cars. From the Mercedes Pagoda to the Jaguar, from Maseratis to the Iso Grifo. I liked beautifully designed fast cars.

Were you a good driver?
Yes. The Iso Grifo could go almost three hundred kilometers an hour. Once Maria and I went from Turin to Rome in four hours. We were going to art critic Alberto Boatto's house. We called him from Turin at midday to tell him, "We're leaving now." And he answered, "We'll be here all day. When you arrive, whatever time it is, even late in the evening, come over to our house." At four in the afternoon we rang his doorbell. He thought it was a joke, that we'd been at the restaurant near his house. There were very few cars, it was a Sunday, and none of the roads were under construction. This was in 1968, when traveling by car was completely different than it is today.

Did you know the great automobile designers like Pininfarina and Bertone?
No. I was friends with a dealer, Walter Bordese.

M.P.'s collection of Arte Povera. In the foreground, *Igloo* by Mario Merz, in the background, Maria Pioppi and the cribs of the twins Armona and Pietra. Maria and M.P.'s home, Turin, 1971.

Facing page: M.P. working on some mirror paintings in the workshop of screen printer Alberto Serighelli. Milan, 1973.

You gave him a picture and he gave you a car?
I paid for the first car, which was secondhand. Then he started to collect and we bartered. Mind you, I said I didn't spend much on cars because I never bought them new. So-called luxury cars depreciated immediately, because no one rich would have bought a used car and they used to change them often. So I could get beautiful and practically new cars very cheap.

Going back to houses, what was the one where you lived with your first wife like? Was it a bourgeois house?
I've always loved antique furniture, as well as family heirlooms, as I still do today. The table you see over there dates from the fifteenth century.

But I don't see work by your friends, only your own. For example, this mirror painting, which depicts a person with binoculars. Who is it?
She's a Bosnian girl named Asja. She was here at our house when I photographed her. She was writing the introduction to the catalogue of my solo exhibit at the museum of contemporary art in Sarajevo. It was her first text as an art critic. After fleeing to the United States at the age of sixteen, at the beginning of the war in Yugoslavia, she had just gone back to Sarajevo. Now she is the chair of contemporary art at the University of Sarajevo.

And this very famous work, the rope with a noose? What prompted you to make it? Was there something in the news that struck you?

It's an object that hangs from the ceiling, like a lamp, obviously with a very different use. The mirror painting takes the drama out of its context and plays it down.

So, in your homes you mix family objects, antiques, and your work. You're very orderly. And you sleep alone, in a small bed.
Yes.

And you don't own anything by other artists?
I have some work by a few of my friends, but I don't keep it at home. Those things are on display in the space at Cittadellarte devoted to the Arte Povera collection. Work that I acquired in the early 1970s is displayed so the public can see it. That includes some of the earliest work by my artist friends: Gilberto Zorio, Giovanni Anselmo, Giuseppe Penone, Mario Merz, Giulio Paolini, and Luciano Fabro, as well as work by Salvo and Gianni Piacentino, who weren't part of the Arte Povera movement.

Getting back to you, tell me about the house where you lived with your first wife.
There was some of my grand-parents' furniture that my father had given me when I got married, and other antiques I had bought. I had a number of wooden sculptures from the Middle Ages and the Renaissance that constituted a small collection.

And from there you went to stay in a studio?
I went to live in the studio on Via Carlo Reymond, a former printing works behind the Museo Nazionale dell'Automobile. In a little room with glass walls, which must have once been the office, I put a bed,

Detail of the photograph used to make the mirror painting *Self-Portrait with Souzka* (1962–67), whose subjects were M.P. and Souzka Zeller, actor in the Living Theatre.

a small gas stove, a folding table for camping, and a portable fabric closet. That's how I furnished my little nest.

Did you live the life of a bachelor? Were there many women?
No, but there were some who passed through.

No significant relationships.
For a short time I went out with a girl who was part of the Living Theatre. There are pictures from that time. The Living Theatre troupe, with Judith Malina and Julian Beck, had come to Turin several times and hung out at my studio.

But by that time you were living an artist's life.
I lived alone with my work.

What about Tazzoli?
The connection with Tazzoli ended after just over a year, but a year then was a very long time, because so many things were happening to me.

What happened? Mario Tazzoli was an important gallery owner, the owner of the Galatea, but he didn't understand the first mirror paintings.
No, he was distraught over the idea that I was making those pictures. He really couldn't follow me down that road. Already the pictures on a reflective black background and even before that the ones on gold, silver, and copper backgrounds worried him. Then, eventually, he turned away completely. He was interested in the romantic aspect of painting, while in my work the romanticism was gradually fading and the picture was becoming phenomenological. In 1963, Tazzoli staged an exhibit of 1962 *Mirror Paintings* at the Galatea, but he was embarrassed by them. He'd commissioned those works and had to show them, but he didn't appreciate them. One day Gianni Agnelli came to the gallery. I was out of sight, and I heard Tazzoli apologizing to him for the exhibit and saying he was ashamed of it. I was shocked to hear those words and I walked out.

Solo exhibition:
*Michelangelo
Pistoletto: A Reflected
World.* Walker Art
Center, Minneapolis,
1966.

Did Agnelli buy any of them?
Not at that time. He bought some later on, when I was showing in America.

Were you and Tazzoli friends?
There had always been mutual respect between us up until the episode I've just recounted.

Who was Gian Enzo Sperone?
He was a young man from Carignano, a town in the province of Turin. Tazzoli had some friends in Carignano and one of them was Gian Piero Bona, heir to a wealthy family of former woolen manufacturers. Then Gian Enzo married Gian Piero's sister. Tazzoli used to meet those friends at Carignano and young Sperone was part of the group. He was studying humanities, and was the son of the caretaker of the school in front of the Bona family's house. At a certain point, Tazzoli hired him as an assistant at the Galleria Galatea. Gian Enzo didn't know much about art, but he was bright, likable, and open-minded, while the other people at the gallery were formal and stiff, a stone-faced group. He was the only person I could talk to and I used to ask him, "Do you know who this artist is? And this one?" And if he didn't know them, I would talk to him about them, but above all I explained my black pictures to him. "You have to understand," I told him, "that today art can no longer lean in a dramatic and tragic direction like Bacon's did. It's necessary to find a way out of this existential suffering." And he listened to me, while no one else paid attention. The others didn't give a hoot what you thought. All

Man with Yellow Pants (1962–64), 200 x 120 cm, mirror painting whose subject is Gian Enzo Sperone, photographed at M.P.'s home in Turin in 1964. Acquired that year by the Museum of Modern Art, New York.

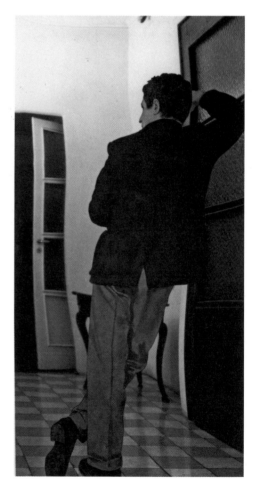

M.P. with Gian
Enzo Sperone,
Maria Pioppi,
and *Quadro di fili
elettrici* (Painting of
Electric Wires), 1967.
Galleria Sperone,
Turin, January 1967.

Gian Enzo Sperone
and M.P. leaning on
*Structure for Talking
While Standing*
(1965–66), reflected
in the mirror
painting *Dog* (1962–
65), on the occasion
of M.P.'s solo show
at Galleria Sperone,
Turin, 1966.

that mattered to them at that moment was that you made pictures they found valid according to their ideas.

Did you have other artist friends in addition to Sperone?
At that time there were no young artists I found really interesting. Saroni, Soffiantino, and Ruggeri were artists who worked with the Galleria La Bussola. Then there were Francesco Tabusso, Giuseppe Ajmone, Felice Casorati's son, Francesco, and Gigi Chessa's son, Mauro. We were quite friendly, as we used to meet at the home of Buzzacchino, a famous hairdresser who collected works by young Turin artists and once a week invited us all to his place, where we used to spend very pleasant and entertaining evenings.

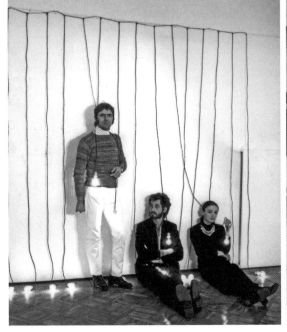

But you talked to Sperone.

Yes, I'd see him when I went to the gallery. He wasn't an artist, but a bright young man who was curious about and open to art. One day a gentleman named Remo Pastori, who was opening the Galleria Il Punto in Turin, asked me if I knew someone who could run it, and I suggested Gian Enzo Sperone. I asked Gian Enzo if he wanted to become the director of a new gallery and he told me he didn't have enough knowledge and experience. I said I would make the necessary suggestions. He accepted the job, and after little more than a year he was showing artists like Lichtenstein, Warhol, and Rauschenberg.

Gallery owner Ileana Sonnabend and M.P. in a 1965 photographic work by artist Marcel Broodthaers.

Then you moved to Sonnabend. What happened?

Let's go back to the moment when I left the Galleria Galatea in despair after Agnelli's visit. A friend wanted to go to Paris and asked me to accompany her. And that's what I did.

Was that your first time in Paris?

Yes. I visited the Louvre, the Impressionist Museum, the Jeu de Paume, and some private galleries. By chance I ran into Bepi

Romagnoni, an artist from Milan, who told me I might find it interesting to visit a gallery where the work of some American artists had just arrived. It turned out the work was Pop Art, and the gallery was Ileana Sonnabend's. I was about to go back to Turin, and on my way I passed the gallery, so I went in. It was empty. I asked if I could see some of the works I'd heard about. Michael Sonnabend was kind enough to take some canvases out of the storeroom and in the meantime, he asked me what I did. I told him I was an Italian artist. I showed him the catalogue from the exhibition at the Galatea and a small picture I had in the car because it hadn't ended up being shown. Michael and Ileana Sonnabend were amazed and said they would come to see my exhibit. A few days later they turned up in Turin, saw my work, and bought all of it, and then they offered to buy me out of my contract with Tazzoli. This happened in 1963, and in 1964 I showed in all the exhibits in Europe along with the American Pop Artists. I was the only European. Leo Castelli took my work to the United States and showed it in his gallery there.

Were they trying to pass you off as a Pop Artist?
Yes, and they had a point. We had something common—the concept of objective art. Something is said to be objective if everyone can understand it, if it is a generally comprehensible representation. Ours was an art that came after Abstract Expressionism, totally focused on subjectivity. In this sense, there was a very clear affinity, although in my work there was none of the emphasizing of the phenomenon of consumption, of the media-based glamour that was a common theme among the American artists. The underlying iconographic theme in my work was the human being and everything around it. An idea of the universe different from the consumerist one that the Americans were trying to pass off as universal.

There was a turning point in your career: the mirror paintings changed your life. Suddenly, you moved from an Italian gallery to a French gallery known all over the world, not just because it was Sonnabend, but because it was Sonnabend-Castelli, the two most important

*dealers in contemporary art at that time. Castelli represented Jasper
Johns, Rauschenberg.*
Ileana and Leo Castelli had been married to each other, and
then she became Sonnabend because she married a family
friend named Michael Sonnabend. Ileana and Leo lived together
in New York. Before they focused on Pop Art, they collected
works of American Abstract Expressionism.

*Warhol had trouble getting accepted by Castelli because he irritated
Jasper Johns, an artist who was influential in the gallery and not an
easy person.*
Well, in Paris, Ileana Sonnabend represented all of them.

L'Uomo nero,
action-presentation
of M.P.'s book
*L'Uomo nero,
il lato insopportabile.*
Salerno:
Rumma Editore.
Galleria dell'Ariete,
Milan, 1970.

*She had Jim Dine, Warhol, Lichtenstein, Oldenburg. And Pistoletto.
And Gian Enzo Sperone became Sonnabend's representative in Italy.*
Beatrice Monti's Galleria dell'Ariete had already showed
Rauschenberg and Jasper Johns in Milan first.

*So you became a great international artist. If I'm not mistaken Castelli
said to you, "Come live and work in America."*
That's right.

When did you meet the exponents of Arte Povera? At what point?
The exponents of Arte Povera didn't exist yet.

Manzoni did.
Well, I didn't know him. I'd heard people talking about him at
a certain time, I don't remember exactly when, in relation to a
specific work, *Merde d'Artiste* (Artist's Shit), and a bit later in rela-
tion to another work, *Socle du Monde* (Base of the World), which
I thought was brilliant. I did know the work of Yves Klein, who
had embarked on a highly innovative path that took him from
blue and gold monochromes to sponges, to impressions of naked
people. Owing to the fact that Manzoni was living in Paris at that
time, and gave his works French titles, I thought of him, I don't
know whether rightly or wrongly, as a follower of Yves Klein.

Did he interest you as an artist later?
I never found him really interesting. I understand his position,
though. Being familiar with Yves Klein's sponges, when I saw
Manzoni's wads of cotton I didn't realize how original they were.
Manzoni was never even part of the discussion among the expo-
nents of Arte Povera. Critics pointed to him after the birth of the
movement. Arte Povera, especially as far as the artists from Turin
were concerned, was something else. In the works of Anselmo,
Paolini, Zorio, Merz, and Penone there is a phenomenological
dynamics at play, and not just an attention to ordinary materials
and objects or the surprise of sensational and striking sallies.

And Boetti?
As far as a certain part of his work is concerned, Boetti left
me cold.

What do you mean? Weren't you friends?
We were great friends. I went to Vernazza, in the Cinque Terre, in
1966, because he took me there. When I made the *Minus Objects*,
though, within the space of a few months he had created objects
that were almost copies of mine. At that time I didn't think his
work was as original as that of others. Then Boetti, moving to

Rome, developed a personal approach that I'd call "enigmatic" or "puzzle-based." The first work of that kind he did in Turin: it was a list of the names of all the exponents of Arte Povera, in front of each of which appeared distinguishing marks whose significance Boetti has never revealed. What he meant by those signs remains an enigma. His compositions of words, his drawings of little airplanes, his graphic puzzles are evidently inspired by puzzle magazines. This concept was totally his and undoubtedly the most interesting part of his work, the one that characterized it even better than when he used the concept of the double, this too derived from other people's experiences. For him, getting away from the milieu of Turin and going to live in Rome was undoubtedly a good move. He had the chance to develop real autonomy.

Who came up with the concept of Arte Povera?

Germano Celant with a formal statement, "Arte Povera: Notes for a Guerrilla War," published in *Flash Art* in 1967.

What was Arte Povera?

If you want to know the meaning according to Germano Celant, you have to read that article. For me, Arte Povera is the expression of a concentric energy that brought to a halt the Futurist trajectory, launched toward the boundless and uncontainable space of modernity. Arte Povera reassessed the idea that the achievements of capitalistic-industrial progress have no limits. Futurism appeared at the beginning of the century, but in the

The mirror painting *Uomo che guarda un negativo* (Man Looking at a Negative), 1962–67, 230 x 120 cm, whose subject is Alighiero Boetti, photographed in M.P.'s studio, Turin, 1967.

The mirror painting *Marcel Duchamp seduto su un Brancusi* (Marcel Duchamp Sitting on a Brancusi), 1962–73, 230 x 125 cm, from a photo by Ugo Mulas.

1960s there was already a sense of the approach of a general saturation that toned down the emphasis on growth.

Is Arte Povera the opposite of Pop Art?
It is the opposite of Futurism and Pop Art.

So what makes you, regarded by Castelli as a Pop Artist, also an exponent of Arte Povera?
Because my mirror paintings don't fit into the concept of consumption taken to extremes, do not reflect the system of artificial needs the way the majority of works of American Pop Art do. The prophet of American Pop Art was Marcel Duchamp, who with his objet trouvé, made the United States the definitive found civilization. A mirror painting, on the other hand, takes the gaze beyond the United States, beyond the American way of conceiving the world. When I speak of universality in connection with a mirror painting, I'm referring to its ability to unite the single element, that is to say the person reflected in it, with every other element that is reflected. The representation of the mirror has no limit, and so is universal. It is not the supposed universality of omnipotent capitalism that is trying to take over the whole world.

The mirror is universal.
So it is in this sense that both the mirror painting and Arte Povera offer an alternative to the American model of consumption. To the former's phenomenology of reality extended to the highest degree is added the latter's concentration on primary energy.

Is that why you decided to break with Castelli?
I never decided to break with Castelli.

*You were considered on a par with Warhol and Jasper Johns. You
were represented by Castelli, famous all over the world, present in all
the American museums, and had a chance to become very wealthy.
Today, some artists are much richer than the art dealers. I'm thinking of
people like Jeff Koons, Gerhard Richter, Damien Hirst, Richard Prince,
the five or six who are multimillionaires and much more powerful than
the gallery owners themselves, something that wasn't happening back
then. In short, you were on the winning team, but they asked you to
become American.*
To be clear about this, I have described the relationship between
art and politics in the United States at that time. The power
of the United States had reached its peak. All that was missing
was a supreme endorsement, a coronation. In the past it would
have been up to the pope to carry out this ritual; in the modern
era, however, that task no longer
falls to religion but to art, as repre-
sentative of the highest intellectual
elevation. So what was needed was an
artistic coronation. Leo Castelli had
succeeded in convincing the upper
echelons of American politics that
the moment had come to attain that
objective. The Venice Biennale of 1964
was the right occasion. Jasper Johns's
stars and stripes had already been
shown at the 1958 Biennale. Those
works blended paint directly into the
American flag, thereby expressing
an indivisible connection. Let's not
forget that Jasper Johns inspired a
whole generation of American Pop
Artists with his patriotic art. And not
only did the actual flag appear in
their art, but all the art they produced

M.P., Steve Paxton,
Otto Hahn, Leo
Castelli, Robert
Rauschenberg,
Ileana Sonnabend,
James Rosenquist,
and Alan Solomon in
James Rosenquist's
studio. New York,
1965.

Facing page:
Scala (Stepladder),
1964, 200 x 100 cm.
Photographic paper
on stainless steel
polished to a mirror
finish. M.P.'s solo
exhibition at the
Galleria del Leone,
Venice, 1964.

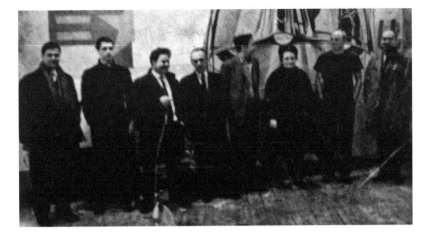

was a kind of flag-waving: Coca-Cola, Marilyn, the comic strip, and the whole range of media glamour. The top prize at the Biennale going to an American artist was to be a demonstration of the fact that United States art had reached the highest level: a certificate issued not just to the chosen artist, but to the nation he represented. In 1964, the artists officially invited to show in the American pavilion at the Biennale were Jasper Johns, Robert Rauschenberg, Jim Dine, Claes Oldenburg, and James Rosenquist. The two founders of American Pop Art were Jasper Johns and Rauschenberg. The jury was not willing to give the prize to the former, because he was too obviously the American standard-bearer, so they focused their attention on the latter. But the works by Rauschenberg on exhibit in the pavilion were not important enough to deserve the prize. When Leo Castelli found out about this, he went as far as calling in the U.S. Navy to transport more of Rauschenberg's work to the pavilion in record time. During the time of the Biennale, it was also shown at the former premises of the American consulate along with the entire roster of Pop Artists from New York. It was clear that the massive presence of Pop Art in Venice coincided with the strong political pressure exerted by the United States on that Biennale. So the prize for a foreign artist was awarded to Rauschenberg, and that was regarded as marking the shift of avant-garde painting from Europe to the United States.

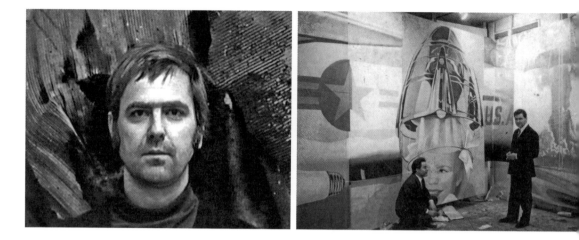

M.P., Turin, 1966.
M.P. with French
critic Otto Hahn in
James Rosenquist's
studio. New York,
1965.

Facing page:
Advertisement
for the Ileana
Sonnabend Gallery
Art International
8, number 5–6
(Summer 1964).
Courtesy
Sonnabend Gallery.

Where were you at that time?
I was staying at the Sonnabends' house in Venice, so I was a
witness to all this. As the Biennale opened, I opened a solo exhi-
bition in a private gallery, the Galleria del Leone, so we were
all there. The year after, in Paris, I was seated in a taxi between
Leo Castelli and Alan Solomon, the director of the American
pavilion at Venice. Leo, who had asked me months earlier for
other pictures to stage an exhibit at his New York gallery, said
to me, "I'll tell you frankly that if you hold the exhibit you'll be
boycotted by insiders, unless you decide to move to New York.
You're a great success in the United States, but if you want to go
on being one you have to forget about being European. You have
to come to the United States and join our big family. Otherwise
you don't have a chance."

How old were you at the time?
Thirty-two.

What was Castelli like?
A man of the world, vivacious and urbane.

Was he an important figure?
Yes, very. He was the exclusive agent of the most important
American artists of the time.

Did he make the market?
Yes, certainly, but he also had moments of economic crisis. He wasn't so much attached to money as interested in success.

Were you in awe of him?
No, we were friends.

But when you had that conversation, and then went your separate ways, was the tone friendly?
Yes, he spoke to me as a friend, or a brother. I'm sure he said those things with my best interests in mind.

In short, Castelli told you that it was all about the Americans in America at that time, so you should become American or you were finished. Did that seem like a threat to you?
Yes, but not from him. He was simply trying to tell me that at that moment the situation was changing. What did they want in America with an Italian? Perhaps, up until the day before the prize was given to Rauschenberg, having an Italian artist

as a mark of an international spectrum of views was useful. But as soon as they got the prize, I was no longer needed to show that Pop Art was international. In the meantime, Ileana Sonnabend had arranged a solo exhibit for me at the Kornblee Gallery in New York. My work was at the Castelli Gallery, and I went there to choose which pieces would go into the exhibit. I found all my mirror paintings damaged. They had been ruined by someone who had taken a hammer to them—not the figures, but the mirrors. Someone had run around the gallery and taken out his anger on the mirrors. I got really scared then. I thought this person might even kill me. That's why I distanced myself from the United States. The violence there was unbearable. But they

didn't succeed in killing me; art gave me the power to go on. Later, I asked Ileana to repair the damaged pictures, and where that wasn't possible I detached the figure and transferred it onto a new reflective background.

Why the mirror and not the figure?
Because the mirror is universal, much more than a nationalized universe. The mirror is more truthful than any sign or image developed for a purpose.

What did Castelli want you to do?
Leo thought highly of my work, but he wanted my art to be regarded as American, because that complied with the nationalistic requirements that he himself had helped shape.

Did they accept you before that?
Yes. Evidently, though, up until a certain time my presence might have been convenient for the strategy of someone in his entourage, but then the needs changed.

Were you accepted as a tourist?
No. Someone at the gallery created this issue, but it was a person with the power to make decisions. I won't accuse anyone, but I will say that someone who turned the U.S. flag into art may have thought that art that went beyond the limits of American nationality was dangerous, even if it shared the characteristic of objectivity with Pop Art.

The flag did take precedence after September 11. When the Twin Towers were destroyed, Americans waved the flag.
But that's how it should be. A national loss of that kind can't help but unite all citizens. Even if it had been an American who had brought down the towers, they would have waved the American flag. It seems obvious to me. Something that makes me think is that the fall of the towers was followed by the preemptive war on Iraq, a war based on invented motives. Who knows what else they've invented? But people have no access to

secrets of state and are proud of their flag anyway. Going back to the Castelli Gallery, I have to say that I had excellent, almost fraternal relations with the Pop Artists, except with a couple whom I didn't know personally. Rauschenberg bought one of my works in 1964, at the same time as the MoMA, and he always kept it on display in the middle of his loft. It's been sold now, along with others, to raise money for the Rauschenberg Foundation. And the same foundation has now invited me to work with its students. At the time there was a political and personal snag that Castelli understood very well. Fortunately, my relationship with America did not pass exclusively through that power. In fact, there continues to be interest in my work in the United States. The MoMA is still showing work of mine that it acquired in 1964, which means that recognition came spontaneously. No one imposed it on them. Everything I've gotten from the United States has been given to me outside the logic of power, and this allows me to feel proud.

Would Castelli have helped you?
I don't know what he could have done. The fact is that I complained loudly, to Ileana Sonnabend as well, and I realized that alone I had no power. So in Turin, at Sperone's, I started to tell my friends, "Guys, we need to do something." I thought the time had come to put a stop to the subjugation of art to the power of the prevailing capitalist system. My work did not represent that power, but in the end I, too, was becoming a consumer product. What could I do to break the chain that dragged me into the market, obliging me to choose between reward and exclusion? Desperate diseases require desperate remedies. I decided to produce a series where the creator would be unrecognizable, and I made the *Minus Objects*, each different from one another, so that it was impossible to market my name through those works. If I had to be a brand, each work shattered that brand.

What did the critics make of that?
For several months, between the end of 1965 and the beginning of 1966, I worked every day on works that were all different,

and as I made them, I put them on display directly in my studio, where I was also living. It was an exhibit in progress. Ileana Sonnabend and her husband came to see what I was doing and it was no use explaining the meaning of that work to them. They left very upset. Artist and critic friends, including Germano Celant, who shortly afterward came up with his theory of Arte Povera, came to my studio frequently, and I explained to them my critical view of the international art of the time. For me, and not for me alone, the *Minus Objects* were not just a response to the events in America that I described earlier, but also marked a decisive passage in the course of my artistic activity. With that series, I developed a completely new theoretical and practical definition: that of difference. Difference of form, style, technique, meaning, material, and character between all the works. They were works so different from one another that each of them seemed to be by a different artist. It was the discovery and the definition of difference in visual art, at a moment of economic and cultural standardization. With that series, I showed that difference and not uniformity was universal.

Today's art seems to have an influence on everyone, much more so than in the past. If you go to the Architecture Biennale, you see that architects are trying to mimic art.
Perhaps because they realize that a link can again be forged between architecture and art as it was in the Renaissance, and together they can try to make changes. Architecture and economic power have created phallic cities, suffering from what we call here the "San Gimignano syndrome," the rush to build the tallest tower. It's a contest to see who has the highest, most sensational, most imposing building, but where is the feminine side of the city? We live in cities as full of fallacy as they are of phalluses, if you'll excuse the pun.

On September 11, though, the phalluses were punished.
There has been a very powerful symbolic "dephallification." The thing that shocked me was not just seeing the towers implode, but watching people throwing themselves into space, as if to

save themselves by killing themselves. A few months earlier the Taliban had destroyed two great Buddhist monuments in Bamiyan, Afghanistan. It is monstrously significant that before arriving at the two modern phalluses, they passed through the two religious monuments. We can see that the relationship between spiritual totem and political-economic totem is very close. These are exemplary events and symbolic of how we should regard spiritual and political phenomena as linked.

Returning to your work, you started with the self-portrait. At a certain point, though, you became interested in social factors, too. And the political component in your work is very important. Why is it so important?
Because what we read in the newspapers is part of our lives. As for the political subjects of some *Mirror Paintings*, I have to say that I pick out an image of events in the street in the same way that I choose a bottle lying on the floor. They are all fleeting encounters and passing moments in life. But never made dramatic. In my work even political demonstrations are played down. The political event is interlaced with, superimposed on, and integrated with the mirror. At the moment when you're looking at the picture, it reflects your surroundings, whether you're at home or in a museum. So there is a spatial and temporal wrong-footing that removes the drama from the scene. My artistic engagement is developed, then, by intervening directly and practically in social and political life, with the aim of contributing creative ideas and projects. And any dramatic action is excluded from this activity, too. The action does not take the form of a critical or rebellious stand, but of a constructive proposition. Criticism and the desire to supersede the old are already implicit in the proposal of the new.

Your story is interesting when considered in the aggregate: a normal boy grows up in a family that loves him, with religious, liberal principles, and lives through the war, displaying a certain difference from an early age. You receive this upbringing, but after the experience of a school run by priests, you distance yourself from religion. It is also interesting that you, while not having a rebellious character and being a man of

common sense, end up leading a fascinating life with this way you have
of doing things. You learn about craftsmanship and the material of art
from your father. Then, urged on by your mother, who is a progressive
woman, you go into advertising, which is a novelty in the postwar
period, and through advertising you get to know contemporary art. So
you realize that the vehicle for your expression is not advertising but
contemporary art. Your life has always been guided by encounters: for
example, Mario Tazzoli tells you to choose, either one or the other. And
you make a first choice, you become a painter and artist. Then, when
you discover the mirror, you break away from Tazzoli and your destiny
takes you onto the international stage and into the world of American
Pop Art, until that fateful Biennale of 1964 at which Rauschenberg
won the top prize in Venice and your American dealer, Leo Castelli,
tells you again that you have to choose whether to be a European or an
American artist. At this point you make another decision and choose to
establish ties with the young Gian Enzo Sperone, who has now become
independent, and with your artist friends in Turin, including Anselmo,
Zorio, Mario and Marisa Merz, Boetti, and Penone.

That sounds pretty normal to me. A kid who doesn't react,
doesn't create tension, doesn't make a fuss, but reflects. I was
constantly observing the world around me, taking in all the
claims, proposals, and teachings that came my way. These always
made me feel ill at ease, creating a growing internal conflict,
but I didn't express these sensations and reflections in any way,
not even in my work. It was almost as if I heard a voice inside
me saying, "Coming into the world, I thought it was going to be
different." What I saw was to a great extent a contradiction of the
good intentions that were trumpeted. Instead I saw the abuse of
people by other people. The fine-looking laws of morality were
being contradicted all the time. If this is civilization, I thought,
then civilization is inhumane.

When did you realize that?
The moment the bombs start to fall and even before that, when
they told me I had to obey certain rules that I then saw were
subverted in practice, even as a child. First of all, there were
the rules of morality. This world asked me questions I couldn't

answer. But I had the opportunity to encounter certain elements, and I started to work on them. For instance, I discovered the icon in my father's studio. There were icons that had to be restored, and on Sundays my father took me to the museum to see them. They presented themselves as the foundations of the civilization or lack of it that was creating all sorts of problems for me, starting with religion, with the connection between religion and politics; there was Christ and there was the Duce, figures that were continually interwoven. Then came the war, fear, terror. We had the Nazis at home and American planes dropping bombs on our heads. The Americans were destroyers and saviors at one and the same time. There was an absurd contradiction in all this. I felt that human beings were idiotic, wicked. Human beings who knew the concept of good and used it to do evil, and there is no evil worse than evil done in the name of good. The evil that comes from religions is by far the worst. All this always upset me badly. I didn't have the means and opportunities to react. I experienced this drama and understood that I would have to find a solution.

M.P. and his father in the latter's studio. Susa, 1971.

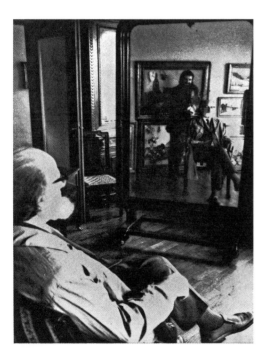

Did you talk to anyone about it?
Every so often I mentioned this perplexity to my father, but he didn't provide any relief. Then at last I understood that modern art was an explosion of freedom, and that in this freedom I would be able to discover my own way of dealing with those issues. The mirror didn't just come one day by chance. I was looking for something that could provide me with an answer to all those questions, and the answers came from the mirror.

How did you arrive at the mirror?
I was looking for the relationship between person and background that I had seen in the icon. In the icons the person was God, Christ, the Virgin Mary.

They were images of people placed at the center of a space that
represented total transcendence, that of the bright and shiny
gold background. The icon had two elements, the human being
and the transcendent. That icon contained all the culture that
had formed, molded, made me, and as a consequence created
all the issues that I found myself needing to resolve. They were
questions to which I had to find my own answers, as none of
what was proposed to me led to real solutions.

So was it a theoretical solution?
A need. A need that gradually led me to develop the relationship
between person and background. As for the person, I asked
myself why someone else, and not myself, should be used
to represent God. Thus the self-portrait. With regard to the
background, in my pictures I had used gold, silver, copper. I felt
that the answer had to come to me from the space that extended
behind the figure. An epiphany had to occur, and the solu-
tion came when the images started to be reflected on a black
background painted so that it became reflective.

*Is there more of an obsession with the background than with the
person?*
Yes, the person is fixed. I am the being fixed in the previously
gilded and now reflective space. The mirror reveals what the
gold suggested but at the same time concealed: the universe
of things that really exist. The whole of what is imaginable
becomes visible; the mirror presents us with the truth of reality.

*In short, you do not create a landscape in the background, but instead
change the nature of the background.*
I didn't start from the landscape, but from the gold background.
The gold of the icon is not a landscape. It is the concept of the
divine, of the transcendent. What relationship did I establish
with that transcendence that gave me no answer? I could no
longer accept not really understanding. I gradually turned the
background of the picture into an answer; the coat of shiny
and reflective black pigment led to the unveiling of all the

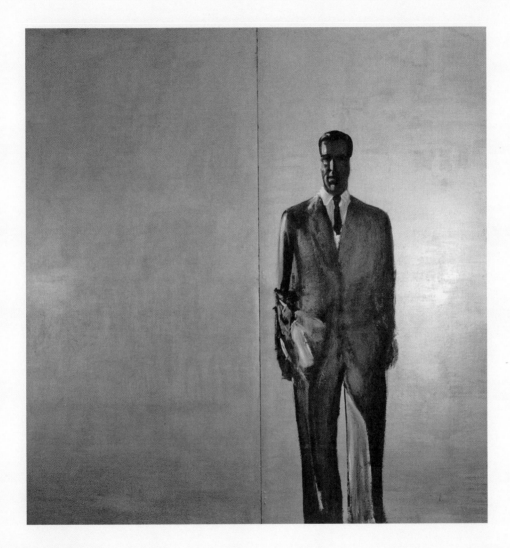

Autoritratto argento
(Silver Self-Portrait),
1960. Oil, acrylic, and
silver on wood, two
panels, 200 x 200
cm. Cittadellarte-
Fondazione Pistoletto
Collection, Biella.

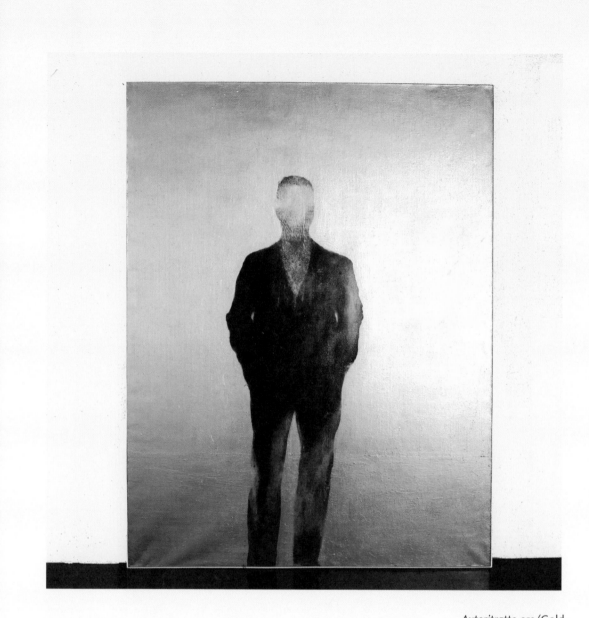

Autoritratto oro (Gold
Self-Portrait), 1960.
Oil and acrylic gold
on canvas, 200 x 150
cm. Cittadellarte-
Fondazione
Pistoletto Collection,
Biella.

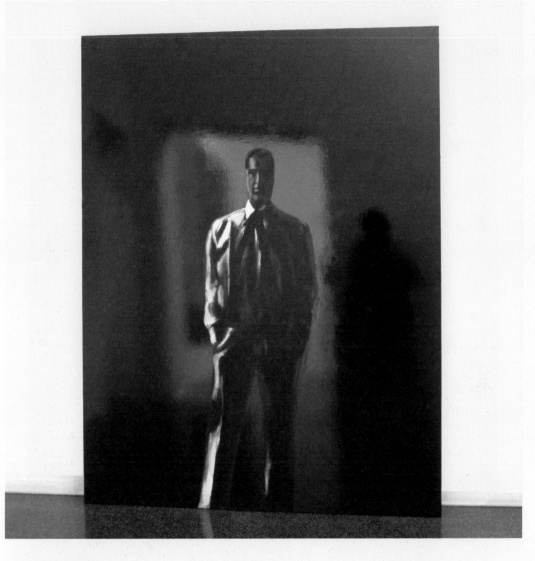

Autoritratto in camicia
(Self-Portrait in Shirt),
1961. Acrylic and plastic
varnish on canvas, 200
x 150 cm. Cittadellarte-
Fondazione Pistoletto
Collection, Biella.

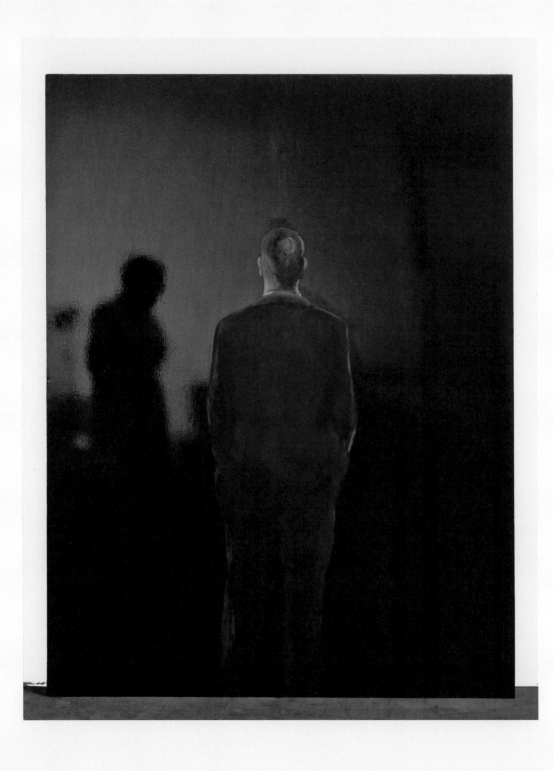

unknowns held in check in the gold backgrounds of icons. After that, all I had to do was improve the quality of the reflective surface, and to do that I used sheets of steel polished to a reflective surface.

If we look at the course of your life up to today, there has been much merit and much work, but there has also been a lot of luck. Your life has been lucky because you had a close family and an immediately successful career, and you are gradually putting your utopian ideas into effect.
In a book that I have been writing since 2000, I even talk of fate. While I was growing up, I understood that I was constructing my fate day by day. I felt that my destiny was taking shape through the circumstances, which led me to say, "There must be a solution." I discovered that I was predestined to work on finding the solution.

What role does talent play in all this?
Probably talent consists of the ability to make analysis coincide with synthesis.

Does talent exist?
Someone who has talent does not feel its lack, and someone who feels its lack can try to develop it. A highly successful musician friend of mine told me, "I have no particular gift for music, but I focus all my will on being able to do what I do with music."

Il presente—Uomo di schiena (The Present—Man Seen From the Back), 1961. Acrylic and plastic varnish on canvas, 200 x 150 cm. Cittadellarte-Fondazione Pistoletto Collection, Biella.

Probably this predestination also gave you talent.
Talent can also come from a series of negative factors that create the need to find a solution, and then you find your talent in your actions.

However, you dismissed a priori the idea of doing some other job, like being a dentist or a lawyer.
Oh, yes. My father had a dentist friend and one day he told me to go and work with him for a while. I tidied up and cleaned the exam room. I wasn't at all interested in being a dentist. You

picked the right word when you said "dentist." I really didn't
know what I was going to do. My mother made my decision
easier by enrolling me in advertising school. Otherwise, with
time I might have ended up devoting myself to another pro-
fession, but deep down I knew that the thing closest to me was
art, but not my father's art. As a boy I used to draw caricatures. I
would see the face of politicians like Togliatti and De Gasperi in
the newspapers and on posters. I used to buy *Il Travaso delle Idee*,
a political and satirical weekly, and amuse myself by copying the
caricatures. I've always had a pretty active sense of irony.

What did you do with those caricatures?
Nothing. They were a spontaneous exercise.

Did you keep them?
A few perhaps, but I don't know where they are now.

You never wanted to do that as a job?
I never even thought about it. I just did it for fun.

*As someone who draws well and who loves drawing, do you find it
frustrating not being able to draw, meaning that you apply your talent
to a more intellectual kind of work in the form of conceptual art and
Arte Povera?*
It's not frustrating because it's my choice.

*Picasso and Matisse were great draftsmen, too. You don't regret not
drawing enough?*
The last drawings I did with conviction date from 1962. They
are five or six faces of people drawn from photographs taken
for the *Mirror Paintings*. These figures are almost a photographic
distortion, a grease pencil drawing, in black, done with great
care. In any case, at that time I used to copy photographs of peo-
ple, blown up to life size, in pencil. I'd attach them to reflective
steel surfaces. What I do is my expression. I don't have any par-
ticular desire to use drawing. That's a bit like asking a poet like
Ungaretti, who wrote a poem that consisted solely of the words

"M'illumino / D'immenso" [I light up / With immensity] if he wouldn't rather have composed, like Dante, a poem that went on for pages and pages.

Have you sought your path, even a spiritual path, in art?
In art I've found the phenomenological dynamics of what is called spirituality. Art spans all the emotional sensibilities and rational requirements of the human mind. The spirituality of art develops by going beyond the dogmatic systems into which it is forced by religions. With my artistic activity I seek, through the potential of my mind, to make the greatest freedom coincide with the greatest possible responsibility.

But in all this soul searching, which began as a search for an outlet in a picture with a mirror background in which you see your reflection, you did not disturb others. At the same time, you led a normal life. Yours is an inner search. You're not neurotic.
No, I'm very cheerful. I look for the positive.

Cheerful, but dissatisfied: you want answers.
Yes, I'm cheerful in the sense that I don't withdraw into darkness or wallow in tragedy.

Let's talk about the religious dimension again.
I'm interested in spirituality free from the monopoly of religion. Spirituality is a phenomenon intrinsic to art, in that it is nourished by primary needs: those of turning the possible into the real and the real into new possibilities. For me, artistic work consists chiefly of trying to understand. Through art, I've been able to understand things that otherwise would have gone nowhere. Artistically speaking, spirituality is an open-ended investigation of all the tangible as well as intangible aspects of existence.

In a nutshell, the thing that most interests you is the meaning of the human condition, of yourself.
Yes, I'm interested in understanding why the people around me act and behave as I see them acting and behaving, in order to

know how I act myself. I see that much of human behavior is not edifying. So I do not think that religions are up to the task of making humanity aware and responsible. In front of a mirror painting, I found myself in front not of the landscape, but of the living world of people. Living people, real humanity, move through my landscape. Through the truth of the mirror, the transcendence of gold becomes immanence of the human. The mirror has given me the mission of becoming involved with the people who are reflected along with me.

But what happens? You make your picture with a shiny background and you see yourself in it?
Yes. Before the figure there is the background. I don't make the figure and then the background around it. First I prepare the mirror surface, then I insert the figure. The observer exists simultaneously in three different modes: the physical one, that of the image fixed on the picture, and the virtual one of his or her reflection.

You as yourself in a mirror?
The artist has always made his self-portrait by looking at his reflection in the mirror. But in all existing self-portraits, the artist appears in the picture alone. In some cases a painter has inserted his likeness among the figures in a large scene, as if in a game of hide-and-seek. In my case, it can be said that the place of the discovery of the artist's individual identity becomes the place of the discovery of the world's identity. Because everyone and everything enters the self-portrait along with the artist.

In other words, the viewer of the work becomes part of the work, so the work changes.
The way the work is experienced changes. There is a shift from contemplation to participation. There is the famous example of an artist, Velázquez, who with *Las Meninas* brought other figures into his self-portrait. He used them to treat the mirror effect as if it were a conjuring trick, which leaves the viewer amazed. The specularity in that work is not real. It is stage-managed, while in

Diego Velázquez,
Las Meninas, 1656.
Museo del Prado,
Madrid.

traditional self-portraits it is always treated with perfect respect
and used as a means of establishing an identity.

When you made your first mirror, were you thinking of Las Meninas?
Certainly not.

In short, the mirror has been a great invention.
An artistic epiphany, but you could also say a spiritual, philo-
sophical, and scientific one.

But what has this mirror changed? It satisfied you because you resolved the issues you had?
In the mirror, the universe that was suspended in the gold background plunged to the earth and stayed there. The picture itself has its feet on the ground and the floor continues in the picture. It could truly be said that the mirror painting descends from transcendence.

Is it a metaphor for Christ? God becoming man?
You are speaking of a human being who is turned into a metaphor for transcendence. This man, who died on the cross, became the symbol of sacrifice, and thus human sacrifice became a symbol of truth. In the mirror the truth does not pass through sacrifice. The mirror is truth without human sacrifice.

You said you find yourself in this world and that the world is your landscape, but you don't understand what you are doing in the world nor what the world is.
Those were the motives that drove me to carry out my quest. With the mirror painting I've been able to identify some guiding principles for developing an understanding of those issues. Chance has cooperated nicely with me in my quest, because it helped me make the discovery. But then it became a protagonist in the work. Indeed, the mirror shows us how everything that is reflected in it takes place by chance. The mirror reveals the principle by which everything in existence depends on the machinations of chance. In the mirror, we see chance constantly and perpetually playing its role.

To recap, you started by replacing the divine icon with yourself and you changed the backgrounds. Then at a certain point, a bit by chance, one of those backgrounds reveals a figure, and you find yourself in front of the mirror. The mirror is what makes it possible to represent everything.
The mirror painting is phenomenological. It functions autonomously. It is no longer an expression of the artist. It is a mechanism that produces visual and mental energy irrespective of my will. For this reason, I say that it shapes me rather

than my shaping it. The photograph is part of the phenomena's mechanism. It has been imposed on me by the mirror itself. The images change unceasingly in the infinite present of the mirror painting. Only the photograph can keep it in memory. The photographic image blocks the present in a still that, inserted in the picture, represents the past objectively. In the mirror painting, present and past coexist, reproducing the dimension of "time."

When did you decide to shift from painting to photography?
A painting can be signed and dated, but it can't represent time directly. A photograph, on the other hand, denotes a precise moment: inserted in my work, it combines with the images reflected in the mirror, which automatically reproduce mutable reality. For consistency, the figures fixed onto the mirror background also have to be automatic reproductions of reality. Only photography offers this automatic recording of the image. At the end of the nineteenth century, painting was thrown into crisis by the advent of photography; just over sixty years later, art and photography found their perfect union in the mirror painting. It was the scientific phenomenology of this work that permitted this union.

While you were making the Mirror Paintings, *did the critics realize what was happening? Did they understand?*
Two critics immediately grasped the meaning of my work very well: Luigi Carluccio and Tommaso Trini. In 1963, Carluccio wrote the catalogue for the exhibit of *Mirror Paintings* at the Galleria Galatea in Turin. He had already presented my works at the same gallery in 1960. Trini wrote a text for my solo exhibit at the Sonnabend Gallery in Paris in 1964. The critics, in general, showed considerable interest in my mirror work from the outset.

Were you elated by all this?
"Elated" would be too strong a word. Let's say I was satisfied.

Were you conscious of having discovered something?
Yes, definitely.

Yet the mirror has fascinated many artists.
The subject of the mirror has always been tackled with descriptive representations. It has never been used directly to make the most of its intrinsic potential.

Is it frightening or enjoyable to discover something?
The opposite of fear. I'd say it was an emotional experience. But that emotion was accompanied by reason. Part of the discovery consisted of the realization that a totally rational creation like a mirror painting could elicit great emotion. The emotion of reason. Besides, the linking of contrasting terms, such as emotion and reason, is inherent in the works we're discussing: for example, immobility and movement, depth and surface, tangible and intangible, front and back, transience and permanence. All these opposing factors come together and coexist in a mirror painting. What I am saying takes place at the practical level and not in a descriptive sense. A union of extremes occurs in the picture: what never changes, because it is fixed in the background, and what always changes, because it is transformed in the same background. In this way, the law of reconciliation is revealed—a reconciliation that consists of the balanced connection between opposing and contrasting polarities. A phenomenon of crucial importance is the relationship between the relative and the absolute. Everything we see in the mirror is relative, in that it happens though combinations. Images are formed and dissolve into other images. If you try to make an instant absolute, that instant escapes you. The absolute exists inasmuch as relativity itself is total and absolute. Then there is chaos. The mirror is chaos and at the same time it is the only order possible. So chaos is order. There is an element that combines all this: chance. Things come together by chance, forming chaos and relativity, which in turn constitute order and the absolute.

Michael Sonnabend in front of the mirror painting *Uomo seduto* (Seated Man), 1962, on the occasion of M.P.'s solo exhibition at the Sonnabend Gallery, Paris, 1964.

The mirror has the capacity to translate all of reality into a single phenomenon that is the image of everything. One of the foundations underlying religions is the concept of truth. The mirror is truth inasmuch as it is the truth of reality. The mirror is truth because it cannot lie, as Eco and the semiologists tell us: every sign created by the human mind can be deceitful, but not the mirror, because it shows things as they are. My spiritual thinking is set out in these facts.

How did the art world react to this insight of yours?
If the fact that it was objectively significant hadn't been clear, they might have talked about it as if it were magic. But my work is discovery and not magic, and this is evident to those who are involved with art and, I must say, even to many who have no artistic background. The work is so simple and direct that it is easily comprehensible. In the first place the viewer recognizes himself in it; those who wish to, then, can find answers to the most complicated questions in it. Personally, I've not been satisfied with my fairly gratifying success in the art world. Indeed, I'm increasingly turning to the real world, which is reflected in my art. I want to have a direct relationship with other people as well as a virtual one.

What was Pop Art about this discovery?
Simply the objectivity in the use of images. Lichtenstein blew up figures from newspapers, from advertising, and from comic strips on canvas, even reproducing the dots created by the printing process. Warhol used silk-screening to make his popular visual messages, in particular the kind that represented typical American consumer products like Coca-Cola and Campbell's Soup cans, and in his portraits ordinary people looked like Hollywood stars. As in Pop Art, my images are immediate and comprehensible to people. As in Pop Art, they are everyday and familiar, but they are not made in the U.S.A. They do not emphasize the glamour of the media, and they do not represent the imagery of consumption.

Is the hangman's rope in front of us here in your studio like Warhol's
Electric Chair?
Warhol's *Electric Chair* was made from an image that circulated
in newspapers. My noose was photographed directly and intro-
duced into the phenomenology of the mirror.

Is your picture a denunciation of the death penalty?
No. It's an object that exists in its own right. It makes no refer-
ence to specific cases. In reality, the noose has its function, just
as a lightbulb and a bottle have theirs. There is no judgment.
Someone can commit suicide, just as he can drink wine or turn
on a lightbulb. But we could say that the specific nature of this
subject recalls the life/death relationship that, like all other
opposing factors, is present in the mirror painting. The images
we see in the mirror are scanned in instants from the passage
between life and death. The reflection shows in the present
forms that did not exist before and will no longer exist imme-
diately afterward. Every form, in fact, dies while it is being born.
It is in this way that the reality dying-being born-dying-being
born is continually transformed.

You also used portraits in the Mirror Paintings.
Yes. I can portray a person and a few years later that person
will no longer be like that, but the memory will remain. In the
future that person will see himself in the mirror painting as he
was and simultaneously as he will be at that moment.

So there is also something cruel in all this.
The truth can be cruel, if you don't accept it with serenity.

Is it fair to say that up until this moment, while using photography
and while having discovered the mirror as a background, you remained
a painter?
As far as the *Mirror Paintings* are concerned, that is the basic canon.

You're not a conceptual artist.
On the contrary, my work is essentially conceptual.

It is a concept, though, in which painting survives. There were two schools, abstraction and representation, and you chose representation.
I turned painting into mirror and photograph. These two elements reduce the very concept of representation to its essence, and at the same time incorporate concepts concerning philosophy, science, spirituality, and every other category of thought.

Do you take the photographs?
No, someone else always does it, I have detached myself from the craft aspect. It was only in the beginning that I copied the photographs by hand onto flimsy paper and then stuck them onto the reflective surface. I did this until 1971. Then I changed to silk-screening, in order to eliminate what might still depend on my hand. However, right from the outset, I refrained from taking the photographs myself.

One thing we haven't discussed yet is the manual aspect of your work. Basically, a painter is a craftsman, and you've always liked that aspect.
In the past, people worked with their hands because there were no machines. From the moment machines were created, they started using them instead of their hands. Before that, the king's portrait had always been done by hand because the camera did not exist.

Will drawing vanish?
Not necessarily. In fact, I don't think so. When I have to plot out an idea, I do a drawing. Almost all my *Mirror Paintings* were born from sketches made by hand. Recently I've created a series of these paintings on the theme of work. They're objects picked up on building sites where you still see people doing physical work, operating power tools. These are almost nostalgic images of a world in which microtechnology is bringing about a global revolution. I use the computer and the Internet, but not directly, just as I have always done with photography. I make sketches that fix my ideas.

Top and bottom:
M.P. during the
realization of some
Mirror Paintings
at the workshop
of screen printer
Renato Volpini.

Facing page:
in the foreground,
Alberto Serighelli,
Volpini's assistant at
the time. Serighelli
went on to open
a screen-printing
workshop of his
own that still works
with M.P. today.
Milan, 1973.

Where do those sketches end up? Are they kept?
In part, yes. Some are kept by people close to me.

*Do you do them in sketchbooks or on sheets of paper? In pencil or
in pen?*
It's all the same.

You don't have much interest in paper and pencils.
Not particularly. This morning I used colored felt-tip pens to make a drawing on an A4 sheet that's been requested to make a mural in Beijing. My assistants scanned the drawing and sent it there, where it will be executed on a large scale.

I asked you the question in order to talk about your relationship with material.
There are other passages related to material that would be interesting to discuss.

We have discussed one—the passage from the canvas to the mirror.
In 1964 I made a series using sheets of transparent Plexiglas. That year they were shown at Sperone's gallery in Turin, accompanied by an essay that was a precursor of conceptual art. In it, I wrote, "A thing is not art; but the idea expressed by that same thing may be." One of these works was titled *The Wall*. It was a sheet of Plexiglas measuring 180 by 120 centimeters, and because it was transparent you saw the wall through it. The part of the wall seen through the Plexiglas was art, while the rest of the wall obviously was not. The transparent Plexiglas was the artistic medium, and another medium was the title, *The Wall*.

Does this mean you've abandoned mirrors?
No, I haven't abandoned them. The *Mirror Paintings* will abandon me, but as long as I live I will not abandon them. The *Mirror Paintings* are like a film that goes along with my life. There is a cinematic aspect to the *Mirror Paintings*, in that each photo fixed onto the mirror is a freeze frame that turns everything that happens in the reflection into a film in real time, a live transmission, because the picture reflects an unbroken sequence of images. In the reflection every instant becomes a frame: the proof lies in the fact that when you photograph one of my pictures you fix the image of that moment, but if you go on photographing it you make a film that follows its unfolding in the present.

The Wall, 1964. Transparent Plexiglas, 180 x 120 cm. Cittadellarte-Fondazione Pistoletto Collection, Biella.

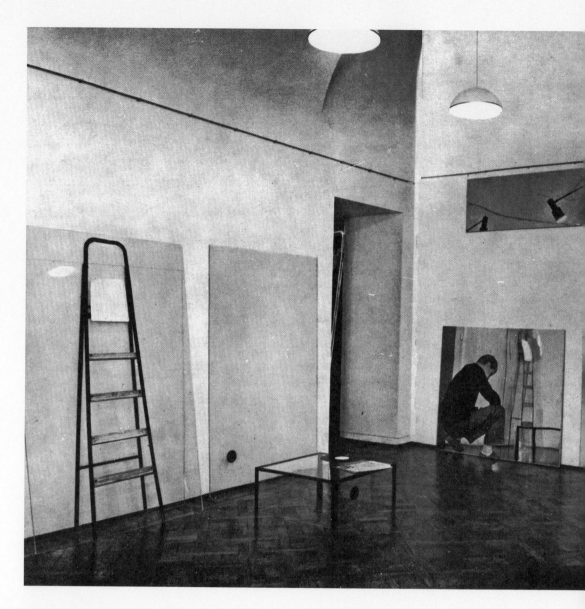

The *Plexiglas* works.
Galleria Gian Enzo
Sperone, Turin, 1964.

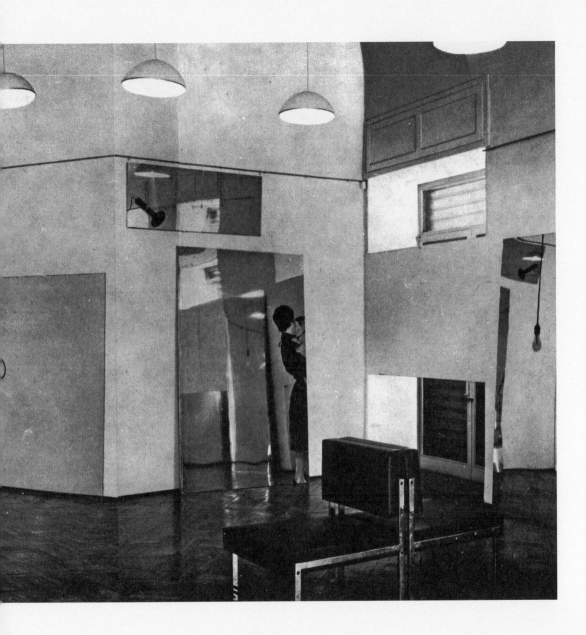

Perhaps that's why you like movies?
Perhaps it is. That may be the reason I spent so much time at the movies.

So the guiding thread is also what your father taught you, that is not to listen but to look. He taught you everything that had to do with gaze, light, image, reflection. Perhaps that's why modern art suits you, because in the modern world image has enormous importance.
In the modern world image has imposed itself universally. It has swept away the rules of religious iconoclasm. Fetish has triumphed everywhere, and not only revoked the conventions of transcendence but dissolved the physicality of existence: nowadays, people walk around looking at their smartphones.

What did Plexiglas have to do with all this?
With neorealist art, the tendency emerged to exhibit any object of practical life as a work of art, and there was much discussion about the extent to which an object was art or not. At the time I sensed a widespread need to define what was art and what wasn't. With the *Plexiglas* work, I set this problem in perspective by reducing it to the essential. As I said before, I made it clear that the idea expressed—in other words the concept of a thing—imposes itself on reality, giving it an artistic significance. Besides, the impression left by a hand on the wall of a cave was the first conceptual work. It wasn't the real hand, but the idea of the hand. Art was born from that idea and human consciousness developed out of it.

Did anyone else continue in that vein?
The following year, in 1965, the American artist Joseph Kosuth created *One and Three Chairs*: a photograph of a chair, the physical chair, and the dictionary definition of a chair. Then he published the essay "Art After Philosophy," considered the manifesto of conceptual art. In 1964, Kosuth had seen the exhibition of the *Plexiglas* work at Sperone's gallery. Personally, however, I asked myself where art might go after the conceptual trend. And I answered myself, after conceptuality comes spirituality. In 1978 I

published the essay "L'arte assume la religione" (Art Takes Over from Religion) and held a series of performances, meetings, and discussions on this subject. In the manifesto I wrote, "'Art takes on religion' means that art actively takes possession of those structures such as the religious which rule thought, not with a view to replacing them itself, but in order to substitute them with a different interpretative system, a system intended to enhance people's capacity to exert the functions of their own thought."

But in a world that was growing ever more secular this idea of the spirituality of art was an antiquated concept.
I'm not talking about art for the church. I'm not talking about sacred art, but about the spiritual independence assumed by modern art.

Are you saying that spirituality derived from the icon comes after the conceptuality of art?
The icon was the first element I used to develop the research that led me to the *Mirror Paintings.* So I think it's understand-able that for me it was logical to compare the spirituality of art with the role played by religious systems, including on a societal level. Through conceptual identification of the artistic process, I defined a rational function that related not just to art, but to any other form of initiation, including a religious one that involves society to a greater extent.

What makes you say that art is becoming spiritual?
The phenomenon of spirituality pervades both art and religion, so it is of great importance to identify a property, or a proce-dure, recognizable in both.

And you did that by making people see that a piece of Plexiglas framing a wall turns the wall into art.
The fact that the concept, the idea, determines the passage from non-art to art is an initiation on par with a social or religious one, by which somebody leaves an unrecognized condition to enter

into a publicly recognized one. In the phase following the conceptual definition of art, art encounters the pragmatic concept that governs access to or membership in a religiously defined and organized society. The phenomenology of the spiritual and the sociopolitical stand on the cold threshold of "concept art." Then they enter, bringing in all the warmth emanated by social life.

Which of your works reflect this theme?
Creations like the *Multiconfessional and Secular Place of Meditation*, opened in 2000 inside the Paoli-Calmettes medical center in Marseille, can be understood in this sense. That work was later shown in several other locations.

That happened much later. At the time it was a question of a simple theoretical argument, a discussion.
I went through a period of intense activity and research that led me, as I was saying, to the publication of the manifesto "L'arte assume la religione," in conjunction with a series of performances staged at the Galleria Giorgio Persano in Turin. In the context of these actions, I wrote in large letters on the wall, "Does God exist? Yes, I do!" and "It is the hour of judgment."

How long did your conceptual art period last?
It lasted for the length of the exhibition, two months.

And afterward what did you do?
In 1965 I started on the group of pieces that, as a whole, were given the name of *Oggetti in meno* (Minus Objects). The *Plexiglas* work was created before the American experience with Castelli and the *Minus Objects* followed that episode.

What was going on? I'm interested because it's very important and because it takes me back to what I thought at the beginning—that there is a spiritual current in your life, but also a territorial one. You have deep roots in the land.
In fact this set of works, called *Minus Objects*, marked the moment when I reclaimed my original values after my

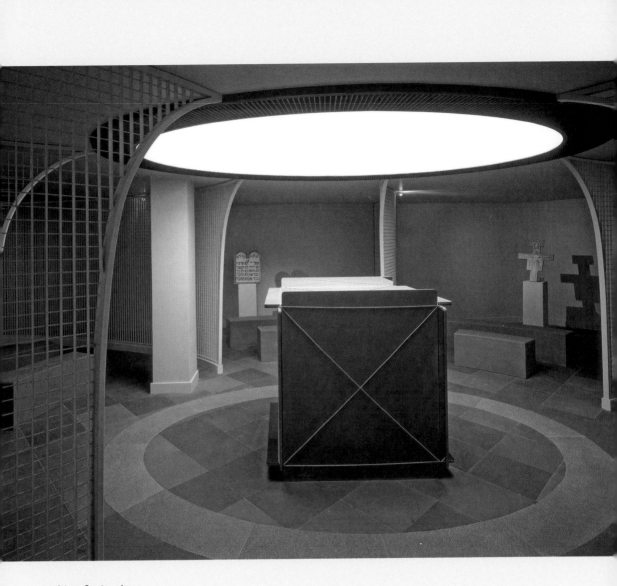

Multiconfessional and Secular Place of Meditation, 2000. Permanent installation, Paoli-Calmettes medical center, Marseille.

experience in the United States. The response to the great system of power that dominated art had to come out of a territory as neutral as it was familiar. Turin, the city where I lived and worked, had already offered me many opportunities, and it was there that I had to go on working for a change in the conception of art in the social sphere. Getting back to the theme of spirituality, I should point out that one of the *Minus Objects* was the *Cubic Meter of Infinity*, which was shown again in 2000 at the center in Marseille where the *Multiconfessional and Secular Place of Meditation* was shown. This cube contains both spiritual and scientific meaning that radiates into the surrounding perimeter formed by the circle of different religions. Also, these works show that by "universal," I mean what can be extracted from imperialist-consumer culture and take root outside it.

What is "L'arte assume la religione"?
Reproduced in the manifesto "L'arte assume la religione" is a photograph, taken by Paolo Persano, of a large mirror that I placed on the altar of the chapel at Sansicario. That mirror reflected and summed up, emblematically, all liturgical representations. It is in that sense that art takes on religion. The mirror placed by the artist on the altar both framed religion in its meaning and put the individual in front of himself, that is to say, at his own judgment. During the performance at the Galleria Persano, to lift the feeling of dismay aroused by the words "it is the hour of judgment" written on the wall, I explained that the time had come for humanity to move on to adulthood, and thus to the age of judgment, of reason.

And how has religion responded to all this?
So far it has not responded.

This didn't create any controversy?
No, because the setting was like an art gallery. The most extraordinary thing that happened in the twentieth century, in addition to the great scientific discoveries, obviously, was the unprecedented fact that art succeeded in acquiring intellectual

L'arte assume la religione (Art Takes Over from Religion) Religion), 1977. Mirror placed on the altar of Sansicario church.

autonomy from all the systems of social, cultural, and religious order to which it had been subject in the past. When an artist turns his own sign into a symbol that replaces every other symbol in existence, as Capogrossi did, for example, he attains the greatest freedom and autonomy. Values that the artist transmits and transposes to the entire sphere of art. When an artist takes on this autonomy, he doesn't do it just as an individual expression, but as a general conquest of art as a whole. This autonomy allows him to deal with any phenomenon of life artistically.

The metaphor for all this is the mirror that is art?
The mirror absorbs the subjectivity of the artist and turns it into interindividual objectivity. The simultaneous presence of every person in the mirror leads me directly into the context of society, but in going there I run the risk of losing the autonomy acquired by art. To keep that autonomy intact, I have to put art at the center of the operation that organizes the social fabric. If art does not change the world, the world changes art. But I'm aware of the fact that the world must change—that is inevitable now—so I believe it needs art as a guide.

Based on what you have said and the story of your life and your work, something emerges that has always been there, but that you don't call spirituality. You've never said that your work has spiritual content.
Certain statements become possible over time. What I have to say about spirituality is increasingly explicit, because I've had a profound experience and carried out slow and careful research. Research for me precedes definition. I think that my research is itself spiritual, but any misunderstanding about what is meant by the term *spirituality* needs to be cleared up.

The relationship you have with religion is interesting. Do you ever use the word God?
I use it in only one situation—when making clear what it means. I don't use it in vain.

To follow the commandments?
No, those who follow the commandments often use it in vain.
What God is needs to be understood.

*I don't think you understand it. You know why? I'm thinking of the old
Jewish proverb. Job says, "A man thinks, and God laughs."*
Jobs says that, not God.

Yes, but you've never spoken to God.
Perhaps I don't need to speak with him. Perhaps God is not a
single and absolute being who makes fun of me because I think.
Perhaps, instead, what is laughable is the invention of a God
thought up by man.

*Apart from all this, there is the search for a spiritual meaning of life
that is, if I've understood properly, summed up by the search for the
background in your pictures, which then became the mirror. Ever since
humanity has existed, there has been this need to find a reason for its
existence and for the existence of the world. Some find answers in the
spirituality of religion, while you find it in the spirituality of art.*
I think art can help us to find answers that religion does not,
or that it has defined as certain since, due to lack of knowledge,
they cannot be disproved. As I said, every human statement
expressed in signs, words, or images can be mendacious. The
mirror, on the other hand, tells the truth. It shows everything
as it is; it cannot lie. It is by peering into the truth of the mirror
that I find answers not tainted by my own will. Art has given rise
to the "artifice" that also includes the religious system. Today, art
looks backward, in the mirror, at human history and draws con-
clusions about its actions, including those related to religion.
We have to start again from this examination in the mirror.

Where is the spirituality in a work of art?
In the first place, art, as I understand it, does not confine spiritu-
ality within dogmatic limits, but sees it as an unbounded phe-
nomenon. It is spiritual to recognize your image in the mirror,
just as it is to recognize the impression of the hand on the wall.

Thought that is shaped by experience and experimentation is spiritual. The distance between the thing, that is, the hand, and the idea of the hand, that is, the impression, becomes unlimited because the unbounded process of human thought develops in it. But to compare art and religion let's go back to the *Plexiglas* work.

This is marvelous: I ask you where the spirituality is in art, and you answer, "Let's go back to the Plexiglas *work."*
We are identifying the *Plexiglas* work as an act of initiation of art. In Christianity there is an act of initiation, baptism. Baptism with water, that is the Plexiglas of the Christian religion. Here there is a great difference between Christianity and Judaism, for Judaism has no need of baptism since it has initiation in the blood. You are born a Jew. But Christians are not born Christians. You have to be baptized to become one. You are not part of Christian society if you don't pass through baptism. Just as the wall is not art if it is not framed in Plexiglas. What is the difference between being a Christian and not being one? It is in baptism that your connotation changes: you enter a theologically organized and defined society. This theology is concerned with social organization, with taking care of the faithful. Through baptism, you enter an art that is called religion. In my research into art I arrived at conceptuality, and it was at that point that I encountered the conceptuality of the Christian religion into which I was baptized. The conceptual phenomenon where Judaism is concerned is far older and you get your membership in the Jewish community directly by birth. Since the beginning, when Judaism was reacting to oppression by laying claim to its independence, Jewish people have found identity in the uniqueness of their God, and in this they have ordained its uniqueness; all this means that those who are born Jewish have no need for baptism. Christianity's weakness as compared to Judaism lies in the fact that the Christian has to be baptized, because this ritual is not seen as put in place directly by God and has to pass through a form of social initiation. Today, the artist finds his spiritual roots outside religions, in that anthropologically speaking his initiation precedes the religious ones.

Have you remained Christian in your work?
I'm not Christian, even though I was baptized. I don't reject
religion on principle; I reject religion because of the way it still
affects everyday life today. I think that religions can change, too,
and I believe that art has an important task in changing reli-
gions. The monotheistic religions, however modern they may be,
constitute a basic problem for the development of a true democ-
racy in the world.

*This demiurgic significance that you assign to art, which has the task of
changing things, is a constant for you.*
For me, as an artist, changing things is a "commission" that
comes from humanity, which finds itself in deep crisis and is
asking for help.

*You look for answers and art provides them to you. Did it give you the
first answer through the mirror?*
I was guided to the mirror by modern artists, by their move
away from the representation of any ideology. All the "isms,"
from the end of the nineteenth century to the middle of the
twentieth century, have taken a highly methodical and intro-
spective approach to art. Cubism experimented with the mul-
tiplicity of viewpoints. Surrealism probed the subconscious.
Expressionism investigated expression, culminating in the
essentiality of Abstract Expressionism. They were followed, from
1960 onward, by Pop Art and Arte Povera. I would leave out
Futurism, which, rather than embarking on artistic introspec-
tion, vehemently embraced the process of modernity as a phe-
nomenon of unlimited growth.

So you're not interested in the Futurist artists?
Certainly I'm interested in them. Indeed, they interest me
greatly, precisely because today I find myself in a relationship
with the world that remained outside art, and the Futurists were
the ones who at the beginning of the twentieth century looked
at the world and how it was evolving.

Who do you find interesting among the Futurists?
Balla and Boccioni most of all, because they tackled the theme
of movement in time and declared that they wanted to put the
viewer at the center of the work, goals I attained concretely with
the *Mirror Paintings.*

Well, we were talking about self-analysis.
Around the middle of the 1950s, some European and American
artists gave rise to the movement of Action Painting, also known
as Abstract Expressionism or Art Informel. I make reference
to them because they had the ability to concentrate within
themselves, that is to say within their own signs, all the energies
of social dynamics, including those of religion and politics.

That's what Fontana did.
Yes, it's exactly what happened in that period. Fontana pierced
the canvas, while Capogrossi developed his sign in another, less
dramatic way.

Does every artist have a sign?
The individual style of the artist has been recognized since the
time of the Renaissance. But it was always a personal touch
applied to the depiction of religious or political images, or of
elements of everyday life. But the modern artists of whom I'm

Sequence of
photographs
by Eadweard
Muybridge,
published in *Animal
Locomotion: An
Electro-Photographic
Investigation
of Consecutive
Phases of Animal
Movements* (1887),
utilized by M.P. for
the mirror painting
*Due donne nude che
ballano* (Two Nude
Women Dancing),
1964.

Facing page:
Franz Kline, *Le Gros,*
1961. Museum of
Modern Art, New
York.

Giacomo Balla,
*Swifts: Paths
of Movement +
Dynamic Sequences,*
1913. Museum of
Modern Art, New
York.

speaking have eliminated any external reference from art, condensing the universe into the subjectivity of their own signs.

What is interesting about your path is that, unlike others, you have your sign, but you go further. You are to some extent an artist like Picasso. Picasso employed different styles over the years, but deep down he was always himself. You've already spoken to me of the mirror, of conceptual art and other things, but always with this idea you have of the spiritual. We have come to the era of Arte Povera, another movement that is in a way part of you. How was Arte Povera created?
Germano Celant, in his 1967 statement, took the *Minus Objects* I created from 1965 to 1966 as the initial reference point for Arte Povera. That series cut loose from the monopoly that the consumer market had imposed on the culture of contemporary art. Becoming a brand, the artist lost the autonomy he had won with abstraction in the 1950s. With the *Minus Objects*, I made each work as if it were done by a different artist, and in this way I smashed my brand. It may seem paradoxical, but erasing my personal sign allowed me to regain my precious autonomy as an artist.

How did Castelli take it?
Very badly, and the Sonnabends took it even worse. They just could not understand why I wanted to ruin myself that way, after having established a reputation with the *Mirror Paintings*.

Two Nude Women Dancing, mirror painting, 1964. Reflected in the work, M.P. in his studio. Turin, 1964.

For them it was impossible for an artist not to be recognizable, something they didn't find in the *Minus Objects*. The more I tried to explain to them that I had intended for the works to differ from one another for a specific reason, the worse it got. Personally, though, starting from that reaction to capital and consumption in art I made a series of discoveries that I wouldn't otherwise have made.

Picasso did the same thing by going from his Blue and Pink Periods to Cubism, unlike Morandi, who painted the same bottles his whole life. Yes, but the situation was different. With the *Minus Objects*, I wasn't passing from one period to another. Every single work was different from the others. We are talking about thirty or so works, all different from one another, whose overall title is *Minus Objects*; and then obviously each object has a title of its own. It wasn't easy to create so many different works; it would have been much simpler to stick to the same formula.

What are the Minus Objects?
I had to give a strong meaning to the concept of difference, and what was behind that difference? Being ready at any moment to make anything that came to mind, without asking myself if it would be acceptable in relation to the previous work or the next one. Autonomous works. As I was saying, starting out from a reaction to capital and consumption in art, I made some discoveries that I would not otherwise have made. I was able to understand some basic phenomena, and one of these was the creation process. Your mind is a little universe similar to the big one. It contains countless possibilities. In making a work, I turned a possibility into reality. Thus, each work is a mental possibility transformed into a real object. And so, coming into existence, each object subtracts one possibility—hence the title, *Minus Objects*. The universe is the great container of possibilities and every physical thing in existence is fruit of the passage from the possible to the real. So everything in existence is one less possibility. Human creativity has a universal character insofar as it translates the possible into reality. With this series, I opened

myself up to new understandings and new possibilities. The *Minus Objects*, as you can see, are closer to the idea of the universal than to that of the commercial.

What are the objects?
There are about thirty of them. *Lunch Painting, Burnt Rose, Cement Columns, Green Pyramid, Landscape, Newspaper Sphere, Cubic Meter of Infinity, Sarcophagus, Globe, Landscape, I Love You, Structure for Talking While Standing...* I'm not going to list them all, but the differences are already evident from the titles. One of the *Minus Objects* consists of a sphere of compressed newspapers one meter in diameter. In 1967 I pushed this sphere along the street, and it became the *Walking Sculpture.* This work that rolled along the sidewalk was immediately taken over by the public, by people walking in the street, especially younger people,

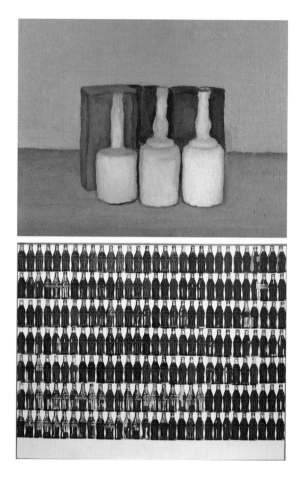

who started to push it themselves, to make it roll, to throw it to one another, without wondering what it was, whether it was a work of art or not. Quite apart from any questions they may have had, there was immediate action. It was then that I realized that the sphere represented chance. I understood that if I wanted to represent chance physically, in other words, give it material form in a symbolic object, I was going to have to resort to the sphere, which lent itself to putting chance to work. Many sports, like soccer, tennis, and billiards, are based on the sphere, and in each of them the players try to lead chance toward their own goal, toward their own success. The most symbolic of all is the sphere used in roulette.

M.P. and his *Globe*, 1966–68, during the exhibition *Vitalità del negativo nell'arte italiana* (The Vitality of the Negative in Italian Art), 1960-1970. Palazzo delle Esposizioni, Rome, 1970.

Facing page: Giorgio Morandi, *Still Life*, 1953. Fondazione Magnani Rocca, Mamiano di Traversetolo.

Andy Warhol, 210 *Coca-Cola Bottles*, 1962. Private collection.

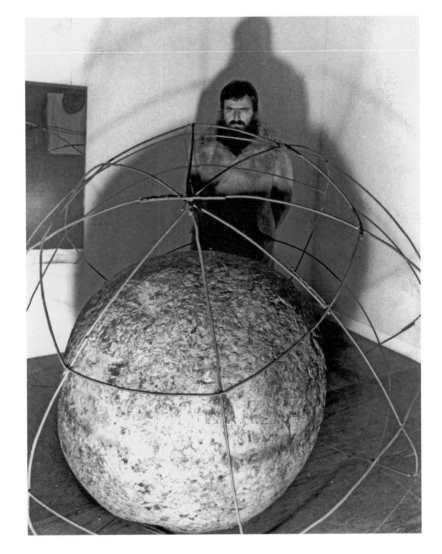

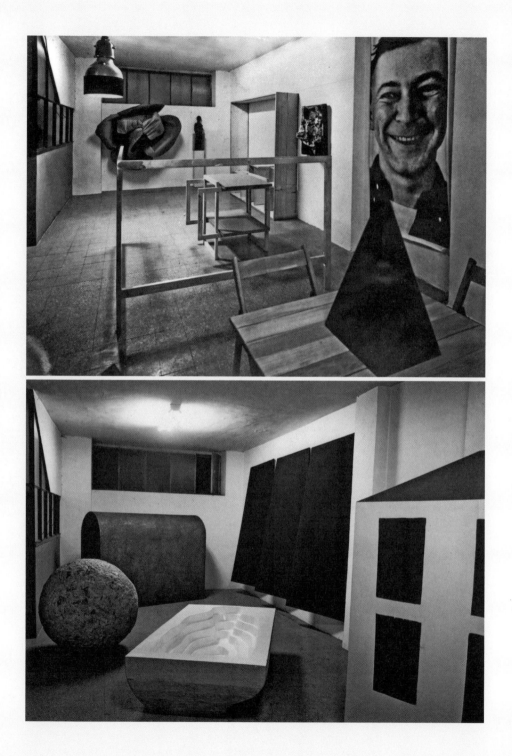

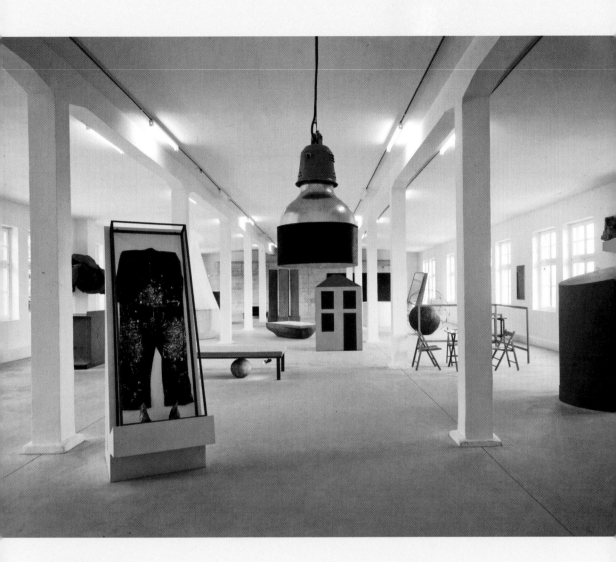

Minus Objects, 1965–
66. Documenta X,
Kassel, 1997.

Facing page:
Minus Objects, 1965–
66. M.P.'s studio,
Turin, 1966.

Minus Objects, 1965–66.
Philadelphia Museum of
Art, Philadelphia, 2010.

How does this fit into Arte Povera?
Arte Povera, like the *Mirror Paintings*, is based above all on the phenomenology of the existing. The works of Gilberto Zorio are centered on the relationship between the different elements that suggest an energy, and so have energy as their subject. Giuseppe Penone's work is phenomenological in that he does not sculpt the tree, but goes to look for the tree that exists inside the beam. It is the search for nature in artifice. In most of Mario Merz's work, he used the calculations of Fibonacci, a thirteenth-century mathematician who produced a progressive sequence of numbers, for example 0+1 makes 1, then 1+1 makes 2, then 1+2 makes 3, then 2+3 makes 5, then 3+5 makes 8, then 5+8 makes 13. In six steps you get from zero to thirteen, and these numbers grow in an exponential manner. The process of growth of the artificial world has followed the same mathematical sequence and has arrived today at an extreme rate of increase.

What difference is there between this and conceptual art?
Conceptual art defines the concept. It is the definition of the phenomenon. It does not practice the application of the phenomenon.

Do you think Arte Povera was very original?
It was original precisely because, rather than prophesying unlimited growth, it envisaged a limit to growth and prepared us mentally to take the necessary steps to deal with reaching an inevitable limit.

And how did you end up no longer alone with your work, but as part of a group?
For me it was extremely important not to be alone.

M.P. during his retrospective at the Galleria Nazionale d'Arte Moderna, Rome, 1990. Behind him is *Sacra Conversazione—Anselmo, Penone, Zorio* (1962–73).

Facing page: M.P. and Mario Merz photographed on the occasion of the exhibition *Arte povera. 13 Italienische Künstler.* Kunstverein, Munich, 1971.

Were you all the same age?
More or less, yes. Mario Merz was the oldest, Penone the youngest.

Did they envy the fact that you were already successful?
Yes, for a while it was a problem for them, until they established their own reputations. For some time there was a very good rapport, but then friction set in. They told me that I never stopped and that I ought to calm down.

Who were the artists who belonged to the Arte Povera group?
There was the group of Turin artists: Anselmo, Boetti, Mario and Marisa Merz, Paolini, Penone, Zorio. In Rome there were Kounellis and Pascali. Then Fabro in Milan, Prini in Genoa, and Calzolari in Bologna.

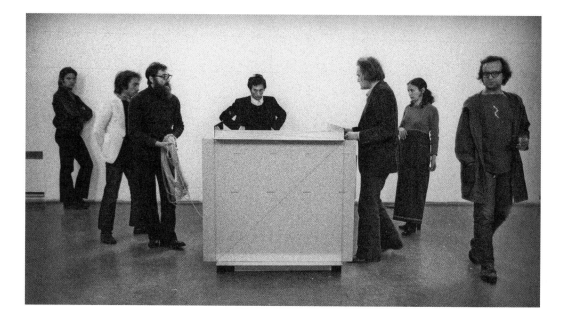

Who decided who the exponents of Arte Povera were? Celant?
Yes, with the agreement of everyone else. Then we tried to work
out whether we Italians were an exception, and after doing
some research we discovered that there were other artists in the
world working with aims similar to our own. There was Joseph
Beuys in Germany, Richard Long in England, Bruce Nauman
in America. Artists in other countries who were moving in the
same direction we were.

There was no one in France?
No, in that period I'd say not.

Who was Christo?
We had been friends since the beginning of the 1960s. He was
one of the exponents of Nouveau Réalisme, a movement that
dated from just before Pop Art. But the movements overlapped.
In fact in the 1960s some Pop Art exhibitions in which I took
part included Nouveau Réalisme. And from 1967 onward there
were several exhibitions that combined Arte Povera, conceptual
art, and Land Art.

Mounting of the
*Cubic Meter of
Infinity* (1965) at
*Arte povera. 13
Italienische Künstler.*
Kunstverein,
Munich, 1971. From
left: Gallery owner
Fabio Sargentini, an
unidentified person,
M.P., Giovanni
Anselmo, Mario
Merz, Maria Pioppi,
and Emilio Prini.

Was Rotella part of this movement too?
Rotella was part of the French group that practiced *décollage*,
artists who tore down posters to stick them onto canvases. It was
part of Nouveau Réalisme, but leaning toward Pop Art.

So Arte Povera was basically an Italian phenomenon?
It was a purely Italian phenomenon but one that, as I have said,
some European and American artists practiced as well.

What about Kiefer and Richter?
Richter showed his works in the 1960s, at the same time as
my *Mirror Paintings*, while Kiefer appeared afterward, with the
Transavanguardia, at the beginning of the 1980s.

*Today Arte Povera is at last well known, sought after, and almost
fashionable, but to which era did it belong? To the years before 1968?*
Yes, it started in 1967.

*Those were also the years of the literary avant-garde, of the Gruppo 63,
of the Nouveau Roman with Eco, Pagliarani, Guglielmi, and Arbasino.
And they were the years of the* Mirror Paintings, *which preceded
Arte Povera.*
Certainly, and there was Grotowski's poor theater, too, just
before Arte Povera.

*Were you successful? You'd already had a lot of success. How was that
time for you?*
I prefer to use the term *recognition*, rather than success. Arte Povera
received considerable international recognition, but was not
immediately a resounding success. That's because it didn't lend
itself to easy and casual interpretations, in that it was engaged in
a criticism of the dominant culture of excess and waste.

When did the movement hold its first exhibition?
In 1967 several exhibitions were held in Italy with exponents
of Arte Povera, but without the name of the movement being
used: *Lo spazio degli elementi, fuoco, immagine, acqua, terra* in June,

at the Galleria L'Attico in Rome; *Lo spazio dell'immagine* in July, at Palazzo Trinci in Foligno; *Contemplazione*, at the Sperone, Stein, and Il Punto galleries in Turin. On September 27 Germano Celant opened the exhibition *Arte povera-in spazio* at the Galleria La Bertesca in Genoa and in December officially presented Arte Povera at the University of Genoa. The first exhibition that bore the title *Arte Povera* autonomously was staged in February 1968 at the Galleria d'Arte de' Foscherari in Bologna.

M.P. during the opening performance of his solo show at the Galleria L'Attico. Rome, 1968.

Did your life change? Did you turn from a solitary man into a member of a group? By 1967 the Arte Povera group existed, but I was already moving in a new direction. In December of that year I opened up my studio to participation by artists using different languages: poets, musicians, filmmakers, and actors turned up and we went out together into the street, out of the institutions, given that for me even the artist's studio was an institution. We put various languages together and went out into the street. It was because of this new initiative that the members of the Arte Povera group came to tell me to stop for a moment: they wanted me to settle down and get my due for the work I had done up until then. I told them I wasn't forcing anyone to follow me. Personally I felt the need to keep going, to develop work based on creative collaboration. So, after opening the studio, I formed a group called the Zoo. The name indicated that we were many different animals, just as the artistic languages were different, and the name also signified coming out of the cage and creating in the street and in places not assigned to art, outside studios, galleries, and museums. The consequence of the *Minus Objects* for me was

The Zoo in Corniglia, summer 1969. Seated, from left: Guido Scategni, Dennis Kaufman, Gianni Milano, Claudia Fiorelli, Carol. Back row, from left: Bill Hagans, Jimmy, Mike Wotell, M.P., Maria Pioppi, Beppe Bergamasco, Anna McArthur.

this: no longer being divided into different people, but working and creating with different people.

What did the Zoo intend to do? What was it?
We simply wanted to create together. We put on little shows in the street. In the beginning we acted as storytellers, performing *L'uomo ammaestrato* (The Trained Man). The performances and texts were put together by talking among ourselves. The people in the Zoo were Carlo Colnaghi, Maria Pioppi, Beppe Bergamasco, Gianni Milano, Henry Martin—an American critic who wrote for *Artforum*—and others. An action preceding the Zoo was carried out in May 1967 at a disco called the Piper Pluriclub of Turin, under the title *La fine di Pistoletto* (The End of Pistoletto). The audience was included in the performance. Twenty people each wore a photograph of me over their faces,

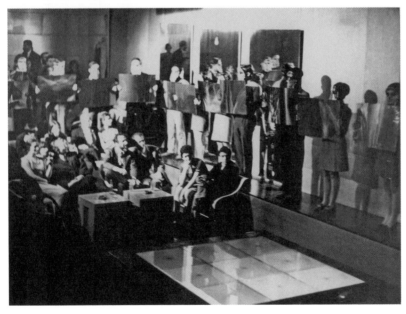

Clockwise from top: *The Trained Man*, performance by the Zoo. From left, art critic Henry Martin, actor Carlo Colnaghi, and M.P. Amalfi, October 5, 1968.

M.P. during *The Trained Man*. Vernazza, August 17, 1968.

The End of Pistoletto, Piper Pluriclub. Turin, March 6, 1967.

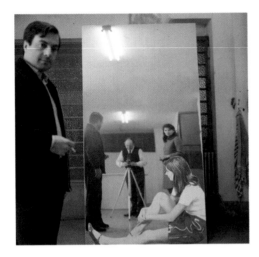

Ragazza seduta per terra (Girl Seated on the Ground), 1962–67. Left, Pietro Derossi, architect of the discotheque. Reflected in the work, Paolo Bressano and Graziella Derossi, subject of the picture.

One of the M.P. masks worn by the audience during the performance at the Piper Pluriclub in Turin, 1967.

like a mask; each of them held a sheet of metal with a mirror finish in their hands and made sounds by vibrating it. Then they took off the masks and put the sheets of metal on the ground, creating a reflective floor on which the audience danced and made music by causing small sheets of metal to vibrate.

How did you come up with the idea? Why the disco? Why the music?
It was a way of getting the public involved. The Piper Pluriclub had been set up by an architect friend, Pietro Derossi, who had decided to bring the famous Piper discotheque in Rome to Turin. He had also invited some exponents of Arte Povera like Boetti, Zorio, and Piero Gilardi to stage performances. The Piper played a very important role in the artistic circles of Turin in those years. In May 1968 I put on another performance there, *Cocapicco e Vestitorito*, a metaphor for consumerism. The first action carried out in the street, however, was the *Walking Sculpture*. Then in the space of a month I made ten short films in collaboration with ten filmmakers. They were then shown at L'Attico in Rome and a museum in Essen, Germany. In Rome the Zoo met the MEV (Musica Elettronica Viva), a group of young American musicians who were living in Rome at the time; one was the jazz saxophonist Steve Lacy. We worked with them several times. We invited them to Turin, and the Zoo and the MEV together crossed the city. Then we held a few street performances in Vernazza, on the Ligurian coast. We came down from the mountains, where we'd been staying with Boetti, a bit like strolling players arriving from who knows where, dressed like tramps. We gathered people as we walked, and when we got to the square I drew a large chalk circle and in it we performed *The Trained Man*. We were

storytellers representing the life and exploits of this
man, who had been raised by a snake in the forest
and then found by us, and who we were showing
to the world as a curiosity. He was a sort of animal
whom we had taught to say a few words, to play a
trumpet, not to bite people.

How long did the performance last?
An hour.

Where did you take it from there?
We took it to Rome, Amalfi, and Belgrade.

M.P. during
the shooting
of *Pistoletto &*
Sotheby's by Pia
Epremiam De
Silvestris, while
he plays the role
of James Ensor's
Self-Portrait with
Flowered Hat (1883).
From the catalogue
of the Galleria
L'Attico exhibition.
Rome, 1968.

Did you tour the world with the Zoo?
We toured a lot: Italy, the Netherlands, Austria, Slovenia, Serbia,
and Germany.

All this without getting paid?
No, except when we put on a performance in a certain place,
such as a beerhouse in Stuttgart; in that case we did get some
money. But we really lived on very little and asked for contribu-
tions in the street. And in the meantime I was selling my work.

Did you do it partly for fun?
Yes, of course.

Were you happy during that period?
Oh, yes. We were really happy. We had an enormous amount
of energy. One night, passing through Turin, we stayed in my
studio. The whole group in the Zoo was lying on mattresses on
the floor, and Maria and I slept in the little study with windows
opening onto the large space where the others were staying. At a
certain point in the night there was an explosion of very bright
light. Maria and I sat bolt upright. No one else noticed that
light, only us. Evidently we had accumulated such a charge of
energy that it had turned into an explosion of light.

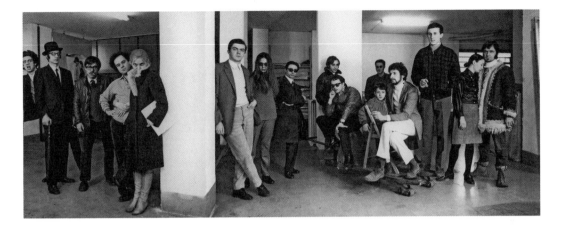

The ten creators of the film for M.P.'s exhibition at the Galleria L'Attico. From left: Franco Bodini, Mario Ferrero, Plinio Martelli, Tonino De Bernardi, Pia Epremiam De Silvestris, Renato Dogliani, unidentified person, Gabriele Oriani, Renato Ferraro, Ugo Nespolo, Enrico Allosio, Franco Giachino Nichot with his son, Paolo Menzio, Maria Pioppi, M.P. Turin, 1968.

Walking Sculpture, 1967. Stills from Ugo Nespolo's film *Buongiorno Michelangelo* (1967–68).

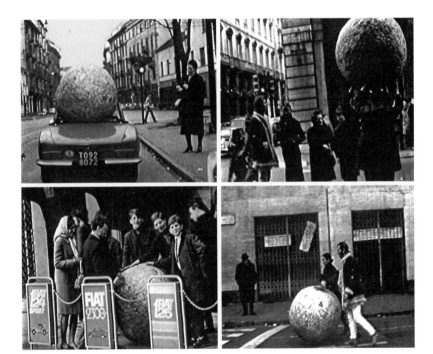

How long did the Zoo last?
It lasted four years, from 1967 to 1971.

How old were you?
At the beginning thirty-four.

Were those the early years in your relationship with Maria?
That's right, Maria was always part of it.

What relationship did you have with the Mirror Paintings *at that time?*
Every so often I made one, fixing a moment of life in the mirror, and the *Mirror Paintings* were a source of income.

M.P. in *Il barocco e le maschere* (The Baroque and the Masks), a series of photographic actions, 1969.

Did people ask you for them?
I was asked to hold exhibitions, as I still am today.

Have you kept much of your work?
I've donated a lot of my work to Cittadellarte to support the foundation.

Who is your biggest collector?
I don't know. The collector who surprised me most was a well-known French writer and art critic. Her name is France Huser. One day I received a long letter from her that moved me. She explained that she had never wanted to collect work, because for her it was enough to see it in museums or galleries. But then she came across one of my mirror paintings with two figures at the International Contemporary Art Fair in Paris. She stopped and asked how much it cost; they told her the price, which was fairly high, and she walked away. As she was leaving, it occurred to her that her father, who had died a short time before, had

left her exactly the same amount, so she went back and bought it. She is a collector of a single picture. She installed it in her home and then wrote to her daughter, who was away on a trip, and told her she had bought a picture and didn't know if her daughter would like it because it was in black and white and her daughter was very fond of colors. When the daughter came back she said, "Mom, this picture is in color!" She had seen her reflection in it and she was wearing colored clothes. She also wrote to me that she thought she was putting the picture in her house, but realized that it was her house that was inside the picture. I thought all this was wonderful. Another collector of mine, Daniella Luxembourg, told me that when she saw one of my works she found it so classical and perfect, but at the same time irksome and irritating, that she was attracted to it. At that moment she had the sensation she could not do without it and paid a high price to buy it. She said to me that sometimes she sees work and feels that she must have it, and it's not until after she's bought it that she understands why. When she buys work she feels it belongs to her, just as the artist feels it is his work when he creates it. I think that's a form of creativity on the part of the art collector: you desire to possess a work, and when you get hold of it, it's almost as if you had made it yourself. That's the healthy side of collecting, whereas it's often marred by financial speculation. Daniella Luxembourg told me another interesting thing—that many years after she started to collect art she understood that what she was looking for in works was not perfection, but imperfection. That's one of the reasons she began to buy the work of Italian artists of the 1950s and 1960s.

Were you on friendly terms with your collectors, or is it that your friends have become collectors?
Some collectors have become friends. For example a well-known architect from Turin, Corrado Levi, is a great friend and a collector of contemporary art. His father used to collect modern art. Corrado was introduced to Pop Art by me and Sperone and then went on to collect works of Arte Povera. In Turin there's another Levi, Marcello, who's also a collector. I got to know him when I

was a boy and working in my father's studio. He used to come to get old pictures restored. I remember doing one of the most demanding restoration jobs for him. He arrived one day with a Neapolitan Madonna from the seventeenth century, a beautiful painting but 40 percent of it had been destroyed, with some of the most important parts missing. It was a job my father didn't want to take on, so I did it instead. Levi didn't want to spend much, so we decided to do it bit by bit. First we set a price, and when the corresponding time had run out I stopped. In the end, I managed to restore almost the whole picture. It was an important test for me, because even expert antiquarians were unable to distinguish the restored parts. In a nutshell, many years later Marcello Levi knocked on my door to ask me to sell him one of my pictures. From ancient art, he had moved on to collecting contemporary art and he bought several of my works, and later he collected many examples of Arte Povera.

Are Corrado and Marcello Levi related?
No, they're not. There was yet another Levi in my life—our landlord in Turin when the war started. In 1943, when I was ten years old, we were leaving to move to Susa and I saw the doorman had a big group of pictures. I looked at them and asked, "Who painted these?" I remember the doorman told me, "They're by de Chirico. Signor Levi is taking them to a safe place."

So you've had close contact with the Jewish community?
In a way, yes, always through art. I have to say that the Jewish community in Turin was very open-minded. It didn't stay separate from society at large. Indeed, it was an integral part. They practiced a particularly enlightened form of Judaism. The Jewish school in Turin was open to everyone.

Members of the Piedmontese nobility have also been very interested in you. How did you get mixed up in that world?
It all started with Anna Pellion di Persano, the wife of Gian Maria, one of the four Persano brothers, sons of Count Rodolfo.

She was passionate about art and started to work in the gallery with Gian Enzo Sperone. Then she and her husband began to collect work they bought from the gallery. Giorgio Persano, one of the brothers, opened the Multipli gallery with Sperone and I made my *Multiples* with them in 1971. Then I went downhill skiing with the Persano family from Sestriere. We used to stop at Sansicario to have lunch in the restaurant where we are right now. At a certain point Sandro Persano, the oldest brother, began to buy land and woods and decided to create a ski area that would connect Sestriere to France through Sansicario, and he succeeded in doing just that. I came here as a guest of Gian Maria and Sandro. One day they told me there was a house for sale, the first house in the old village to have been restored. I was passionately enamored of the mountains, so I bought it. The ski area was created and given the name Via Lattea. The Piedmontese nobility followed Sandro Persano, and lots of aristocrats acquired chalets and apartments in Sansicario. In 1976 I was invited to take part in two exhibits at the Venice Biennale and at the same time Giorgio Persano and Germano Celant organized a retrospective of my work at Palazzo Grassi.

Anna Pellion di Persano, Gian Enzo Sperone, Gianni Piacentino, and M.P. in Piacentino's studio. Turin, 1967.

The exhibit filled all the spaces in the building. At that point
I said to Giorgio, "Giorgio, you're still handling the *Multiples*.
Why don't you open a real art gallery?" I've always been good at
playing devil's advocate. Giorgio opened his gallery and we've
worked together ever since. Then there's Paolo Persano, the
youngest of the four brothers and a photographer. I've always
worked with him, too. The photograph published in my mani-
festo "L'arte assume la religione," which I was talking about
earlier, was taken by him. That's my real relationship with the
Piedmontese nobility. I was living in Sansicario at that time.

Apart from aristocrats and Jews, who bought your works in Turin?
A lot of small industries had sprung up in Turin, mostly allied
with Fiat. Many of these industrialists became interested in art,
because their ambition was to form a new aristocracy based on
the industrial economy. So they bought into the idea that art
is ennobling.

M.P. and Paolo
Pellion di Persano,
reflected in
Slanting Mirror at
Giorgio Persano's
gallery, Turin,
1978. Collection of
the Metropolitan
Museum of Art, New
York.

Mounting of M.P.'s
retrospective at
Palazzo Grassi in
1976. In the mirror
painting: Giuseppe
Penone, Gilberto
Zorio, and Giulio
Anselmo.

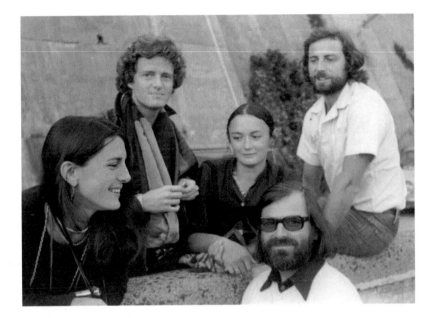

Giorgiana Pellion di Persano, art consultant Steven Richard, Maria Pioppi, M.P., and Giorgio Pellion di Persano. Corniglia, 1977.

The bourgeoisie, the aristocracy, and members of the Jewish community who took an interest in art appreciated Piedmontese artists who had not yet become world famous. Was the same true of the museums?

In Turin and in Rome, I had the privilege of seeing some of my works acquired by museums of modern art that normally didn't buy contemporary art. *The Visitors* was purchased by Palma Bucarelli in 1968 for the Galleria Nazionale d'Arte Moderna in Rome. A short time before, in 1967, Palma Bucarelli had been on the jury of the São Paulo Bienal in Brazil, and she, an Italian, was the only one on that international jury who didn't know my work. My work won an award. Returning from Brazil she told me, very honestly and with enthusiasm, that everyone wanted to give me the prize and that she had had to go along even though she wasn't familiar with my work. At which point she asked me if I could donate work to the Galleria Nazionale d'Arte Moderna in Rome. I told her that I wasn't willing to donate work, but that if she wanted I'd sell it to her. She was quite upset by my

The Visitors, 1962–68.
Painted tissue paper
on stainless steel
polished to a mirror
finish, two panels,
230 x 120 cm each.
Collection of the
Galleria Nazionale
d'Arte Moderna,
Rome.

answer, as she claimed it was a great honor for an artist to be represented in the museum. I stuck to my guns, saying that I didn't give my work away but sold it, and in the end she bought it and the work is still there. Palma Bucarelli was the partner of Giulio Carlo Argan. In the late 1960s, Argan gave a lecture in Rome. I was in the audience and I remember taking the floor to dispute what he had just said. He was intrigued and became an admirer of mine. In 1968, Argan wrote the preface to the catalogue of my solo exhibition at L'Attico and described the *Mirror Paintings* as the threshold between life and death. In 1975, on the occasion of my exhibit at Gian Enzo Sperone's gallery in Rome, Argan came to the gallery before the opening and spoke of the significance that my work had in his view, as a threshold between life and death. On his way out of the gallery he tripped over the doorstep and fell to the ground, nearly breaking his neck. A strange twist of fate.

Giulio Carlo Argan and Palma Bucarelli at the Teatro Eliseo. Rome, 1977.

Were the collectors in Turin different from other collectors around the world?
I don't think so. Perhaps they collected more out of ambition than out of a desire to speculate. They certainly had no idea that those works might be able to get them out of trouble when times got hard, something that actually happened to many of them. In any case, it was an extraordinary adventure that involved artist, gallery owner, and collector. There was reciprocal agreement.

Do you know any collectors outside Italy?
Yes, in Belgium for example I met some of the top European collectors. A number of them collected my work and I spent time with them, too, but this happened at a time when Arte Povera didn't exist yet.

And in America?
In New York, Rockefeller and Philip Morris acquired my work in 1965, and Dominique de Menil, founder of the museum of the same name in Houston, Texas, and her husband, John, were among my first collectors in the United States.

Did you have direct contacts with the collectors?
Not initially. In Europe collectors went to Sonnabend, and in America they went to Castelli. I've always respected my agreements with the galleries.

It's fascinating that all this happened in the course of just a few years, a decade.
That's right, it all happened in the 1960s, up until 1970, when we did the last Zoo performance at the Teatro Uomo in Milan. That's where I understood that there was no point in going on, because doing something in a theater that was then repeated for several evenings made no sense. I didn't want to become an actor. My idea was to connect different branches of the arts. Of course, that way you found yourself doing theater, given that theater unites the different languages of art, but for me that had been a consequence, not a choice I'd made in advance. So at that point the Zoo experience ended.

When did the rags arrive?
The rags had been in the studio for a long time. I used them to clean the *Mirror Paintings*. Then, in 1967, in a place that sold garden ornaments, I saw a concrete statue of Venus and bought it. I took it to the studio, covered it with shiny mica, and placed it against the pile of rags, and the *Venere degli stracci* (Venus of the Rags) was born. Rags then became the most commonly used material in Zoo performances.

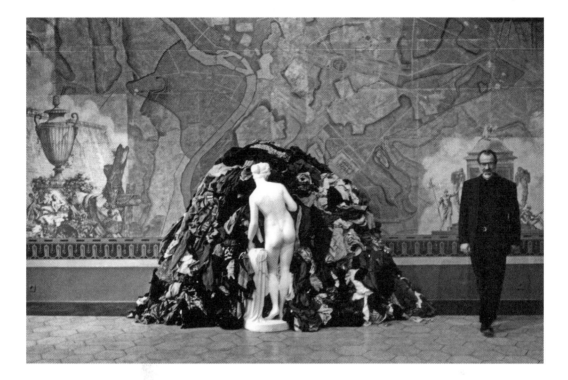

M.P. and *Venus of the Rags* (1967) at the American Academy in Rome, on the occasion of the exhibition *Joseph Kosuth—Michelangelo Pistoletto*. Rome, January 1992.

Facing page: M.P. in *Bello e basta*. Teatro Uomo, Milan, 1970.

Was that Arte Povera?
Yes, *Venus of the Rags* has even become an emblem of Arte Povera. It's a work that has many meanings. First of all, there's recycling: it represents the consumed consumer product, brought back to life thanks to the undying beauty of the nude statue. Expressed in another way, it's the same principle as the *Mirror Paintings*: the relationship between what changes and what never changes.

At that time, you'd left Tazzoli, Sonnabend, and Castelli. Who was handling you?
In Turin I went on working with Gian Enzo Sperone and Giorgio Persano. But from 1975 to 1976 I held an exhibit at the Galleria Christian Stein called *Le Stanze* (The Rooms) that lasted for a year, from September 1975 to October 1976: twelve consecutive shows, one a month, in the same space, presenting an inquiry into the nature of the creative process developed in

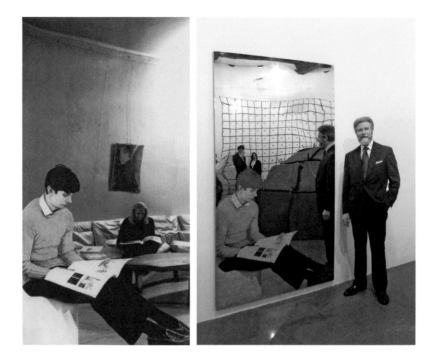

Gallery owner Christian Stein, at her home, reflected in the mirror painting *Art International* (1962–68), whose subject is her son Maximilian Stein. Behind her, on the wall, the mirror painting *Figura di profilo* (Figure in Profile), 1962. Turin, 1968.

Maximilian Stein photographed alongside the work *Art International* on display at the Museo Cantonale d'Arte. Lugano, 2010.

space and time. This particular concept of an active exhibition, running for a year, then led to the concept of "continents of time," which was reflected in various subsequent experiences.

Were you already living in Sansicario?
Yes, I was in Sansicario.

Why did you move there?
After the intense activity of the Zoo, I thought the best thing to do was to get out of the fray. Skiing has always been my passion, and the fact that staying in Sansicario would let me ski was what led me to make the decision to go and live in the mountains. I had a sort of studio there, in what used to be a stable, but I moved around and created work directly in art galleries. In the summer I went with Maria, the twins, and Cristina to Corniglia to work with the people in the village.

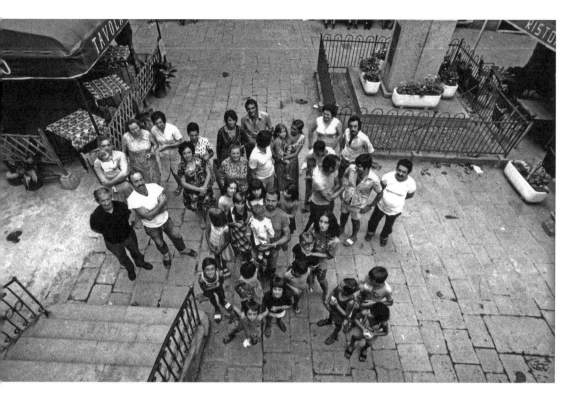

M.P. with residents
of Corniglia, 1975.

Did you ever take vacations?
In Corniglia people used to ask me why I was never able to take
a vacation, because when I arrived there I got everyone involved
in my work.

*You're not a laid-back person. You have a calm personality, but you
always have to be doing something. Have there been times when things
didn't work out? I'm thinking of Alberto Moravia. I worked with him
and knew him very well. He was a great writer, but his life was a series
of ups and downs. I mention him because, like you, he achieved success
when he was very young, younger than you, and remained a successful
man all his life. It's not easy to have such a long creative life, because
art is always to some extent a matter of fashion. Have there been diffi-
cult moments for you?*
Certainly, but I don't really know how to distinguish the ups
and downs in my life, having always been on the lookout for

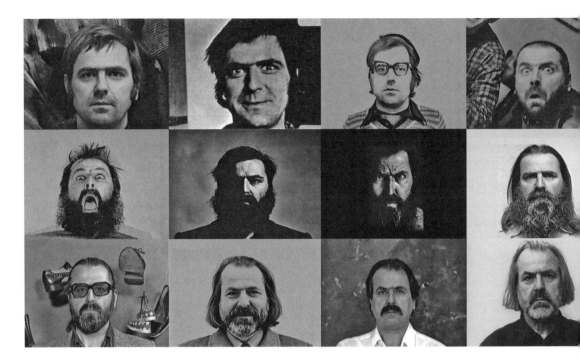

different situations. And I've always sought out difficulties—I can't claim that they just happened to me. When things started to go a certain way, I began to move in other directions. So crisis has been part of what I do. I also wrote the "Teoria del passo di fianco" (Sidestep Theory), which says, "Anyone looking for me will never find me where he expects."

Do you like teasing people?
No. It's not teasing. I was talking about creative dynamism: I feel the need to create on the move.

Members of the Arte Povera group have taken issue with that.
Perhaps some of them would still say that it'd be better if I retired.

Why?
Because I raise questions that art normally shies away from. Because I make use of my freedom shamelessly and try to make

M.P., series of photographic portraits from 1966 to 1990.

Facing page: Joseph Beuys, *We Are the Revolution*, 1971. Germanisches Nationalmuseum, Nuremberg.

that freedom and responsibility coincide, but I won't settle for making exclusively metaphorical works. I try to act directly on the reality of life. Talking about a new society is not enough for me; I want to work with people to create that new society.

With the Minus Objects *you turned yourself into about thirty different artists, as if you were having plastic surgery.*
There is a fantastic American artist named Cindy Sherman who takes photographs of herself in different guises. She is interpreting the desire to be different. It's always her, but it's other people, too.

Do you consider her a good artist?
Yes.

Among today's artists whose work commands high prices, who do you think will survive? Which are the artists who mean something?

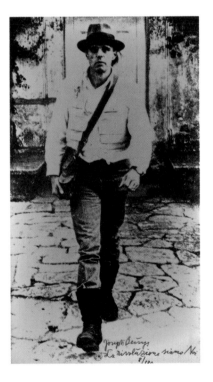

They will all survive. When someone goes down in history, he survives, in the sense you mean.

Earlier you mentioned Beuys.
Beuys is an artist to whom I feel very close from the viewpoint of the creative process: he was an artist who involved society. He founded the Düsseldorf school. He didn't just create objects, but a movement, too. But, unlike Beuys, I don't like to act the shaman; with regard to everything else, I'm with him.

What about Warhol, who was very shy?
Warhol was a shaman.

Was Warhol a great artist?
Sure. Being a great artist also depends on what you represent at a certain moment and in a certain situation.

Andy Warhol, *Self-Portrait in Profile with Shadow*, 1980 or 1981. Hamburger Kunsthalle, Hamburg.

In any case, once the Pop Art period ended there were other artists, like Richard Serra.
Yes, Richard Serra was part of a movement mentioned in books that dealt with Arte Povera as well.

Whereas Alexander Calder was not part of the same movement.
No, he lived and worked in the era of Capogrossi. Calder had the wonderful idea of mobile sculptures.

Was he an interesting artist?
Certainly. He was a great innovator.

I'm trying to understand your tastes, to understand who has attracted you over the years.
It'll be hard for you to come up with an artist who's earned a place in history and who I don't think is any good. I go to museums, and when I see all the art I enjoy every piece.

Kiefer?
I'm interested above all in his dark side. Since I like black, his work with black intrigues me. I ask myself what he would have done with black if he had lived in the 1930s.

Richter?
He produced his first work in the same period I did. I've always said that he's very good because he arrived at photography; he has just one defect, he painted photographs but without the mirror. Much later, along with his material surfaces, he showed a mirror and realized he could use that material, too. Richter has what you call talent. He has talent and skill.

Other artists you like?
Recently I went with Maria to an exhibition of Thomas Schütte's sculptures at the Castello di Rivoli and I really liked them. He manipulates and distorts the human image through computer technology. It's like seeing special effects from the movies created in bronze.

Are you jealous of other artists?
All artists are jealous, in the sense that when they see a fine piece of work they'd have liked to have done it themselves. No one is able to appreciate art more than artists.

Which work by the artists we've mentioned do you wish you'd done?
The most successful work by the members of the Arte Povera movement. Their work has touched me so deeply that I've bought some of it.

Are you a collector, too?
Not in the true sense of the word. I like some things that I feel close to and possessing them means getting even closer.

Have you thought much about the market? For your own sake, to defend your work and the prices it commands?
The market for my work functions independently of me. Much

of my work, as I told you, has been donated to Cittadellarte and constitutes the foundation's assets. I didn't give the foundation any money, because I didn't have any, but I did give it some work. I don't have money. Wealth for me is what you're able to do for the responsible transformation of society, which is Cittadellarte's mission. If I were interested principally in money I'd be very limited, that is, I'd limit the possibility of continuing my work. I'm interested in the concept of sharing. Through Cittadellarte I'm able to work on the plane of sharing. We have lots of projects. Part of the income comes from the activities that are carried out at the foundation, but it's not enough. Public funding is limited, so the assets consisting of the donated works have to be managed well.

Going back to our quick roundup, when Damien Hirst's work, the dissected cow and the medicine cabinets, first appeared, what did you think?
I like some of his old work. The idea of the medicine cabinet is symbolically interesting. But the idea that you need to dissect animals to be sensational and make money disgusts me.

What about the apparently childish objects that Jeff Koons makes?
Jeff Koons is an extraordinary person, and great fun. He deserves the success he has had. I'm thinking of the puppy made of flowers in front of the Guggenheim in Bilbao. It's a celebration of beauty and nature. There's a passionate sense of kitsch in his work. Then he married the porno star Cicciolina and got the whole world talking about that marriage. I've met Cicciolina, she's a decent, kind, delightful lady. I've known Koons a long time, I know he thinks highly of my work. The first puppets he made had reflective surfaces. Evidently the mirror excites everyone, for different reasons. But my motivation is not kitsch; indeed, it's the opposite.

M.P. and Jeff Koons. Armory Show, New York, 2004.

Facing page: Jeff Koons, *Puppy*, 1992. Guggenheim Museum, Bilbao.

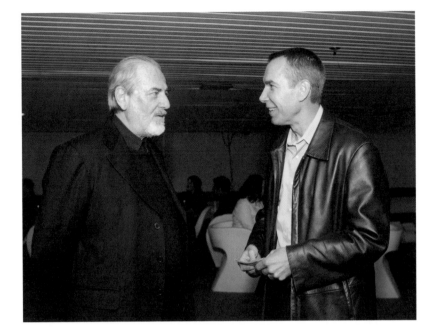

And now there's a new artist, Urs Fischer, who is to some extent the successor to Koons. He makes big puppets, too.
I'm not familiar with his work yet.

What about other young artists?
Cittadellarte, with the Fondazione Zegna, has published a book titled *visible*. Nine young curators from different parts of the world were invited to take part, and in turn each of them invited five artists. They were artists who don't just work on personal creations but who, in one way or another, perform activity that involves society. At the same time the visible Award was set up. In 2011 it went to Helena Producciones of Cali, in Colombia, a group of artists who for seven years have been staging a street action festival.

Let's get back to you: we were saying that in the 1970s you sort of went into hiding in Sansicario.
I wasn't in hiding in Sansicario. Ironically, I could say that I was doing what the ancient prophets did: I went up the mountain to meditate.

Were you a good skier?
Fairly good. I'm better now.

And do you still go to Sansicario?
Yes, always.

Are you a sportsman?
I would be, but I don't have time to devote myself to sport.

The 1970s were the period of terrorism, of the killing of Casalegno and Tobagi, the Red Brigades, the Moro kidnapping. Were you in Sansicario during those years?
During those years I made *Autoritratto di stelle* (Self-Portrait of Stars), the *Divisione e moltiplicazione dello specchio* (Division and Multiplication of the Mirror), I staged the exhibition *The Rooms*, lasting a whole year, and published the manifesto "L'arte assume la religione." I presented the latter on March 16, 1978. Just as the news of Moro's kidnapping came, I was writing "It is the hour of judgment" on the wall of the Galleria Persano. The dream of the 1960s had turned into a nightmare. I had an eight-year-old daughter and drugs had found their way into the schools in Turin. Taking the family to Sansicario was a bit like evacuating to the country during wartime.

M.P., action on the occasion of *Division and Multiplication of the Mirror: Art Takes Over from Religion.* Galleria Persano, Turin, 1978.

Facing page: *Self-Portrait of Stars,* 1973. Photograph on transparent film, 200 x 105 cm. Cittadellarte-Fondazione Pistoletto Collection, Biella.

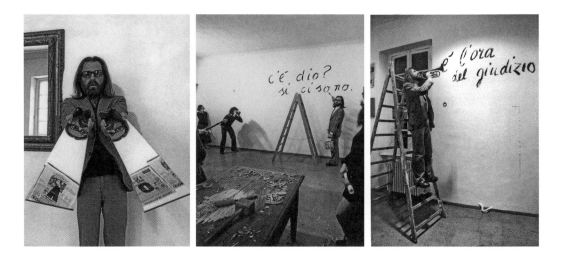

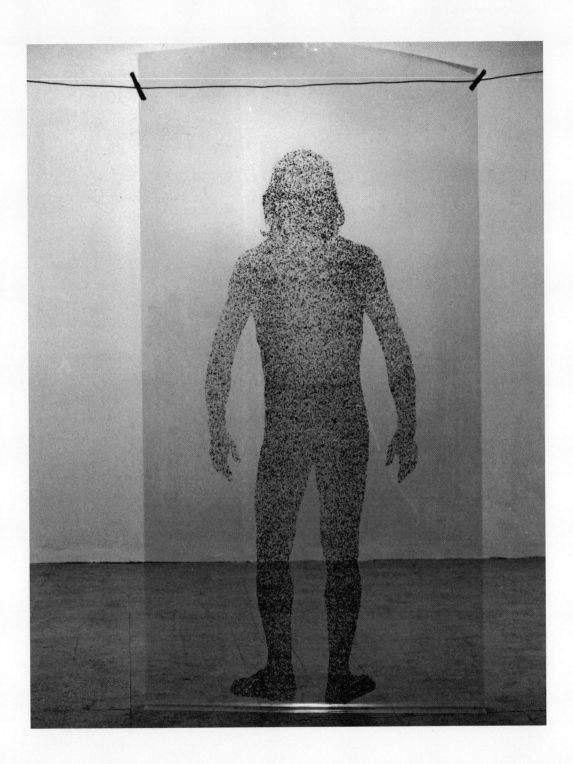

Did you take drugs?
No. I've taken a few hits on a joint with friends and that's all.
I considered it a useful experience in that it showed me it was
harmful. But some friends took a lot of different drugs and
unfortunately risked their lives.

Like Boetti.
Like Boetti, and then Festa, Angeli, Schifano.

Do you think they were important artists?
Yes, in my view they were good artists.

Festa's brother, Lo Savio, died young, too.
Yes, he did. I think Lo Savio was the best of the lot, a sort of
Capogrossi of sculpture; we might say he anticipated American
Minimalism.

*Did you say anything? If you saw Boetti getting into drugs, didn't you
try to say something to him?*
No, on the contrary. At a certain point it became difficult for
me even to spend time with them, because the drugs created
something like a psychological wall around those people.

So you took refuge in the mountains.
Not because of Boetti, for sure, but the air you breathed there
was clean and the noise muffled. I think there was only one
telephone in all of Sansicario, at a café, and when someone
called they came to look for me or brought me a message.

Why didn't you choose your father's house in Susa?
By that time my father had sold the house in Susa. He'd gone to
live in San Remo.

When did your parents die?
My mother in 1971, the year the twins were born, and my father
in 1987.

So your father was alone for many years.
No, he remarried. He married a much younger woman who took good care of him, but since my father's death I've had no more contact with her.

Did you speak often?
Well, no, being deaf he couldn't talk on the phone. But he came to see us in Corniglia and in Sansicario. You know, my father got a driver's license at the age of sixty-eight. They passed a law that said that with rearview mirrors you were allowed to have a license even if you were deaf, so he got one.

Did you give him a car?
He bought one for himself. But he didn't drive much. After a while he realized that his reflexes were no longer quick enough. One day he got scared and stopped driving.

Have you stopped driving, too?
No, I still drive. I'm even a bit impatient. The speed limits annoy me. All through the 1990s, first from Turin and then from Biella to Vienna and back, Maria and I drove thousands of kilometers every month.

What car did you have?
Sometimes a BMW and sometimes a Mercedes.

And did you go to see your father when he was in San Remo?
Yes. He'd gone to live in San Remo with his new wife and he went on some great trips with her. Every so often Maria, the family, and I went to see them. Then he left everything to his wife in his will.

Did that bother you?
Not at all. I've made my own life. I never counted on inheriting anything. On the contrary, I was very happy that my father left the property in San Remo and the funds for her future to this person, who had looked after him for many years. And after my

father's death I bought around fifteen of his paintings from her. I bought them because I wanted to keep them together, in part for my grandchildren.

Why didn't he leave you anything?
He asked me what I thought, and I advised him to leave everything to her. He'd already given me some furniture and other things from the house that I cared about and I look after them lovingly, but I thought it was right for him to leave everything to his second wife.

Do you not believe in inheritance?
I don't believe in material, physical inheritance, but in the artistic one I received during his life, not after his death.

When your mother died, did you grieve much?
I don't like to suffer, so I avoid it. If I'd let myself be carried away by the emotion I'd have suffered too much.

You never suffer?
Not much.

Not even in love?
I've never suffered in love. Even if Maria and I unfortunately have fights occasionally.

What do you fight about?
Work issues.

Is working together a good thing or not?
It's a good thing but you don't always see things the same way, and then sometimes the discussion gets a bit too heated. With Maria's personality everything settles down quickly, though. And after a little while I don't think about it anymore.

What do you do when you quarrel?
I shout. I let off steam by shouting. Then I go to another room,

and then I calm down. We don't argue often, but we are engaged in so many activities, a lot of different projects that involve relationships with many people. Sometimes it's necessary to make difficult decisions and, especially when you don't get the results you want, you vent your irritation on the person closest to you. And Maria and I are always together.

In the 1970s, which was practically a time of civil war, you decided to move your family to Sansicario, but as you said before, it wasn't just to go skiing.
No, it was to distance myself physically in a way that permitted me to distance myself mentally from everything that had happened up until that time. Not to cut myself off, but to think more clearly, to reflect, while still working.

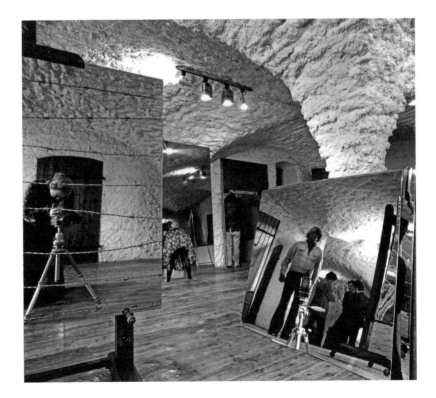

Nini Mulas and M.P. reflected in mirror paintings in M.P.'s studio in Sansicario, 1975.

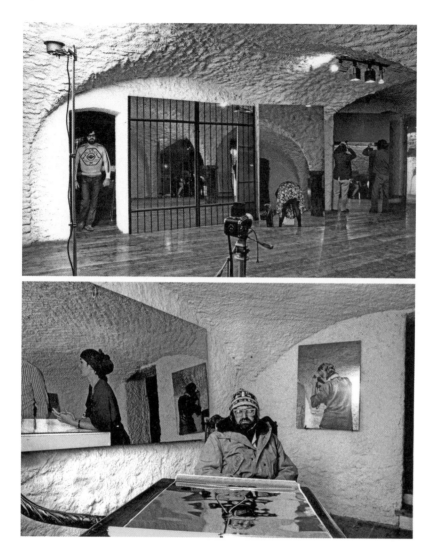

M.P. in his studio in
Sansicario, 1975.

Were you a communist or a member of the Communist Party?
No, I've never belonged to any party.

*Did you have problems with the militant criticism of that time? At a
time when it was absolutely necessary to be on the left, when all intel-
lectuals were on the left, what position did you take and how did the
critics treat you?*
Having left-wing views doesn't mean being a communist.

*At the time though, before the fall of the Berlin Wall, many
intellectuals were.*
I would say I've always been a left-wing libertarian, if such
a thing exists.

And how did that work out for you?
Well, I'd say. We artists were the ones who created the situation.
The art world was regarded with suspicion by political militants,
but there was also a neutrality that was accepted. Luckily a lot
of critics were interested in what we were doing, and instead of
opposing us they joined in. As an example I could point to all
the critics who took part in what we did in Amalfi in 1968.

What happened in Amalfi in 1968?
A major exhibition was staged in the Amalfi arsenal under the
title *Arte Povera + azioni povere* (Poor Art + Poor Actions). It was
a very important exhibit, partly because it involved the lead-
ing Italian critics of the time: Menna, Trimarco, Celant, Trini,
Boatto, Bonito Oliva, and others. That exhibition gave space not
only to the works and actions of the exponents of Arte Povera
but also some actions by foreign artists, like the Englishman
Richard Long and the Dutchman Jan Dibbets. I was present, too,
with the Zoo street theater group. We put on *L'uomo ammaestrato*
in the city's main square. That year there had been large-scale
protests at the Venice Biennale, where I'd been invited to hold a
solo exhibition. Some artists and some critics had gone to throw
stones. When I realized that things were descending into aggres-
sion and violence, I decided not to go to Venice and was unable
to carry out the project I had in mind. I'll tell you about it. I had
distributed a manifesto inviting anyone who wanted to do so
to collaborate with me at the Biennale, and there'd been many
responses. The idea was to sleep in my room at the Biennale
during the daytime, and since Maria always traveled with a
black bundle it was decided that everyone should turn up with
a bundle of his or her own. I had prepared a series of hooks to
hang the bundles from the ceiling, so that it would look like a
sky with black clouds. By day we'd sleep under the black clouds,

so visitors would find sleeping humanity. Then in the evening, once the gates closed, we would emerge from the Biennale to create small works that in the morning some of city's residents would find on their windowsills like presents.

Did you have a relationship with the Red Brigades, Potere Operaio, or any other movements?
The only contact I had was during the occupation of the Triennale in Milan in 1968. I'd been invited to the Triennale, and Maria and I wanted to see what was going on. We found ourselves in a crowd of young people who were holding assemblies, and when night fell we dozed off on chairs. I found a blanket with the words "make love, not war" written on it and covered myself with that. At a certain point everyone vanished and Maria and I were alone when the police burst in. After signing a document, we passed between two rows of armed policemen, as if we were on parade. We joined up with the Zoo group and went on with our performances. In the meantime, all around us the search for new community relations, new encounters, a freer and more open life, was turning into political struggle, and various movements had come out of this, including the Red Brigades. There was even a time when many intellectuals sympathized with those political movements. I and the Zoo kept away from all that. In 1969, Celant was preparing a book titled *Arte Povera* and asked me for pictures and I sent him some photographs of the Zoo with phrases written on them; one of them was "If politics is a four-engine plane, I travel by glider." The motto "make love, not war" was fine with me, but it was being turned into "make war, not love."

Did the Red Brigades ever threaten you?
No.

You never did anything that bore witness to what was happening in that period?
As I've said, I was and am against any form of violence. I'm interested in ideas, not aggression. I've never wanted to represent drama and I've always tried to get away from it. Some

Vietnam, 1962–65. Painted tissue paper on stainless steel polished to a mirror finish, 220 x 120 cm. The Menil Collection, Houston.

mirror paintings, including *Vietnam*, have images of marches or rallies, but they are memories of events totally devoid of political emphasis, as were all the Zoo's performances.

Do you think Italy started to fall apart with the Red Brigades and the [Aldo] Moro kidnapping?
I simply found myself again in that absurd situation of human delirium that I had lived through as a boy and that was being repeated in a different form. The Khmer Rouge were slaughtering their fellow countrymen in Cambodia, while in Rome the Red Brigades were killing Moro. How could things like that happen after the genocide of the Jews under Nazism? Everything that I'm doing with Cittadellarte—*Third Paradise, Rebirth Day*—is still, as it was with the Zoo, a response to the horrors that we see repeated at every turn. We spent part of the year they kidnapped Moro in Berlin, guests of DAAD; there I held an exhibition that was spread around fourteen institutions in the city, one of them was on the other side of the wall. After Berlin I had two winters of exhibits in the United States. In 1979 I was invited by the mayor of Atlanta, Maynard Jackson, to interact with the whole city, developing the *Creative Collaboration* project. Maynard Jackson was the first black mayor in the United States, elected in a city that up until then had been the most racist in the nation, the city of the Ku Klux Klan, and the situation had changed to such a degree that all the council members were black. The mayor had also been appointed president of the National Conference of Democratic Mayors. He gave me carte blanche to perform anywhere in the city, so that a new culture in the life of the city could be created with art. I invited the jazz musician Enrico Rava, the composer Morton Feldman, and the theater director Lionello Gennero, already part of the Zoo, to work with me. We worked for two and a half months, involving the entire city.

Did he invite you because he was familiar with your work?
Yes, he had gotten to know it through an American curator.

Opening of *Creative Collaboration* with Lionello Gennero, Maynard Jackson, mayor of Atlanta, and Shirley Franklin, who would become the city's mayor in 2002. Atlanta, 1979.

M.P., Atlanta, 1979.

Who were the curators who followed your work during that period?
My work was no longer handled by a gallery. I worked with Steven Richard, a young curator who had decided to be a manager of visual art and had invented the profession of art consultant, something that was to have great success in the United States. Art consultants have become advisers to collectors.

Speaking of the United States, I believe it was more or less those years that saw the emergence of Basquiat, who died young, another victim of drugs. Do you think he was an important artist?
Yes, his work was considered very intriguing, spirited, and unconventional, and a denunciation, too. He came out of the tradition of street graffiti artists and was one of the first to make it in the art world. His art cut across boundaries, and as an African American, he made his own revolution. He was so aggressive and free that he became an example of freedom in America, as well as very well known and rich.

Why were Clemente and Warhol attracted to him? What did they have in common?

Perhaps a critic would find it easier to answer that question.

Those were the years, more or less, when the artists of the Transavanguardia came onto the scene: Clemente, Cucchi, Chia, De Maria, Paladino. Later there was Schnabel in America and in a certain sense De Dominicis, too. What do you think of De Dominicis?

I think he was a good artist, but we could talk about that for a long time. I prefer him in the second part of his career, when he distanced himself from Arte Povera. Early on he created physical works, objects, and for me he was less interesting during that period. In a way his story is similar to that of Alighiero Boetti, but one had trained in Rome and the other in Turin. Boetti then went to live in Rome, moving away from the *objectuality* of Arte Povera, while De Dominicis didn't change cities but breathed the air of the Transavanguardia. However, his work always had a surreal vein. Even in his behavior he assumed the attitude of Dalí. In

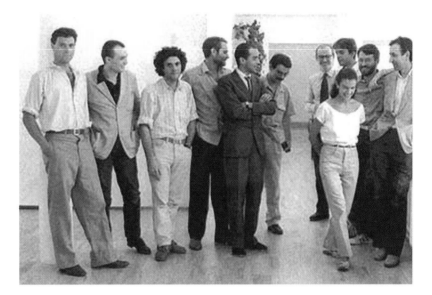

Some exponents of the Italian Transavanguardia movement at the Museum Folkwang, Essen, Germany, 1980: Sandro Chia (left), Mimmo Paladino (third from left), Francesco Clemente (fifth from left); right, gallery owner Lucio Amelio.

Facing page: Jean-Michel Basquiat, *La Colomba*, 1983. Private collection.

Gino De Dominicis, *Death Notice*, 1969.

my view, his irony in the object works was too obvious and literal, while in the two-dimensional works of the later period his ironic side was incorporated into a more complex and persuasive expressive sensibility. With the Transavanguardia there was a return to painting. For De Dominicis this tendency was a good kind of stimulus.

Who was the driving force behind the Transavanguardia?
Achille Bonito Oliva, but the artists, too. I'd say that together they realized that there was no painting in Arte Povera and conceptual art, the movements from which they'd emerged, so they worked on that. Schnabel came to Italy and fell in love with their work. It was during that time that I met him in New York. He told me he was very interested in what was happening in Italy with the Transavanguardia.

Were you in love with those artists?
I wasn't in love, but I understood the meaning of what they did. It might sound like I'm tooting my own horn, but I think that the reversal of perspective in the *Mirror Paintings* was

in large part responsible for that movement. In the mirror
we see in front of us what is behind us, and that perspective
tends to prompt you to reconsider the past. The artists of the
Transavanguardia brought pictorial forms of the past up to date,
and in this way they "trans-passed" the avant-garde.

Paladino referenced Brancusi's heads.
Yes, and Chia referenced the paintings of the early twentieth
century, that was the general direction. They took a step into the
perspective of the rearview mirror. With Arte Povera we stopped
time and began to turn back the Futurist idea of unconditional
and unlimited progress. We will have to wait and see whether
the Transavanguardia has taken things in the same direction
or another.

You're saying Arte Povera brought you to a halt.
For me it was a turning point. In 1967, at the same time as
the *Venus of the Rags*, I made a milestone with the date 1967
engraved on it, as an affirmation of a historic present. For me
it represents a turning point. Faced with the mirror you can't
keep moving forward, so what do you do? You turn around. It
was Arte Povera that started this change of direction. In 1967 I
placed this marker, the *Pietra miliare* (Milestone), at the center of
the gallery, and at the same time I opened up my studio to crea-
tive collaboration.

*Didn't you feel nostalgic when you witnessed the birth of the
Transavanguardia? Didn't it make you want to paint again?*
No, but I did start sculpting. In November 1981 I was in New
York for an exhibit at Salvatore Ala's gallery and Christmas was
approaching, so I had the idea of creating a secular nativity.
Unable to find any reproductions of ancient statues, like the
Venus or the Etruscan that I'd utilized in the past, I decided to
make them myself, digging them out from my memory bank
using a very light material that's extremely easy to sculpt: rigid
polyurethane foam. That material kept me completely absorbed
for several years.

M.P.'s exhibition
The Nativity at
the Salvatore Ala
Gallery, New York,
December 1981.

So, with Arte Povera finished, you turned back?
Taking a step backward in front of the mirror, we see ourselves advancing in the mirror itself.

Was the Transavanguardia important?
As a movement it was a bit too literal, but as an idea it was a good one. Saying "let's go backward" is a going forward that is reflected forward. We should bear in mind that the mirror is in front of our eyes and, by showing us what is behind us, it opens up a great perspective in front of us.

Schnabel has the good fortune to be a film director, too.
Right. You've hit the nail on the head.

How were other artists doing at that time?
They were selling. They had a circle and were making money. Chia moved to New York when their work got popular and bought a home in Manhattan. Then he bought an estate in Tuscany, where he now lives. But he doesn't do anything like Cittadellarte there; he makes wine.

M.P.'s exhibition *The Nativity* at the Salvatore Ala Gallery, New York, December 1981.

And Cucchi?
Cucchi has an energy of his own, with a real bite. I like Paladino, too. Sometimes he reutilizes natural materials, as in the work where horses are swallowed up by his *Montagna di sale* (Salt Mountain).

And Clemente?
Clemente staged an exhibit at the Guggenheim that, in my view, didn't do him any good.

And Cattelan?
Cattelan has said that he decided he wanted to be an artist when he saw one of my pictures.

Apart from the satisfaction of knowing that he was inspired by your work, do you think Cattelan is an important artist?

Certainly. He has been able to make very good use of the phenomenon of denunciation, utilizing the media, too. He's really brilliant.

There are artists who have insisted on sticking with one thing, like Balthus, who painted young girls and cats, and Lucian Freud, who portrayed obese and unhealthy men and women. Painters we call "classical," who have ignored the various trends and continued to work on their pictures. Who are these artists? Given that, as you rightly say, there is freedom and everyone does what he wants, in a way these are artists untouched by any fashion. They are classical painters.

I've already talked about Balthus. I can say that Lucian Freud is a good painter, just as there are great dramatists, but Shakespeare is something else. You know, a ship is a wonderful thing with many different parts, but what interests me are the bow and the propeller. Freud is a fine vessel, but he's neither the bow nor the propeller.

Pablo Picasso, *Self-Portrait*, 1901. Musée Picasso, Paris.

And Picasso?

He was both the bow and the propeller. He was a genius. To draw a parallel with music, I'd say that Picasso is the Louis Armstrong of painting. He changed the voice of art. Picasso already drew and painted very well as a child. His father was a painter, too.

You like self-portraits, and Freud painted a lot of them.

But mine are not real self-portraits. If I wanted to paint self-portraits like Freud's I would have done it, but they didn't fit in with what I was trying to do. My mission was a global one pursued through art.

There is a very interesting phenomenon in art. Degas went on with his
painting after Cubism existed, as did Monet.
I'll give you an example that you may not like. When homo faber
was born, monkeys didn't stop being born. Monkeys still exist.
When we see that through a certain process an artist arrives at a
new form, we shouldn't expect the artists who came before him
to adapt to that form. For instance, I superseded Pop Art with
Arte Povera, but I didn't expect the artists engaged in Pop Art to
take up Arte Povera.

For someone like you who came to art from advertising, what do the
famous Italian designers, from Giò Ponti to Vignelli and Gaetano
Pesce, represent? Is there something they have in common? A certain
synergy with artists?
Those are great designers, and their prototypes remain master-
pieces, but there is a difference between art and design and it
needs to be made clear: Art, of any kind, always aspires to be
unique, while design, in the modern era, is intended to multiply
an object. The designer is never alone. He always works with the
manufacturer. Of course, there have always been craftsmen who
made objects, but they made one-off pieces rather than multi-
ples. The designer has to take into account the practical use of
the object multiplied by thousands of pieces. So he designs in
direct collaboration with the manufacturer. I have no objection to
the extraordinary creative skill of some designers, but their aim
is very different from that of an artist. Designers make multiple
pieces; artists make one-off pieces. Andy Warhol didn't do design,
even though he made multiples, because he brought the idea of
multiples into the one-off piece, and so it is art. Design proper
was born with industry, with the multiplication of objects.

Have you ever made furniture?
Yes.

Were you a designer when you did so?
My intention was not to do design, but to make a piece of fur-
niture. In fact, one of the *Minus Objects* was titled *Mobile* (Piece

of Furniture). That piece was made out of some wooden frames that were supposed to be used for paintings and that had been lying around for some time. I joined them together so they looked like a piece of furniture. Two of those frames were left over, and as I needed a bench to put things on I used them as supports for a slab of marble that I had in the studio, and so I assembled that bench. Then one day Agneta Holst, at that time wife of the photographer Oliviero Toscani, turned up. She wanted to produce artists' furniture. She saw my bench and asked me if I could replicate a certain number of them, about thirty if I remember correctly. But it was a question of the reproduction of a work, not of design intended for production. Then there was a company in Milan, Memphis, that decided to produce artists' furniture and asked me, Chia, Calzolari, Cucchi, Franz West, Paladino, and others to participate in the project. I made a work that was entitled *Mobile* (Piece of Furniture), some very light iron rods that outlined the shape of a closet. A totally unusable object. Then I made another amusing one, consisting of a small metal suitcase on which I wrote, "We are all designers," echoing Beuys's words, "We are all artists." The suitcase had a transformer inside it and out of this came an electric wire that led to a pink neon light, in the shape of a flower, hanging on the wall. It is clear that the meaning of this work establishes a dialectic between design and art. Then I made a number of pieces of furniture called *Segno Arte* (Art Sign). They all had different functions—benches, tables, desks, beds, closets—but were based on a single drawing. It wasn't the drawing that was adapted to the object but the object that was adapted to the drawing, so it was art and not design.

What is the work called Mediterraneo?
It was created in one of Cittadellarte's offices: the political office. Cittadellarte is divided into sectors called offices, and the political office has a basic project called "Love Difference—Artistic Movement for an Inter-Mediterranean Politics." It starts out from this work of mine, which is a table with a mirrored top in the shape of the Mediterranean Sea. The table is surrounded by

Door—Art Sign,
1976–97. Wood
and laminated
plastic, 230 x 140
cm. Cittadellarte-
Fondazione
Pistoletto
Collection, Biella.

Art Sign, 1976–93.
Installation at
Cittadellarte-
Fondazione
Pistoletto, Biella.

chairs that come from different countries in the Mediterranean region and in themselves already represent differences. Seven of the tables have now been made, and international meetings on subjects concerning the cultures and politics of the Mediterranean are held around them. Marseille was selected as European cultural capital of 2013 by a jury seated around the Mediterranean table, as the city had chosen the Mediterranean as its theme. This table is not design, either, but art and politics.

You spent a long time in Turin, home to various very interesting people who, like you, never left their city. I'm thinking of Carlo Mollino, the famous designer, architect, photographer, and collector, who today is known and venerated everywhere. Were you interested in what he did?
No, I knew nothing about it.

That's typical of Turin. There are some great figures who lived there almost in silence, like Primo Levi, for example.
Turin was a city where the most diverse things happened. It was like a garden with many varieties of flowers. De Chirico came to Turin and invented metaphysical art, because he saw the arcades,

Giorgio de Chirico, *Piazza d'Italia*. Bergamini Collection, Milan.

Facing page: M.P. and *Love Difference—The Mediterranean Table*, 2003. Cittadellarte-Fondazione Pistoletto Biella, 2008.

the chimneys, the monuments, the automobiles, the trains, the palaces, and the factories as if they were concentrated in a single picture. The present and the past coexisting perfectly. De Chirico, with the concept of metaphysics, codified the phenomenon of the simultaneous presence of different times pictorially.

And then cinema, television, radio, I think even fashion was invented in Turin.
Turin was already a creative city before the war. But then everything has always been taken away from it, starting with its role as capital of Italy.

But you didn't leave.
No. I didn't feel the need to escape. There was a lot going on in Turin. But today I live in Biella—with art I've created my city here.

But in the so-called dark years, the 1980s, you lived in Berlin, in New York, in Atlanta.
It was the end of the 1970s and I felt at home in those places.

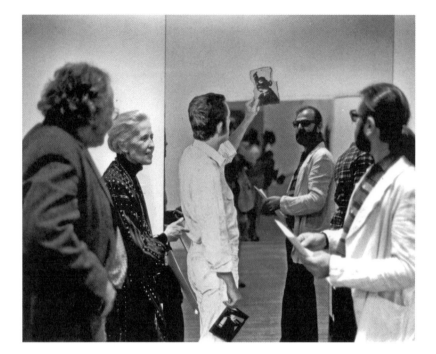

Harris Rosenstein, director of the Institute of the Arts at Rice University, collector and patron Dominique de Menil, and M.P. in front of the mirror painting *Man Looking at a Negative* (1962–67). Photo taken at the *Mirror-Works* exhibition at the de Menil Museum at Rice University, Houston, 1979.

And what was happening at that moment inside you?
After Berlin I devoted myself, ironically speaking, to the reconquest of the lost world. In the United States I held a retrospective in seven cities. At the de Menil Museum at Rice University in Houston I showed the mirror works. Then there was *Creative Collaboration* in Atlanta, *Minus Objects* at the Los Angeles Institute of Contemporary Art, *Rags* at the Berkeley Art Museum, work with lightbulbs at the San Francisco Museum of Modern Art, furniture at the Georgia Museum of Art in Athens, and at the Clocktower in New York I created a new installation titled *The Arrow* with rags, earth, and bones.

Did that relaunch you in the United States, despite the break with Castelli?
It was a good way for me to renew contact with that great and extraordinary country. Later I did a big exhibition at PS1 in New York. All my work was represented, from the earliest pictures up

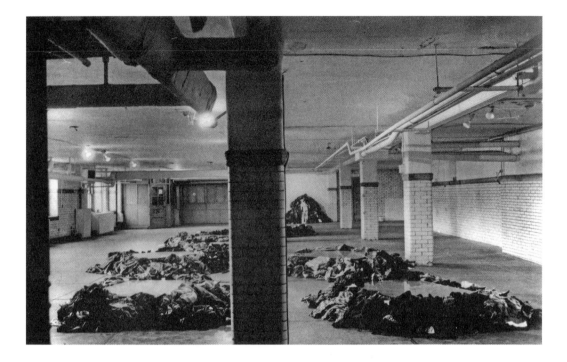

The Big Dipper, Seven Orchestras of Rags, 1968, and Venus of the Rags, 1967. Installation at The Knot, PS1, New York, 1985.

to 1988, the date of the exhibition. PS1 in New York had never before been offered to one artist in its entirety, from the basement to the top floor, and it has never happened since.

Was Alanna Heiss already there?
Yes, the exhibition was curated in tandem by Alanna Heiss and Germano Celant. In 1985 Celant organized a major exhibition of Arte Povera at PS1 titled *The Knot.*

Did you have pieces in that exhibition, too?
Yes. The whole basement was filled with the installation *The Big Dipper,* composed of seven pieces from the *Orchestra di stracci* (Orchestra of Rags) that represented the constellation, and *Venus of the Rags,* which played the role of the North Star, as well as various works in other spaces. After that exhibit, Celant became curator of the Guggenheim Museum in New York.

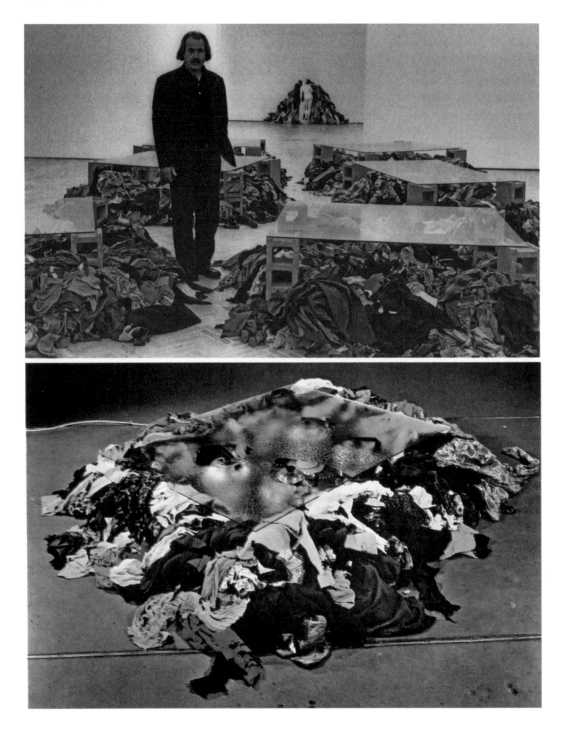

Rudi Fuchs and M.P. at his solo exhibition at the Palacio de Cristal, Madrid, 1983.

Facing page: M.P. during his retrospective at the Galleria Nazionale d'Arte Moderna, Rome, 1990. At the center the work *Orchestra of Rags*, 1968, in the background *Venus of the Rags*, 1967.

Bottom: *Orchestra of Rags*, 1968. Rags, glass, kettles, and burners, 50 x 150 x 180 cm. Cittadellarte-Fondazione Pistoletto Collection, Biella.

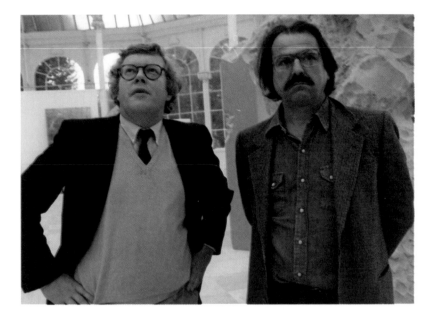

And in the meantime the Castello di Rivoli museum had been set up in Turin.
Yes.

So, was Arte Povera finally consecrated with the Castello di Rivoli?
The Castello di Rivoli, directed by Rudi Fuchs, has not concentrated on Arte Povera but opened itself up to an international panorama. Arte Povera still had to wait for what you call "consecration." In the first place, it was little known in the United States. Besides Paula Cooper and Ileana Sonnabend, only Christian Stein had shown Arte Povera in America in the 1970s and 1980s. In 1968, Leo Castelli, having discovered that something was going on in Italy, decided to include two exponents of Arte Povera, Anselmo and Zorio, in a group show. Anselmo was the first name on the alphabetical list of artists and Zorio the last, but in the reviews of the exhibition the A and Z were removed, leaving only the Americans. Strange, don't you think?

Why did it take so long for the exponents of Arte Povera to be recognized?
I quarreled a bit with Sperone and Pero, his partner, in 1970, when
I thought it was very important to dedicate a place to those artists
in order to make them constantly visible, and not just during solo
shows at the gallery, and Sperone's was funding several Turin-
based exponents of Arte Povera through an exclusive on their
work. The Arte Povera objects were bulky and it wasn't enough to
give them a space like the one utilized for pictures, which can be
stored in containers and taken out when necessary to show them
to critics and collectors. For about two years, in 1968 and 1969,
there was something called the Deposito d'Arte Presente, or con-
temporary art warehouse, in Turin—a large space where we artists
installed our works. We even obtained sponsorship from some
industrialists. That worked for a while, but then complications
arose that prevented the initiative from continuing. It was at that
point that I suggested that Sperone and Pero set up their own
Deposito d'Arte Presente. They told me they couldn't, that the
cost would be too high with respect to the market value of works
of Arte Povera. So I decided to rent an apartment in Turin, on Via
Provana to show some works that I bought from Sperone. The
twins were born there in 1971. There was no furniture, just art.
Ileana Sonnabend, who in the meantime had moved her gallery
to New York, came to see the collection and straightaway asked
me to persuade all the exponents of Arte Povera to make her their
sole agent. Fearing that what had happened to me with Castelli
might be repeated, I didn't want to assume that responsibility. I
was afraid that she would take them en masse only to drop them
altogether afterward. And I thought she could contact the artists
directly. Over time she showed the works of Paolini, Anselmo,
and Zorio repeatedly. Then I got that Ileana Sonnabend was not
Castelli, that she had an international outlook that was different
from the American one held by her ex-husband.

But who was buying Arte Povera? Panza?
Panza bought American art almost exclusively, first by artists
from New York and then from the West Coast, and more recen-
tly some works by German artists. Among Italian artists, he

Rehearsals for *Year One*, Corniglia, winter 1980–81.
Neither, 1976.
Opera with lyrics by Samuel Beckett, music by Morton Feldman, set design and direction by M.P. Teatro dell'Opera, Rome, 1977.

Bottom: Soprano Martha Hanneman.

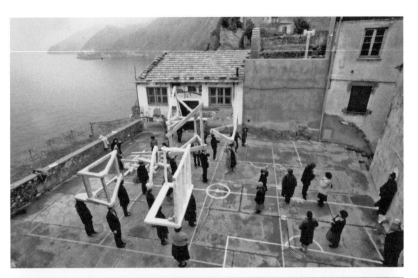

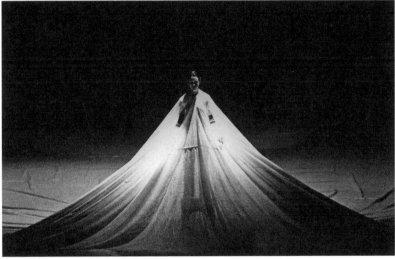

acquired works by Mochetti and Spalletti—I don't think there was anyone else. He started to collect third-rate Italian artists, but then someone told him he was making a mistake and took him to Leo Castelli in New York, and he immediately placed all his trust in him.

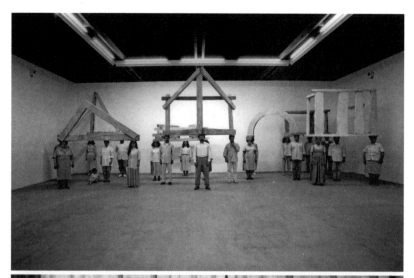

Year One.
Museo d'Arte
Contemporanea,
Castello di Rivoli,
1991.

On the stage of the
Teatro Quirino, at
the end of *Year One.*
Rome, 1981.

M.P. (seen from
behind) directing
rehearsals of *Year
One.* Corniglia,
winter 1980–81.

Facing page:
Samuel Beckett,
Paris, 1960; Morton
Feldman, New York,
1963.

In the meantime you went on traveling.
Before those trips I worked with Samuel Beckett and Morton Feldman on *Neither*, an opera commissioned by the Teatro dell'Opera in Rome. Then in 1980 I staged a theatrical performance with the people of Corniglia, *Anno Uno* (Year One), which I then took to the Teatro Quirino in Rome, the Theater im Marstall in Munich, and the Castello di Rivoli and Teatro Regio in Turin. And now it's going to Paris, to the Louvre.

Where did you meet Feldman?
I met him in Rome when I worked with him on *Neither*. The title came from the text Beckett wrote specifically for Feldman's music. It signified "neither this nor that, neither one nor the other." I think the text of *Neither* is the work that reflects Beckett's vision most essentially. Feldman's music was like a razor blade that did precisely that, dividing this from that. I changed the scenery every night for seven nights. In fact there was not just one set, but one and another and yet another. The opera was directed by Marcello Panni and the singer was Martha Hanneman.

And where was your studio at that time?
My studio was like *Neither*, a bit there and a bit not there. In the mid-1960s the studio was behind the Museo Nazionale dell'Automobile in Turin, and it was there that I created the *Minus Objects*. In 1967 I opened it up to collaboration, and then with the birth of the Zoo I abandoned it until 1972, when I set up a small studio at Sansicario. From 1975 to 1976, with the exhibition *The Rooms*, my studio became the Galleria Christian Stein in Turin for a year, and then it moved to the Galleria Persano, also in Turin, until 1978. While in Berlin and the United States I didn't have a studio anymore. In 1980 I moved my studio to the square in Corniglia and at the end of 1981 to Salvatore Ala's

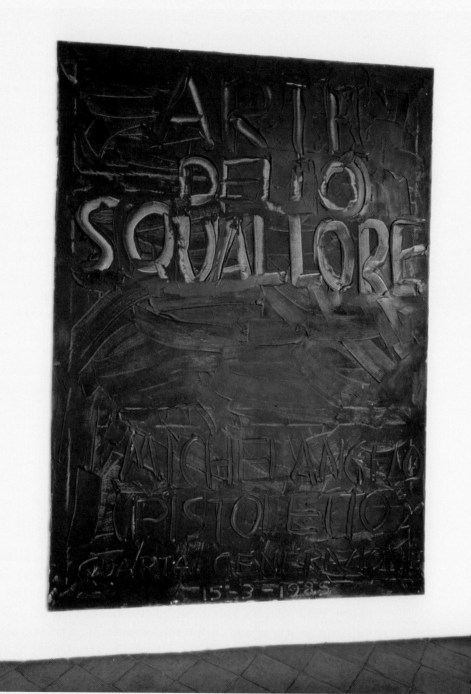

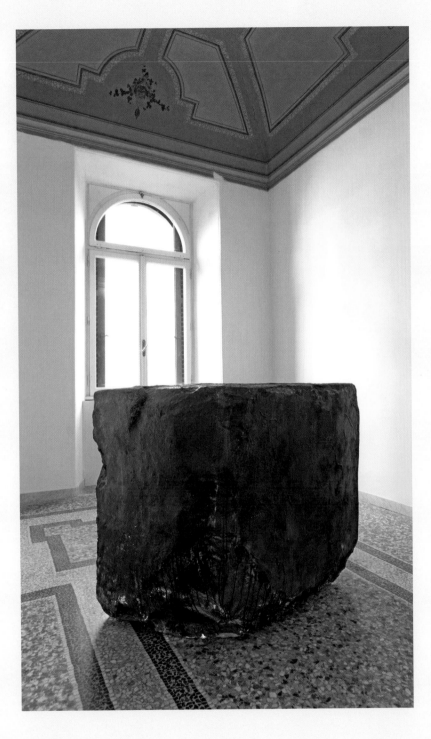

Art of Squalor,
1985. Nondescript
material on canvas,
250 x 180 cm.
Giorgio Persano
Collection, Turin.

Low Volume,
1985. Expanded
polyurethane, 90 x
130 x 100 cm. Mario
Pieroni Collection,
Rome.

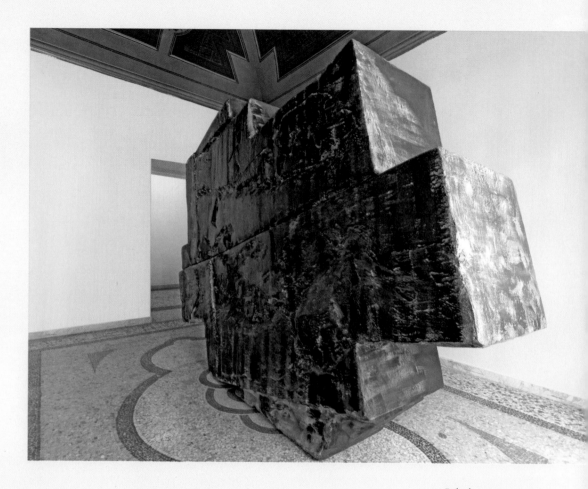

*Polychrome
Diagonal Volume*,
1985–86. Expanded
polyurethane, 300 x
210 x 75 cm. Mario
Pieroni Collection,
Rome.

gallery in New York. After that and for the rest of the 1980s it was at Via Bologna 230, in Turin, where until 1984 I made my polyurethane sculptures and from 1985 to 1988 the black volumes for *Arte dello squallore* (Art of Squalor). In 1989 I moved on to *Anno bianco* (White Year), and since then I've not had a studio of my own.

What is the principle underlying your sculptures? Why the transition from black to white?
In 1985 I started to make sculpture-paintings in a black color for a series called *Art of Squalor*. They were pictures that took the form of volumes, so they were at once sculptures and paintings. They represented the dark, concentrating the dark of the night right in the midst of the daylight. The setting in which they were displayed was brightly lit and contained these dark volumes that looked like black holes, condensed forms of material that I called "nondescript material." In 1988 I was invited to Perugia to present those black sculptures in a space called Opera. They asked me how to word the invitation to the show, and I told them the title was *White Year*. I turned the situation on its head: after a long night the light had to return, after so much black, white had to come. The exhibit opened in December 1988, and then in January 1989 the *White Year*, a work that was to span a whole year, began. I was planning to make large slabs of white plaster to be used as blank pages where events could be recorded. So all of 1989 would enter my work, as if it were a mirror. In November of that year an extraordinary thing happened: the Berlin Wall came down and the cold war came to an end.

Prophetic.
I had learned to play off of coincidence, and I felt that moment marked the exit from the tunnel. The age of darkness was over.

Did that lead you to set up Cittadellarte?
It was a chain of events. Let's take them in order. In 1990 I was asked to teach at the Academy of Fine Arts in Vienna. At the

beginning I said no, as I had no intention of becoming a teacher, but the president, architect Carl Pruscha, told me, "Pistoletto, I know you're an artist who can change things in this academy of ours. We need someone innova-
tive like you. Please, say yes to us."
I replied that I wasn't interested
and he told me, "You'll be able
to do what you want, and even if
I don't understand what you're
doing I'll back you to the hilt."
At that point I couldn't turn him
down—it was an offer of trust
and freedom. So I worked in
Vienna for a decade, doing truly
transformative work. I promoted

a kind of activity that was no longer linked solely to the tradi-
tional fine arts, but to creativity for society as a whole. We worked
on themes that would later be developed at Cittadellarte, too:
the environment, gastronomy, clothing, the home, production,
communication, and the use of the new media. I took students
to stage performances in places outside the academy, and every
month we held an exhibit of their work that was open to the
public, something that at academies usually only happens at the
end of the year, and even then not at all of them.

M.P. with Suwan
Laimanee and some
students at the
Academy of Fine
Arts in Vienna, 1995.

How did you manage with your own work?
Well, you know, I came and went. Even now, everyone asks me
that. I've always found a way to do many things at once. Maria
and I went to Vienna every month, sometimes for a week, some-
times for two, sometimes for the whole month, and I made the
Mirror Paintings in Milan in the studio of the screen printer,
whose name was Serighelli. At the academy in Vienna we had
a kitchen and two cots to sleep on. They offered us very good
accommodations but we chose to live there, just as now we are
connected to the Cittadellarte offices. At times Maria cooked for
150 people, between students, assistants, and visitors. In 1991, in
Biella, I had already bought some of the abandoned industrial

buildings that were going to become Cittadellarte. So there started to be a lot to do in Biella. In addition to the renovations, we were always doing performances with the Stalker group, which I worked with constantly.

Where did the students at the academy come from?
From all over the world, but especially Eastern Europe. The Iron Curtain had fallen, and Vienna was the closest city for them.

Did you discover you had a vocation for teaching?
I understood that at the academy it was possible to do something for the young and with the young.

In all this time, among all the young people that you met, at the Zoo, at the academy, and at Cittadellarte, did you discover anyone who went on to become an important artist?
Depends on what you mean by important. Some have done well for themselves in the milieu of official art, showing at the Biennale, at Documenta, and at other events. I'm think-ing of Lotte Lyon, an Austrian; Leopold Kessler, a German; Haegue Yang, a Korean; Gigi Scaria, an Indian; Tom Dale, an Englishman; Sarah Rifky, an Egyptian artist and curator; Plamen Dejanoff, a Bulgarian; Raphaëlle de Groot, a Canadian; Bea Catanzaro, an Italian; Juan E. Sandoval, a Colombian; and Cai Dongdong, who is Chinese—to mention just some of them. But my teaching was not and is not aimed at self-referential art. So I don't think there have been any failures. They've all learned to use their creativity to do something in the world. Some through movies, others with television, teaching, fashion, or other cul-tural and social activities. All of them have certainly carved out careers for themselves. I always told the students, "Don't imag-ine that there's room for everyone in the museum. Perhaps for a few who are really interested in it. But there is room for everyone in other places. You can use art in all sorts of ways, society needs you. You'll have the possibility to intervene in the world with your creativity." This is what I taught and what I'm continuing to teach here at Cittadellarte, too. Creativity, so not

just art for art's sake, but also, and above all, as interaction with the vast context of everyday life.

So, in a way, you discovered you have pedagogical skills, too. Do you like having people around you?
Every time you're with these students it's like climbing onto a stage at the theater. You have an audience that also participates, so teaching is a kind of performance.

You haven't put on a costume in many years, though. Until you decided to wear black you liked to keep changing.
Yes, I liked to change, but at a certain point perhaps I changed once and for all.

Do you have a black overcoat?
I have two—a light one and a heavy one.

I do wonder how you find all these black clothes.
Usually my daughter Cristina finds them. She's an expert at finding black clothes for a few euros for me and for Maria.

Does Maria always dress in black, too?
Practically yes. She already did when I met her. We didn't make the decision together to dress in black.

I'll say it again—you're lucky. Almost every museum contains Pistoletto work. This year MoMA placed one of your works in front of one of Warhol's.
I'm pleased, because Warhol's work is multiplied in my picture, and this happens in other shows and other homes, too. Warhol is a champion of the America that Marcel Duchamp showed us, like a *monde trouvé*, through *The Large Glass* installed at the Philadelphia Museum of Art. I held a retrospective exhibition in that museum in 2010: my mirrors inevitably engaged in direct dialogue with that work of his and at the same time with the America reflected in my *Mirror Paintings*. A talk with Jeremy Rifkin, the theorist behind the Third Industrial Revolution,

was held in Philadelphia with the museum and the Wharton School at the University of Pennsylvania, as part of a series of conferences organized by Cittadellarte. He has attracted a lot of attention in Europe but, as he said in his speech, not so much in America. Well, the *Terzo Paradiso* (Third Paradise) projects toward the future a prospect shared by Rifkin's Third Industrial Revolution, as well as by Gilles Clément's Third Landscape. Andy Warhol lived at the end of the second age. As you see there are already some who live in the third.

M.P. with Gilles Clément at a dinner talk dedicated to *Rebirth Day*. La Monnaie, Paris, 2012.

Tell me how you arrived in Biella.
In 1991 I came to Biella because an art gallery in the city was showing work of mine from various collectors. The gallery owner asked me what I was doing, and I told him that I was looking for a place to set up a foundation, a place to carry out activities.

Why did you want to create a place for activities?
I thought the moment had come to bring the threads of all the work done together and embark on a grand new initiative. To do this I needed a place. If in the 1960s, in order to try to change things, we turned our backs on the institutions of the art world; now with the same aim in mind I wanted to create a new institution. Continuing my conversation with the gallery owner in Biella, I looked out of the window of the gallery and saw a large white building. I said, "I'd like to find a place like that." He told me that it used to be a textile mill and was for sale, and that he knew the owner, but he advised against buying it, as it was full of drug addicts, dealers, and thieves, and just going near there you ran the risk of getting mugged. I said I was interested anyway and he telephoned. We went over, and the owner of the mill showed me the large part that was still his, with some

stately halls filled with heaps of rubble and a complete mess. The rest had been sold off in small lots to the aforementioned delinquents. He told me what he wanted, we negotiated, and I decided to buy it. I signed a check on the roof of the car, in the middle of the courtyard, so that everyone could see. Then the now former owner asked me if I had a notary I trusted. I said no, so he called his and told him he was selling the mill to a certain Michelangelo Pistoletto. The notary asked to speak to me and on the telephone said to me, "Michelangelo, I'm your cousin." So I also found some relatives in Biella, and they then helped me in practical matters. It was great. Gradually I acquired thirteen lots to put the parts of the old factory back together. Then I bought some adjoining former establishments and the 7,000 square meters became 22,000. Some parts still have to be renovated.

And all this became a foundation?
Yes, in 1991 I set up an association for the Pistoletto Foundation. Then in 1998 the association was transformed into a foundation.

And what is the purpose of this foundation?
Its purpose is to develop Pistoletto's work and to create situations in which art is involved with society. It's explained in the statute. But there is also this thing about Pistoletto's works, because that allows me to donate to the foundation works that can be used for its development.

Who decides to sell them?
The executive committee.

Are you the president?
No. Giuliana Setari is the president, Maria Pioppi is the vice president, and we have a director, Paolo Naldini, and some advisers. I'm the artistic director.

Who is Giuliana Setari?
She's an enthusiastic collector, who now lives in Paris and with whom Maria and I have always had a great relationship.

Facing page:
Main building of Cittadellarte-Fondazione Pistoletto, Biella, 2010.

Music room and poetry room. Cittadellarte-Fondazione Pistoletto, Biella, 2010.

Opening of M.P.'s retrospective exhibit at the Galleria Nazionale d'Arte Moderna, Rome, 1990. From left: Anna Imponente, curator of the exhibition along with Augusta Monferini, astronomer Remo Ruffini, M.P., and Giuliana Setari, current president of Cittadellarte-Fondazione Pistoletto.

Facing page: M.P. in a room at Cittadellarte, and seated on a work by Charlie Jeffery for the exhibition *Letteratura di Svolta* (Turning-Point Literature), 2008.

Column room. Cittadellarte-Fondazione Pistoletto.

A capable person of great sensitivity. She is originally from Abruzzo. I met her when she and her husband, Tommaso, who's equally passionate about art, were living in New York. They bought *Venus of the Rags*. Right now their collection is on display at La Maison Rouge in Paris. In 2001, Giuliana and Tommaso Setari set up the Dena Foundation for Contemporary Art, which organizes international artist's residences. It was in New York, and it's now based in Paris.

So you came to live in Biella.
Yes, but not right away. We moved in 1994, after we'd had time to do the first round of renovations.

And in the meantime you were living in Turin?
Yes, we were living at Via Milano 13 in Turin, in a building designed by the great eighteenth-century architect Filippo Juvarra that had remained intact because it was used as a warehouse for a long time.

Merz lived on Via Milano, too, didn't he?
After a while he arrived, too.

Were you and Merz friends?
In the beginning we used to see each other
more, but then we drifted apart somewhat.
Everyone was working on his own.

Arte Povera broke up?
No, but everyone led his own life. Then some-
times we would meet each other at the open-
ings of shows of our work.

In short, in the 1990s you left Turin.
Yes, I left Turin to come to Biella.

You still work as an artist, but you devote a lot of time to the founda-
tion, too.
I devote a lot of energy to the foundation, that is to the activities
of Cittadellarte, which started out as the University of Ideas,
or Unidee.

Is Cittadellarte's university certified and recognized by the state?
Cittadellarte is a foundation recognized at the regional
level. The University of Ideas is private and issues certificates
of attendance.

What do the students do here?
They come from all over the world—the language is English—
and they work on art projects involving social change. The
courses are run by experts in a wide variety of fields: sociolo-
gists, communicators, urban planners, critics, filmmakers, pho-
tographers, artists. Individually and collectively, the students
carry out experiments of interaction with different areas of
society. Right now, for example, ten of them are doing a project
in a very rundown part of the city of San Remo, the La Pigna
district. Unfortunately San Remo is known only for its festival,

M.P. with the artists in residence at Unidee, reflected in *Cage Mirror* (1973–92). Cittadellarte-Fondazione Pistoletto, Biella, 2002.

Facing page: M.P. in his studio. Turin, 1987.

its casino, and its production of flowers, while the beautiful historic part is almost completely abandoned. A few residents have created an artistic-cultural association that for three years now has invited us to collaborate on the regeneration of the old quarter. The students of the University of Ideas have officially set up a group that will stay in touch even at a distance. Each member will work on finding degraded areas in his or her own region, like La Pigna in San Remo, and bringing them back to life. A couple of years ago the Cittadellarte students arrived in San Remo and saw an old, abandoned church at the center of the district. They published an advertisement announcing that a casino was about to open in that church. This gave the city and diocesan administrations a shock. They asked themselves what was going on in La Pigna and finally began to pay attention to the district and listen to the problems of its residents. It was an opportunity to start reviving that part of the city. Every year different activities are launched. The underlying theme that

inspires the actions of the young people is always that of regeneration set in motion with the *Third Paradise* project.

What is Third Paradise? *Which came first, the now widely known symbol, or the concept?*
The concept came first, but the symbol followed immediately afterward. To define the *Third Paradise* I can read to you from the opening of the book *The Third Paradise*: "Aware of the symbolic function of art, I decided to propose a symbol that could serve as a guide on the path toward a new stage of civilization. I conceived the symbol of the *Third Paradise* as a compass that would indicate the direction to be followed. What I had in mind was a sign that would be at once a reference to the past, a consideration of the present and a projection into the future. The mathematical symbol for infinity, composed of an unbroken line that forms two circles, permitted this synthesis. In one circle is inscribed the most remote past, the time when human beings were totally integrated with nature, while the other circle can be identified with the second phase of the past, the one in which humanity disengaged itself from nature in a process that has led to the artificial world in which we live today. Artifice and art have the same root: the term 'artifact' indicates something 'made with art.' Alongside the marvelous advances achieved with modern progress, catastrophic conditions that threaten the survival of the human race have also been created. At this critical juncture art must assume the basic responsibility for the human dalliance with the artificial. A very strong pressure is being focused in the present, due to the tension, which has grown exponentially over the last century, between the natural and the artificial sphere. I felt the need to liberate the crucial point that links the two circles from that pressure by opening a third circle: an area ready to accommodate future time. Out of this has come the 'new sign of infinity,' symbol of the Third Paradise. From the central circle, as in a mother's womb impregnated by the two earlier paradises, the natural and the artificial, the new humanity is born. I would like to make it clear that the choice of the term 'paradise' is not connected with the religious concept of transcendence, but with an

ideal of life on this Earth. The ancient Persian root of the word 'paradise' signified 'walled garden,' a place filled with life and protected from the aridity of the surrounding desert." I thought that what I was doing with Cittadellarte, which was already a workshop of social change, was not enough. It was necessary to find the courage to transmit a clearer message, a farther reaching and more engaging one. "Who do you think you are?" some people must have thought. "I believe I can do it" was my answer. Then if I didn't succeed, so be it, but I had the freedom to create. I was like a secret agent with a license to create, instead of a license to kill. Society was asking me to be creative. I felt as if human society were my client and were asking me to think of something to change the situation. I thought that, at this time of extreme risk for all of humanity, the first thing that was needed was a symbol, and art has a symbolic basis. In order to meet society's need for profound change, art had to bring to society itself a symbol that would represent that change, something that could be a banner for everyone, something to follow in order to move forward. The new symbol of infinity is the banner of the *Third Paradise*: it consists of three circles, the outer ones representing natural paradise and artificial paradise, while the central circle is the union of nature and artifice. Humanity has slowly detached itself from nature to create the artificial world that has assumed all-encompassing dimensions over the last century. The ancient image of the apple with a bite taken out of it represents the detachment of the human race from nature. That bite has become the artificial planet that threatens to fall and crash on the natural one. The time has come to reconcile ourselves with planet Earth and integrate the artificial into nature. I've even created a work titled *The Reinstated Apple*.

That is the background of your pictures.
The background of my pictures puts the world in front of a mirror and brings us back to reality. In the face of that reality we see that we have acquired an enormous capacity for construction and an equally great one for destruction. The two forces have grown together. Now we have to make them coincide and coexist, to

prevent the latter from annihilating the former. Humanity certainly wants to survive. We immediately think about our children and grandchildren. The *Third Paradise* is a project about life. In the two circles of the traditional symbol for infinity, the unbroken line passes from one circle to the next as if in an endless intersection of life and death. In the new infinity sign, the line draws a third circle between the other two, representing the duration of physical life, and thus the time of the existence of a person, a community, or a whole society. The central circle is the space and time of earthly life. It's up to us whether it's paradise or hell. Paradise and hell are here on earth. The tangible paradise that we can and should create lies in the central circle, while in the other two circles there are the before and the after of our earthly life, which extend to infinity. The *Cubic Meter of Infinity* is to all intents and purposes this: a finite body that contains the infinite. It is like the central circle that holds the infinite in the finite. This circle represents the world, and now that we've taken possession of that world artificially, we are fully responsible for it. The art critic Achille Bonito Oliva has come up with a good definition of the three paradises described by the symbol: the first is the paradise of unawareness, the second that of knowledge, and the third that of responsibility. The *Third Paradise* symbol is not just a drawing, but a receptacle of mental energy that can be transformed into physical energy. The two lateral circles are like the two poles of an electric battery and the circle in the middle is the container of the electricity.

Is this an anthropological, philosophical, or ethical project? How do you see it? Is it a work of conceptual art, or does art have nothing to do with it?
Art is certainly involved, in that I trace everything back to the artistic phenomenon. Art comes before everything else. I always hold up the example of the first work of conceptual art, which was a handprint left on the wall of a cave. The world that has developed from that print is a world made by art, for it is "artificial." Following that first work, humanity went from concept to concept, and every stage of its history corresponded to the

movement toward a new conquest. Thought was enriched by
every practical result, and in turn developed new ideas and new
practices. A long, slow process that gradually accelerated until
it reached the speed attained in the last century. Conceptual art
reveals this process and takes stock of it. Personally I maintain
that, after taking conceptual stock of art, it is necessary to take
conceptual stock of religion. For religion, in all its forms, has
developed out of a conceptuality born with the artistic print on
the primordial wall. Religion is the most widespread and deep-
rooted phenomenon in human society and holds its reins. Art
and religion are linked in the development of another phenom-
enon—what we call "spirituality." It is necessary to take stock
of this connection conceptually, too, in order to understand
to what extent the art system and the systems of the different
religions might favor or thwart passage to the *Third Paradise*. To
understand how these systems can contribute to the respon-
sible transformation of society, which, in my view, ought to be
sped up as much as possible, given the increasingly urgent need
for it. All sectors of the social fabric are involved in this new
responsibility, but the most delicate and problematic one is
religion. In fact, religions have shaped the psyche of humanity
for millennia, so they are responsible for it. As soon as the first
work of art was created, the human imagination invented magic,
which then developed into religion. Anthropologist James
George Frazer said that magic gave rise to religion, which in
turn gave way to science. I agree fully, but he forgot to consider
art. The reason is that it has only recently become intellectually
independent, whereas previously it was always an integral part
of every human activity, mental as well as material. Personally,
taking on the role of an intellectual artist, I place art before,
during, and after magic; before, during, and after religion; and
before, during, and after science in the order of development
of human thought. The *Third Paradise* implicitly carries this
message. In fact art, in full autonomy, has assumed the maxi-
mum responsibility. And the *Third Paradise* ushers in the age
of responsible humanity. The symbol is there. Now what the
symbol signifies needs to be realized in a tangible way.

Who decides all this? Who decides on the realization of the Third
Paradise? *And who is going to do it?*
All of us together, but not through rebellion. About ten years ago
Cittadellarte held an exhibit in Switzerland titled *Critique Is Not
Enough.* Everyone can contribute to change in a constructive way.

Are there pictures of the Third Paradise?
I've worked with the symbol of the *Third Paradise* in many different
materials. The first was the symbol drawn in the sand. The symbol
had to be redrawn every time it was put on display. The work was
bought by the gallery owner Salvatore Ala. Then I drew the symbol
with a plow on the island of San Servolo in Venice and in Assisi,
where I made it in the form of a pathway flanked by 121 olive
trees. And at the Baths of Caracalla I shaped it out of the relics of
ancient Roman architecture. Those are just a few examples.

Is the Third Paradise *your latest work, your latest concept?*
The *Third Paradise* can be represented with physical artworks,
but in reality it is a work based on time, as was the *White
Year.* That work had an opening date and a closing date, from
January 1 to December 31, 1989. We know what happened that
year. The *Third Paradise* began in 2003 and we don't know if and
when it will end. Society or nature will decide that.

Let's talk about the symbol.
The three circles, which in reality look like ellipses, are not all
the same size: the central one is like a womb formed inside
the symbol of infinity. I drew this womb larger than the other
two circles that come from the traditional symbol. It's as if the
middle circle were the sum of the two opposing circles. Over
time the central one is destined to expand and include the space
occupied by the circles at the sides, too, so the middle one will
increasingly take on the shape of an ellipse. I've already made
a drawing that shows the growth of the *Third Paradise.* The two
lateral circles will stay outside the central ellipse. The positive
and the negative will remain the same size, while the ability to
draw energy from them will increase. But the evolution of prac-
tical reality is going to shape the *Third Paradise.*

Golden Book of the Third Paradise, 2006. Glazed ceramic, 4 x 42 x 50 cm. Cittadellarte-Fondazione Pistoletto, Biella.

Third Paradise, umbilical mark, photograph, 2006.

Facing page: The new sign of infinity, *Third Paradise* symbol drawn in sand by M.P., 2003.

Third Paradise, M.P. and Cittadellarte, CAMeC, La Spezia, 2007.

M.P. draws *Third Paradise* on a mirror.

Third Paradise, Bread, 2009.

Third Paradise, 2010. Radura del Bosco di Francesco, Assisi, property of the FAI (Fondo Ambiente Italiano).

M.P. plows *Third Paradise* for the planting of 121 olive trees in Assisi.

Facing page: *Third Paradise*, 51st Venice Biennale, San Servolo, 2005.

M.P. creates the new infinity sign, the *Third Paradise* symbol in the garden of the Baths of Caracalla in Rome, using marble and mosaic vestiges from the baths. Rome, September 2012.

Rebirth Day, December 21, 2012. Students at the Liceo Artistico Statale Medardo Rosso in Galbiate hold hands to form a sequence inspired by the symbol of the *Third Paradise.*

Third Paradise. Day of environmental sustainability, organized by the Education Department of the Museo d'Arte Contemporanea, Castello di Rivoli. Rivoli, July 12, 2012.

Facing page:
Third Paradise, Cittadellarte-Sharing Transformation. Kunsthaus, Graz, 2012.

Third Paradise—Rebirth Day, created by M.P. for *Io Donna* insert in *Il Corriere della Sera*, December 21, 2012.

Facing page: *Third Paradise—Does God Exist? Yes, I Do!* Created for *Facing Walls, Opening Windows*. Galleria Continua, Beijing, 2012.

Third Paradise, design for the solo exhibition *Year One—Paradise on Earth*. Musée du Louvre, Paris, April 2013.

Drawing the symbol of *Third Paradise* around the spire of the Mole Antonelliana, M.P. created the representative image and prize for the winners of the 64th Prix Italia—International Competition for Radio, Television, and the Web, titled "The World in the Mirror. Images and Sounds from 5 Continents," 2012.

Nelle Piramide del Louvre 2013

What did you do with Gianna Nannini?

In 2007, we did an extraordinary thing that lay somewhere between the symbol and the reality represented by the symbol. Mario Pieroni, my agent in Rome since the 1970s, had been asked by Gianna Nannini to organize visual art projects in a space underneath her studio in Milan. Pieroni got me involved right away. In the meantime I had met Gianna at a party, in Biella of all places, and we had decided to hold an exhibit together of sculpture and voice. I suggested *Orchestra of Rags*, a work I'd created back in 1968, in the form of the *Third Paradise*.

I explained to Gianna that the *Third Paradise* is the union of nature with artifice, and that the two form a great womb that will give birth to the new humanity. Being a sensitive and intelligent person, as well as an extraordinary rock singer, she immediately told me, "I'll use my voice to make a singing sculpture with the word *mama*." At the center of the space I installed the *Third Paradise* with kettles and rags and covered the walls with sheets of reflective metal with various images, including one of Gianna with her belly exposed. And her voice spoke the word *mama* throughout the space. Gianna drew energy, she says, from the meaning of that work, to the point of deciding, after three years, to become a mother, and that's how her daughter, Penelope, came to be. In the meantime this work went to Moscow, Minsk, and Bari. In 2011, Gianna wrote the song "Paradiso-Mama" and sang it, accompanying herself on the piano, at the opening of my solo exhibit at the MAXXI in Rome in March 2011. On that occasion the vocal sculpture *Mama* wafted around the space dedicated to Cittadellarte. In the image imprinted on the reflective sheets at the first exhibition in Milan, Gianna appeared with her arms raised and spread and her legs apart, to represent the golden proportions of the human body in an image that recalled Leonardo da Vinci's Vitruvian Man. A significant difference, though, consisted in the fact that in my work, instead of the man at the center

M.P. and Gianna Nannini, Milan, 2007. Courtesy Zerynthya, Rome.

Facing page: *Art Sign—Gianna Nannini*, 2007.

of Renaissance geometry, there is a woman at the center of present-day geometry. The symbol of the navel is the center of this work and signifies the continuity of the human race. The umbilical cord unites each person to his or her mother, from the remote beginnings to the distant future.

We have spoken of the war you lived through as a child, of a sort of war even in the art world, of the Red Brigades, and of the wars that still rage today in various parts of the world. Unfortunately, there has never been a world without war and we have to bear this in mind. The religions you were talking about are the main pretext for wars in the world. Is it important for an artist to think about changing the world? This question leads me to the main reason I created Cittadellarte, *Third Paradise*, and *Rebirth Day*. As you see, religion and politics are closely linked and together they play on the human psyche as well as on human flesh—today as in the past. I've just written something that I think will be my last manifesto, titled *Omnitheism and Democracy*; in a few pages I explain with great clarity that democracy and monotheism are not compatible with one another. Democracy is a horizontal phenomenon based on relativity, while monotheism is vertical and absolutist. Faith in

the absolute leads to dictatorship, understanding of relativity
leads to democracy. The mirror reveals an indisputable principle,
the absolute relativity of existence. If you look for the absolute
in reflected images taken directly from life, all you find is rela-
tivity. To me this observation is a response that becomes both a
spiritual and political principle. Omnitheism means fragmenta-
tion of the concept of God into the individuality of each person.
When each individual is aware and responsible, democracy comes
into existence spontaneously. The concept of God is not excluded,
but it is not exclusive. On the contrary, it is inclusive as it can be
identified in each person, that is, in everyone. In this interview,
the arguments put forward before and the ones that will be made
from here on turn around this axis: omnitheism and democracy.

So recently you wrote this manifesto called Omnitheism and
Democracy. *How was this manifesto created and what is omnitheism?*
I coined the term *omnitheism* at the end of the book *The Third
Paradise*, published in 2010. In those pages I wrote, "During a
performance in 1976, I wrote on a wall 'Does God exist? Yes, I
do!' This declaration deconstructs the pyramid structure at the
top of which is set an absolute master, typical of monotheism....
The monotheistic religions have contributed to the hierarchical
and political structuring of the various peoples, among which
monstrous conflicts have then arisen. 'Yes, here I am!' signifies
that everyone is god, and thus there is no longer just one god, as
he is found in all people: the concept of monotheism has been
replaced by that of omnitheism. If my daughter or my nephew
were to ask me 'Does God exist?' I would answer 'Yes, you do!'"
The manifesto started with that passage and developed it fur-
ther. The word *omnitheism* presents a completely new notion, an
alternative to the message conveyed by the term *monotheism*. Its
underlying sense is that of the breakdown of the idea of a single
and absolute god into the multiplicity of human beings. It is
clear that I am taking the mirror as my intellectual guide here.
It shows us the image of what exists directly and has no limits
of space or time, as it acts always and everywhere, incessantly, in

front of the material. The *Breaking of the Mirror*, a performance staged at the Yokohama Triennale in 2008, at the Alexandria Biennale in Egypt in the same year, and again the following year at the Venice Biennale, highlights the process of identification between mirror and human society. By shattering the mirror you obtain innumerable fragments, with different shapes but an identical capacity for reflection: each of these has the same property as the unbroken mirror. Just as each section of mirror has the ability to reflect, each human being has the capacity to think, using his or her brain reflectively. The broken pieces of mirror, sending the light back and forth, produce reflections of one another, in a similar fashion to what happens in the relationship between people's minds. The idea of god is generated through reflective exercise of the mind, but the divine remains a reflection that is an end in itself as it lacks a substantial element to mirror. What we are certain about, with regard to the concept of the divine, is the human capacity to reflect, a term that links mirroring to thinking. So god remains a purely mental exercise. Over time what I call "theism" formed, and many different religions developed around it. Omnitheism could be seen as a revival of pantheism, but this interpretation would be inaccurate. There is a substantial difference and it needs to be pointed out. Pantheism asserts that God is everything and everything is God. For omnitheism this remains a supposition, albeit a credible one. Certainty lies instead in the human mind's capacity to reflect and work things through, which has as its limit the proof of what it asserts. The same thing should be said with regard to monotheism. Omnitheism neither denies nor affirms the existence of a unique and absolute creator god; it simply limits the divine to the capacity of the person to understand and assigns to him the responsibility for every one of his acts. This individual responsibility, reverberating in society, becomes shared responsibility. Some religions reject the possibility of representing God with any image, but the fact remains that its essence is conceived by the human mind and it is therefore an idea that implies a hypothetical reality. The Roman Catholic religion uses

human figures to represent divinity, but they are integrated into the concept of a supreme being, as with the figure of Christ, or venerated as beings with supernatural powers in that they are able to work miracles, like the Madonna and the saints. The gold of Byzantine icons assimilates all these figures into the luminous reverberation of transcendence. As I said before, by turning the gold into a mirror I have put all human figures in their true place, here on earth, with everything that this iconic change entails. In a small mirror painting that I made for the Italian Ministry of Cultural Heritage and Activities a hand appears that points a finger, as in Michelangelo's fresco on the ceiling of the Sistine Chapel. In my work, however, the finger points to its own reflection in the mirror. My work responds to Michelangelo's with a question: did God create *homo*, or did *homo* create God?

What is the role of art in the creation of omnitheism?
In the manifesto I wrote, "For me any reference to spiritual sensibility is the subject of art," and added, "Advances in modern and contemporary art allow us to define as spiritual a dynamics of research that brings together freedom and responsibility. Spirituality pervades human sensibilities, and is expressed by following our rational and emotional capacities, which are combined to produce effects that are always different. Art is able to pick up and express the broad range of variations essential to spirituality." After the many "isms" that characterized twentieth-century art, omnitheism can be understood as an artistic movement that is not confined solely to the introspection of art, but reaches out actively into the whole fabric of society. Modern art has taken spirituality out of dogma. I think of art as a spiritual source, with all the consequences that derive from it on the practical plane of ordinary life. Omnitheism offers everyone the possibility to exercise to some degree the same autonomy, the same freedom and responsibility, as was acquired by the artist over the course of the modern avant-garde eras.

What is the relationship between omnitheism and democracy?
It could be said that omnitheism arises from the need to create
a true democracy, spread all over the world. It is my convic-
tion that democracy cannot coexist with monotheistic dogma.
Monotheism is rooted in the concept of the absolute, of a single,
impending, vertical, and pyramidal power. Dictatorships are
founded on the same absolute ideal on which monotheism is
founded. It might seem that this phenomenon concerns only
the great monotheistic religions, but in reality monotheism is
also found in cultures characterized by other religious tradi-
tions. Indeed, in these areas a political leader becomes the god
of the nation, a one and only deity like a pharaoh or an emperor.
The other forms of divinity become a populist expression of
this one god, useful for obtaining consensus and legitimizing
absolutist power. Democracy, on the other hand, is conceived
as an interconnection between people, in other words, in the
horizontal sense of relativity: just as we encounter it in the
phenomenological vision of reality within the mirror painting.
Omnitheism does not acquiesce to the kind of spirituality that
asserts and exerts its absolute power over the world, but entrusts
to each person the power of his or her own freedom and
responsibility. These are the properties of omnitheism, essential
and indispensable to bringing about sharing, participation,
and exchange—absolutely required factors in the realization of
true democracy.

What do you mean by the "theorem of trinamics"?
Trinamics is the dynamics of the number three. It is a combina-
tion of two units that gives rise to a third new and distinct unit.
In trinamics, three is always a birth that takes place through
the chance or intentional combination of two agents. Male and
female, for example, are two elements that when connected cre-
ate a third that did not previously exist. It is the dynamics of
creation. Out of the connection of the two elements of freedom
and responsibility an unprecedented social structure is created.
The theorem of trinamics helps us understand how a new con-
cept of society is born from the conjunction of omnitheism and

democracy. The symbol of the *Third Paradise*, formed of three circles, also becomes the symbol of trinamics. In fact all opposing or simply different terms, such as nature and artifice, can be represented by the two outer circles, while the central circle represents the birth of the third element, which did not exist prior to their connection. I'm interested in observing and tracking the phenomenology of trinamics in order to understand how it is possible to create a balance between the differences, conflicts, and clashes that undermine society in our time.

In a nutshell what is your message? What are your concerns? And what are your answers?
I start with the *Mirror Paintings*, which connect the fixity and immobility of photographed images with the incessant movement and mutation of reflected images. This work takes the form of a mediation between different factors and an indication of a combinatorial phenomenology that can be seen as a universal dimension. It is the law of continual creation that I've called "trinamics." So art takes on the active role of connector between the different components of the social fabric, in the first place those of spirituality and politics. These have been the cornerstone of the social structure since the very beginning and in the present moment are assuming connotations capable of bringing about a new conception of society. Spirituality and politics translate into omnitheism and democracy. In the trinamic sense, I unite these two terms to give rise to the third element, to the third stage of human history. Growth and decrease, war and peace, amalgamation and sharing, making money and providing services for free are some of the innumerable factors that are waiting to be connected in order to produce socially redeeming effects. As you can see, my message is constructive. As a practical matter, I've set up Cittadellarte, a workshop for the responsible transformation of society. In this workshop, two artistically fundamental elements are united: form and content, in other words aesthetics and ethics, in turn made up of emotion and reason, which have to find an equilibrium in a spiritual as well as political sense. They are all components that,

like the colors on a painter's palette, have to be mixed well and transferred with sensitivity and skill onto the canvas to achieve a perfect composition. Cittadellarte is not the work of a single creator. The work is the product of many creators, of everyone. Personally, I try to offer people the means they need to participate in the realization of great work branded with the trinamic symbol of the *Third Paradise*.

But what is the art? Who is the artist?
In the statement I made in 1964 with the *Plexiglas* text, I made it clear that the passage from non-art to art occurs through an initiatory medium, which in that case was Plexiglas, intellectually defined by the term *concept*. In any sphere of social life initiation is a conceptual ritual that marks the passage from one state to another, practically from a no to a yes. With the *Minus Objects* of 1965 to 1966 I brought about the transformation of no into yes through the pure act of creation. Something that was not there, but was possible, became real. Creation, therefore, as transition from nonbeing to being. In any nonartistic sphere, initiation is a well-defined ritual that leads into a predetermined and closed mental and practical realm, such as that of a religion. Artistic creation does not bring either the mind or the body into a defined or circumscribed territory but into an uncontainable open space-time. The art of the past adhered to the forms of religious, political, and popular initiation. Entering the twentieth century, however, it has gone down the road of self-identification, arriving at its essence. With the *Plexiglas* work and the *Minus Objects* I joined together two points of art that I consider essential: the conceptual rule and the unbounded freedom and mobility of the creative act.

For a long time the two concepts of art and beauty went hand in hand. Yes, of course, but beauty isn't absolute, either; it's relative. Picasso showed us that a woman with two eyes on the same cheek can, in art, be as beautiful as the *Mona Lisa*. I think that the classical concept of beauty is linked to the feelings stirred directly by nature. Sex has a primary role in this because it stimulates the pleasure

hormones, including visually. In the classical era, in fact, great prominence was given to this sense of enjoyment, while in the Romantic era beauty became more ascetic and abstract. Perhaps Picasso can be called a Romantic of modern art.

Rome, for example, is an absolute masterpiece because it is beauty and ugliness together. It's a layered city that never stops. Like Florence. The difference between these two cities is enormous. The former has the fascination of historical stratification, the second lives off the fame of a Renaissance that created the modern world. Here are two cities that show how much the idea of beauty is relative.

What is strange is that if you're in Piazza Navona and look at all the masterpieces around you, from Bernini to Borromini, you are immersed in such beauty that it can make you feel unwell. And then, if in the midst of these marvels you see ugly things, too, people walking though the square indifferent to its beauty because they are caught up in their everyday thoughts and their problems, that for me is what makes it a complete, living work of art, because everything is there.
Yes, art can make you feel unwell, but only if you understand it. Not everybody who goes to Rome is able to distinguish one stone from another, one window from another, one door from another, one piece of wrought iron from another. The majority of the people who go to Rome look at things as if their beauty was taken for granted. If I walk around this city I do nothing but rejoice, because I understand exactly what is passing before my eyes. For me it's like seeing Rome at the time of the ancient Romans and simultaneously the way it was in the Middle Ages and then in the eighteenth and nineteenth centuries. I'd rather not comment on the twentieth century. The fact remains that art has its periods, its styles, its traditions, its innovation. With the *Venus of the Rags*, I put classical beauty and its opposite together.

In all these projects, from the Third Paradise *to the* University of Ideas, *which are all realities—Gianna Nannini has had a daughter, your university has students, your mirrors are in the museums and in addition*

*still have a market and therefore exist, and if a lot of them sell the uni-
versity will be able to function better—there is a system. You may be a
peaceful and tranquil man, but art is by virtue of necessity a body blow.*
No, it is not necessarily a body blow. It can also be balm for
the mind.

*Today, August 1, 2012, would you like to do something new and forceful
to draw the line with what is going on?*
It's what I want to do with you. Perhaps it can be done with this
book, too.

*We can't put everything in the book. We haven't told the whole story, but
we have talked about the complexity of a life that ranges from its roots
in specific territory, to the family, to the historic events that have marked
it, to growth, love, work, to the randomness of things, to how chance
can instead be constructive, and a thousand other things. Having
said that, perhaps this book, which could itself be an artwork precisely
because of its precision and imprecision, because it is neither a book on
art nor a biography, can become a third work that is neither yourself
nor your work, but what it has to say.*
When you speak of art as a body blow, my reaction is that there
is no need to be deliberately aggressive. We shouldn't get caught
up in the conflict, but should try to create principles that bring
about change.

*But if, for example, I put one of your works in a public park, aren't
I doing something that will change the lives of the people who go to
the park?*
I'm not interested in that kind of monumental art. In the
past those works recounted facts that were considered socially
symbolic. Almost all modern monuments are purely formal
expressions. What interests me is for the work to bring about
change; otherwise it can turn back into a political or religious
symbol, or be reduced to nothing but an aesthetic exercise.
I've been asked to allow the symbol of the *Third Paradise* to be
used as a commercial trademark, but I said no. The symbol of
the *Third Paradise* is not a brand—it's a symbol of change and

transformation. It's a symbolic tool that can be used by anyone who in one way or another wants to take on new responsibility. So it can be an inspiration for work that on December 21, 2012, the date of *Rebirth Day,* unites the world.

What is Rebirth Day?
The process of preparation for *Rebirth Day,* December 21, 2012, the first universal day of rebirth, began in March 2012. From the end to the beginning. The announcement made by Cittadellarte read, "December 21, the winter solstice in the northern hemisphere and the summer solstice in the southern one, is a date that has been celebrated by mankind since time immemorial. A fateful 'end of the world' connotation, as widespread as it is unfounded, has been attributed to this day in 2012, proposing a theme that is recurrent in mythologies and religions as well as in the literature of fantasy and science fiction. All imaginative factors aside, this date can take on a symbolic meaning, as it effectively corresponds to a climactic phase of human history....The whole of human society is now in the reckoning and so must face a historic transition, a complete change....A new perspective opens up that involves everyone, without exception, in the daily effort to implement the process of rebirth—each according to his or her abilities and possibilities. On December 21, 2012, let us meet in streets and squares all over the world, and on the Web, to take part in the great inaugural celebration of the Third Paradise....Let's participate, on this day, with whatever form of expression we choose (performance, music, sound, installations, images…) in a great common artwork." So, everyone united in a global work of art to revive the ancient holiday and invest it with a new significance projected into the future. In fact, *Rebirth Day* will be marked on that day for years to come all over the world. On December 21 of each year, anyone who wants to can celebrate the festival of rebirth and everyone will be able to see whether change is really happening. Joyfully taking part in this celebration signifies accepting personal and collective responsibility for the transformation of worldwide society.

Facing page:
At 7:00 p.m. on December 20, M.P. was in Rome to celebrate *Rebirth Day* with the president of Italy, Giorgio Napolitano; at 5:00 p.m. the next day he was in Brussels to celebrate *Rebirth Day* with the president of the European Commission José Manuel Barroso; at 8:00 p.m. the same day he was in Paris, at the Louvre for the performance *Third Paradise-Rebirth Day.* Manuel Barroso seated next to M.P. at the celebration of *Rebirth Day.* Left, Paul Dujardin, director of BOZAR, the Palais des Beaux-Arts in Brussels, and Inês Sérvulo Correia, and right, Jan De Cock. BOZAR, Brussels.

Giorgio Napolitano, and M.P. on December 20, 2012. Opening of *Third Paradise* and celebration of *Rebirth Day.* Baths of Caracalla, Rome.

*Third Paradise-
Rebirth Day.* Musée
du Louvre, Paris,
December 21, 2012.
Courtesy of the
Musée du Louvre.

I have a feeling we're not close to that point right now.
Personally I'm hopeful, because shared consciousness is growing
and in recent years a change for the better has been taking place,
even though there are still truly enormous reasons for concern.

*Let's hope that the new world born on December 21, 2012, is better than
this one.*
You should never think it's not worth doing something con-
structive because it may turn out to not be of any use. It's worth
a try, and just doing it makes you feel better.

*Seeing that you're a famous artist, shouldn't you write something like "I
hate civil war"? Even if "hate" is a word that doesn't fit with your way
of thinking?*
But if I write "I hate civil war," then people will ask me, "Then
what should we do?" I have to find a way to answer the question
not so much in words, but by doing something. I'm for love,
not hate.

*Rebirth Day, SUSA
(Sentiero Umano
di Solidarietà
Ambientale e
Artistica), 58
kilometers from
Turin to Susa, Italy
(starting from
Palazzo Madama in
Turin). 12:21 p.m. on
December 21, 2012.*

That was just an example, a way of saying that preaching peace doesn't get you anywhere.
That's right. If you don't work in the field, if you don't do something to bring about change, change won't happen. It's a question of rebuilding piece by piece, starting with that delicate part of the human mind that is spiritual sensitivity.

What is spiritual sensitivity?
It's what art can bring beyond religious instruction, which atrophies the intellectual capacity and autonomous responsibility of human beings throughout their lives.

Are you saying the Ten Commandments are outdated?
No, they just have the drawback of being negative, rather than acting in a constructive sense. Instead of going on issuing commandments, it's time to teach people how to think and to assume personal as well as collective responsibility.

Then do you think the Ten Commandments need to be rewritten?
They exist and they're certainly of value, as they tell people not to kill, for example. But then you need to explain to me why they go on killing. What is needed is to stand in front of the mirror and realize that if you do harm to someone you are doing it to yourself. I often say, "If someone kills someone else somewhere in the world, I'm the one who is doing the killing. If someone does something good for someone else somewhere in the world, I'm the one who is doing something good for that person." I'm responsible, everyone is responsible, not someone else. We are responsible, because we face ourselves in the mirror.

You often use the word responsibility. *What do you feel responsible for?*
I'm responsible for you and you're responsible for me. Let's get down to the basics: why do we look for God? Because we need the other; one person by himself or herself can't do it. We are all looking for the other. Knowing that I need you, though, you can manipulate the relationship in such a way that I become increasingly dependent on your will and on your power. That's why there

are laws and prisons. Normally, however, someone who has power
over others tries to use it without ending up in jail. It is time for
the relationship to be made reciprocal: I'm an authority for you
and you are an authority for me. We are mutual guarantors of the
part that the other looks for in us. Reciprocity and sharing start
from the capacity to guarantee that no one has to go and look for
the other person so far away that all sorts of opportunism and
abuse are able to slip into the gap between the two individuals. If
the other is God, the distance is infinite, and too many people and
too much potential for fraud come between one and the other.

Do you think that's a typically Italian attitude?
It's an attitude typical of religions, above all the monotheistic
ones, in which the other is one and the same for all. The other is
not you, but who knows who and who knows where?

The church says we are all equal and meritocracy doesn't exist.
I don't know what the church means by meritocracy.
Meritocracy is fundamental for Protestants, for example. You
can do anything you want so long as you obtain the best result.
This is your personal merit, and the other can be exploited any
way you like. Then if God is substituted for meritocracy, what
you get is general submission.

Not everyone is capable of doing what you've done: throwing away suc-
cess to try to achieve it in a different way.
It's not like that, I go from one success to another because I
work. It's necessary to say these things to people. It's necessary to
communicate, to teach, as I'm doing with the University of Ideas.
The young need to be taught to become involved with society
through art. Mine is a school of spirituality and democracy.

There are periods within the Mirror Paintings. *You don't just put the*
portrait, groups, or the hangman's noose in the mirror. You put a politi-
cal message in the mirror. For you, the mirror is a mode of expression,
as the cut was for Fontana, as squares were for Mondrian, and so on.
But unlike them, you illustrate time as a witness. You don't read, but

to some extent you use the methodology of the photographer and the writer, which is that of bearing witness to your own time.
They bear witness to various moments in my life. The *Mirror Paintings* follow events as they occur, and the same events are fixed in the mirror, which is an ongoing record of existence. In a way the *Mirror Paintings* are my diary. I think that, for example, you could use them to make a micro-museum of history and customs from 1960 to today. Even though the two people in *Adamo ed Eva* (Adam and Eve) are naked, it's obvious that they're from the 1970s because of the way her hair is styled. It's hard to avoid the characteristics of the time.

I have the impression that today you're more interested in looking at the world than at art.
Art is the primary means of seeing the world and acting in it.

But perhaps you've practiced so much art that you've gone beyond it.
No. It seems like that because I don't talk about the things artists normally talk about: success, their sales, rivalries with other artists. My principle is to identify with what exists, but it starts from art and goes back to art.

Humanity is at the center of all your work. At the moment you're focusing on political and religious issues, even in terms of words—not so much the written word as the spoken one.
I'm interested in the relationship between my thought and that of others through the mediation of the word: while I think I talk and while I talk I think.

So it could be said that you are now in a phase of your life in which you're seeking an alternative philosophy to the current situation.
I feel a great need to take responsibility. I always say that if art doesn't change society, society changes art. The exponents of Action Painting were not working to make money, but then it was the economy that absorbed the phenomenon. The total freedom of the artist was very useful to represent capitalist laissez-faire, even if originally this art form was not intended to

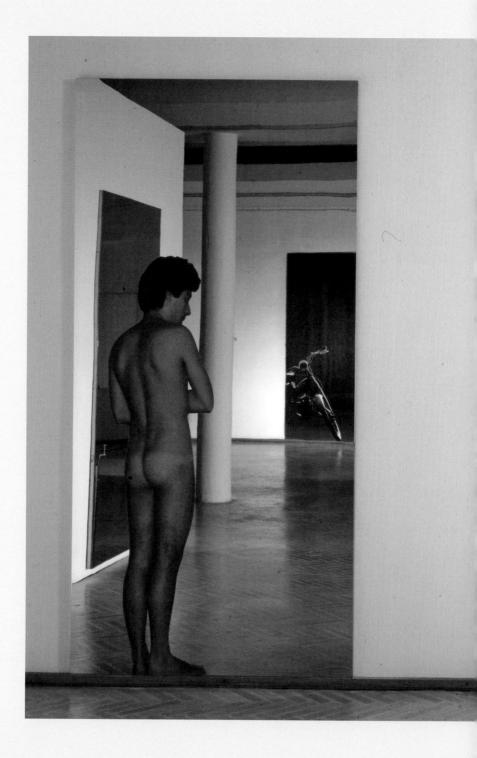

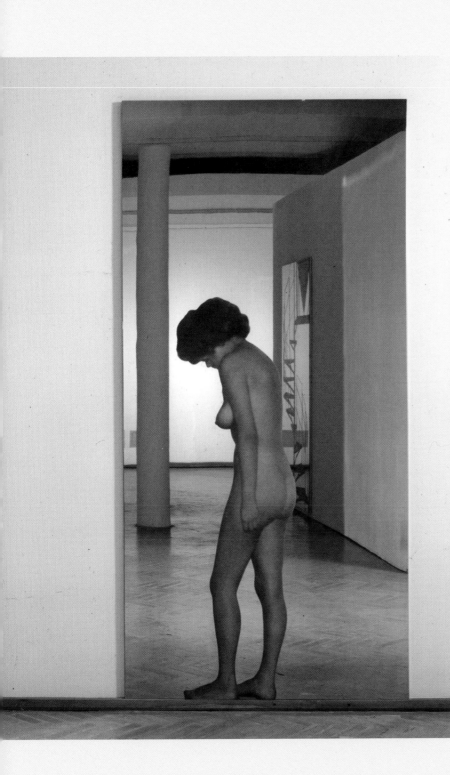

Adam and Eve,
1962–87. Silk screen
on stainless steel
polished to a mirror
finish, two panels,
230 x 125 cm each.

represent capitalism but itself. So it did not change society, but was changed by it.

Does your work play down the existential crisis of depression?
Take Yves Klein's *Leap into the Void*: it could be described as an example of the existential drama in which artists were living before the 1960s. There was still a link with the Renaissance type of space and they looked at the world through the window. The only way Yves Klein could imagine entering a new space was to jump out of the window. In my mirror painting, on the other hand, the space opens onto the ground floor, so it's a door and no longer a window. As a result the existential tension of that period is totally defused. Opening a door does not mean falling tragically into the void.

Setting your ideas aside, your work is in peo-ple's houses, in museums, in parks. Who works alongside you?
As Troisi said, start from three. We don't start from zero, the situation of transformation is under way, even though when I set up Cittadellarte they told me it was pure utopia. For the Bordeaux Biennale of 2011 I invited a number of artists already recognized for their ability to interact with people. Like Jeanne van Heeswijk, STEALTH.unlimited, eXZJt, Marjetica Potrč, Bureau d'études, and Opéra Pagaï. For the sociopolitical content I invited William Kentridge and even a museum, the Van Abbemuseum in Eindhoven. They all interacted actively with the local people, obtaining extraordinary results.

Today you want to be heard, too.
Yes, but that's not all. Starting with *Venus of the Rags*, I've been working a lot on the concept of recycling. The regeneration of waste materials is already happening. I even use plastic, which a

Yves Klein, Harry Shunk, and János Kender, *Leap into the Void*, 1960. Metropolitan Museum of Art, New York.

Alain Juppé, M.P.,
and Frédéric
Mitterrand.
Bordeaux Biennale,
October 6, 2011.

few years ago I was worried about, but I'm less worried now because I know it can be recycled. For example, a few months ago the architect Luca Zevi invited me to create a work in Venice for the Italian pavilion at the Architecture Biennale. He asked me to make a work that would be emblematic, and I created *L'Italia riciclata* (Recycled Italy). I reconstructed Italy out of the things left over from previous editions of the Biennale.

Now your main concern is that the global situation of humanity is unsustainable and something has to be done to bring together the technological world, on which we depend today, and nature. Art, for you, is a sort of demiurge that can be used to integrate politics and religion in a different way.

Yes, it's true: science and technology, instead of distancing us from nature, have to help to reintegrate us into it with new and sophisticated discoveries and means. I love science. I'm interested in knowing, discovering things. But science, if it wants to go on existing, has to ensure the survival of humanity. Without human beings, science is dead. If for no other reason than to save science, humanity must be saved. Even as far as the extreme tensions stemming from religions and politics are concerned, a new type of workshop exists. For example I took part in TED[x] Milano, bringing the *Third Paradise* symbol with me. It was an open international workshop with researchers in every field participating, presenting extraordinary experiences and discoveries that are extremely important for our understanding, on the human and social plane, too.

The image, which for years you saw as the only way of representing humanity, is no longer enough for you today and you prefer to express yourself in words. Is that right?

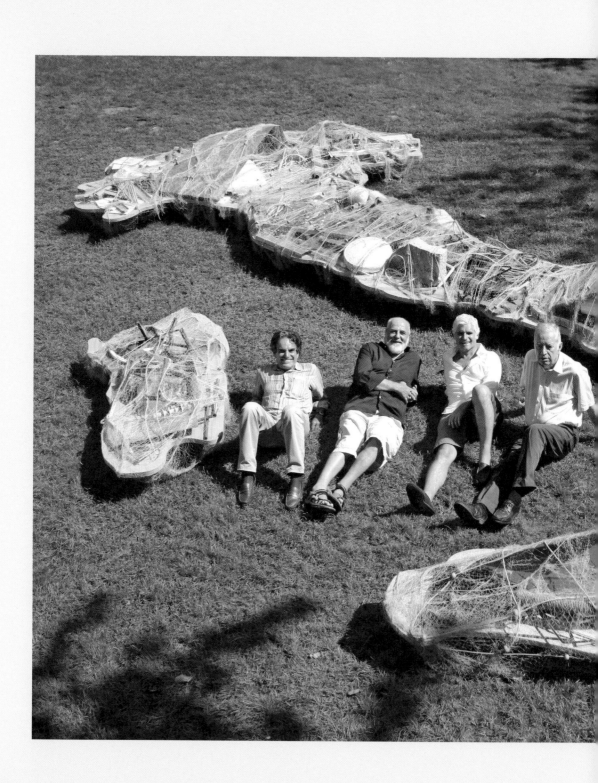

Recycled Italy, 2012.
Salvaged materials,
40 x 793 x 812 cm.
Created for the
13th International
Venice Architecture
Biennale for the
Italian pavilion
curated by Luca
Zevi. In the photo,
from left: Luca Zevi,
M.P., Maurizio
Molini, and Mario
Pieroni.

It's not enough anymore, because we are now living in a world of images, and I don't want to try to compete with today's image system. The word serves to explain what may not be understood from the image. The symbol is an image, too, and needs to be explained verbally to communicate its meaning. Six years ago at Cittadellarte we decided that the visual art show planned for an annual event titled "Art at the Center of a Responsible Transformation of Society" would be an exhibition of books titled *Turning Point Literatures*. We put the books on display as if they were sculptures, each on a white base. They were books written in the last twenty years and engaged in some way with the transformation of society. After making a selection of titles suggested by the public, we put thirty of them on display. I told myself that in order to be as clear as possible about Cittadellarte's intentions and objectives it was necessary to use the word as well as the image and plastic forms. People ask what a picture, a sculpture, an installation means, whereas in a book the meaning is stated directly. Personally, I consider words very important, because I want to communicate things that have to be understood and not just sensed, imagined, or, as happens in the majority of cases, misunderstood.

Browsing through one of your catalogues or looking at your works, one may have the desire to possess one of your works, but the possession of an idea is very different.
You've made an interesting observation. One of my pictures can make you think and you can even buy it, since I'm not in the habit of giving my works away, while an idea can make you think and be communicated free of charge. Personally, I'm much more willing to donate my words than to donate a picture. In my 1994 text "Progetto Arte" (Art Project), the concept on which Cittadellarte is based, I stressed the specific character of the *Mirror Paintings*, which consists in the coexistence of opposite signs: taking this premise as our starting point, the two poles of making a profit and doing things for free have to balance perfectly. In economics, weight should be given not

only to pecuniary advantage, but also to the existential advantage derived from unpaid individual and collective engagement. *Rebirth Day* is a work of voluntary participation on a worldwide scale. Theoretically, each of us has the possibility of being rewarded for the work we do with the appropriate amount of money, but in the meantime we can also do things for free. The profit deriving from these actions can even be greater than the monetary compensation. Everybody, bar none, from the wealthiest to the poorest, can contribute to collective well-being by offering some of his own time to the community free of charge. The return in quality of life is guaranteed. If this is done, the necessary money arrives as a result.

You began with the background, with the icon, with the mirror, with rags, with polyurethane, with various materials, while the material you use now is the word. Paradoxically, the man who doesn't read speaks. Why do you speak today? Because you're more experienced?
Yes. Besides, I started in 1964 by writing the text about the *Plexiglas* work, then in 1966 I wrote some things on the *Minus Objects*, and in 1967 I published a booklet titled *Le ultime parole famose* (Famous Last Words). Since then I've always accompanied my work with text, announcements, and written declarations. As the project of interaction with the social world gained substance, the written and spoken word became an essential means, though not the only one. I don't read books, but I do read the mirror, so I've let the mirror speak. I wouldn't have the confidence I have today on the spiritual plane if I hadn't come to see the world through the mirror.

And photography?
Photography has played an important role in my work, first as a component of the *Mirror Paintings*, then as a means of inquiry: in 1993 the Witte de With museum in Rotterdam and the Fundação de Serralves in Porto published the book *Pistoletto e la fotographia* (Pistoletto and Photography) by Jean-François Chevrier and Jorge Molder.

There's another thing this conversation made clear: you need to put things in order, but you don't like anything that is closed. Closure scares you.

I'm opposed to the closed, monotonous, and absolutist mentality. It's necessary to have references that keep the mind in balance, but they cannot be regarded as fixed and immutable, as they depend on the conditions in place at different times and in different environments. My sense of order is flexible because it is renewed in relation to the circumstances. Order is like beauty. Order and beauty coexist in classical Greek, Roman, and Renaissance forms, but order and beauty can be found, as I said before, even in the disjointed and discordant forms of Picasso, to speak of an artist who exemplifies modernity. In any case, I'm referring to precise positions of mental order; unrestrained freedom creates states of senseless reality. I feel the need to give sense to things, and so to balance freedom with responsibility.

Proof of the imperfection of life, and at the same time its perfection, is that we know we are going to die but when we die it's still imperfect.

Perhaps for animals death is not an imperfection, because they do not have a system of memory like ours. We instead live the memory of ourselves instant by instant. We are terrified by the idea of losing the memory of our existence, but that's the only thing we really lose when we die.

What about melancholy, malaise, happiness?

They are beautiful and ugly, pleasant and unpleasant feelings, but they are always sensations that can be handled with reason, that create awareness. I've never vented my feelings through my work, and this has helped me refine them. It's a quest for an underlying rationality.

Art is very important in today's world, but it really has no utilitarian purpose. You can live without a picture, but you can't live without water or bread.

Knowing how to make bread is an art, too, but we are living at a time when there is a shortage in the world of the water needed

for life and many people do not have enough bread to eat. These, too, are problems that I pose for myself as an artist.

There's a lot of talk about culture, but I don't know if culture and art are the same thing.
Art can be seen as a specific activity or as knowing how to do things, as in the saying "doing things artfully." In both cases it is culture. In the latter, though, art is integrated into every other human activity. Personally I'm engaged in a third way of doing art, intervening directly in various sectors of the social fabric to introduce a new culture into them.

Culture is knowledge. That's what Dante has Ulysses say: "Consider well the seed that gave you birth: you were not made to live as brutes, but to follow virtue and knowledge." What is interesting about modern art is that art has become popular, even though some works have astronomical prices.
This can be positive—I mean fostering familiarity with modern and contemporary art.

Once everyone could see Caravaggio's paintings in the churches, but they had a religious implication, while today art is no longer a prerogative of religion or the wealthy prince, so the artist's role is different.
The separation between the religious or aristocratic client took place some time ago. Today, there is a way of doing art slowly emerging that is not tightly bound to the market. The visible Award set up by Cittadellarte-Fondazione Zegna is in fact intended to encourage artists who take art out of its self-referentiality and the traditional socioeconomic system.

The fact that art is also a market in my view is not a bad thing, as life itself is a market.
There are markets and there are markets. One Cittadellarte motto says, "Every product assumes social responsibility." And to that I'd add: whether it wants to or not. Art is also a product that assumes social responsibility. Art, in particular, should be considered a guide to ethics as well as to aesthetics. The artist

ought not to be thinking solely about selling his work on the market, but about acting on the market itself to take it toward a new ethical status. The artist's work cannot be considered totally detached from what goes on around it. Art today, even when it's abstract, runs the risk of becoming a mere representation of the systems of power. Damien Hirst, the artist we talked about earlier, has decided to go along with the system of financial speculation, going so far as to match speculation on the stock market through auctions. If he had done it as a denunciation I'd have found it brilliant, but I don't think he saw it that way. It seems that his goal was the glamour of success. "The richer you are the better you are" is the usual yardstick. I don't seek wealth in money, but in what good I can do for humanity with money. And I believe that artistic engagement can do a great deal in this sense. Cittadellarte has a stock of work that it can sell to raise the money it needs to survive. Obviously this means relying on the market and the overall economic trend. There's nothing that can be done about this, except making the wisest choices possible. Other sources of income are support from the region and specific projects. With these funds, Cittadellarte carries out activities that produce an appreciable cultural and functional surplus value, injected directly into the context of society. The market functions for the work, but not for the responsible trans-formation of society to which Cittadellarte is totally committed. The objective is to mold young people capable not only of pro-testing but also of proposing, and who in addition to organizing revolts learn to govern democratically. I want to tell you about a work I did to explain the concept of power with respect to the democratic method. It's a photographic work titled *La Conferenza* (The Lecture). Twenty people are seated in front of a speaker, and both he and every member of the audience have cameras. The audience photographs the lecturer and at the same time the lecturer photographs the audience. So we have the picture of the speaker taken twenty times, while the entire audience appe-ars in a single picture, the one taken by the lecturer. The entire audience is focused on the person of the speaker, while the person of the speaker is multiplied by the number of people in

the audience. This is power. I did another work in which many people take pictures of each other, in such a way as to include everyone present. This is the democratic method.

Is this idea of democracy a recent one or have you always had it?
It's an idea that came to me from the *Mirror Paintings*. When I realized that in the reflected image of life everything happened as a consequence of relativity, I understood that that was a truth that had to be interpreted not just on the intellectual level but also on a social and political one. First of all, however, I connected the message of the mirror to religious practice founded on the concept of the absolute. I'm talking about the monotheistic religions, naturally. With regard to both politics and religion, I realized that the mirror was a reliable guide and that for both, religion and politics, the principle of relativity held true. Besides, democracy is founded on the premise that absolutist positions are basically contrary to its nature. But the monotheistic religions, basing themselves on the absolute, are absolutist. Religions are not removed from politics; on the contrary, they influence and direct it. The success of democracy inevitably depends on the religious mentality. Monotheism is fundamentally in conflict with democratic thinking and makes its practical application difficult. With the manifesto *Omnitheism and Democracy*, which I am in the process of making public, I'm proposing a shared path for spirituality and politics where democracy can develop in the place of absolutism.

You affirmed the importance of art when you said that Castelli arranged for the United States to win the top prize at the Venice Biennale because up until that moment the American empire had not yet been anointed. So art has enormous power. For example, I don't think Pope Julius II would have been so famous if it hadn't been for Michelangelo, whereas Michelangelo would have been somebody even without Pope Julius II.
I believe art has immense power, as it is the basis of what makes us human and today can guide the future of humanity itself, but it can and must do this by interacting with social, political,

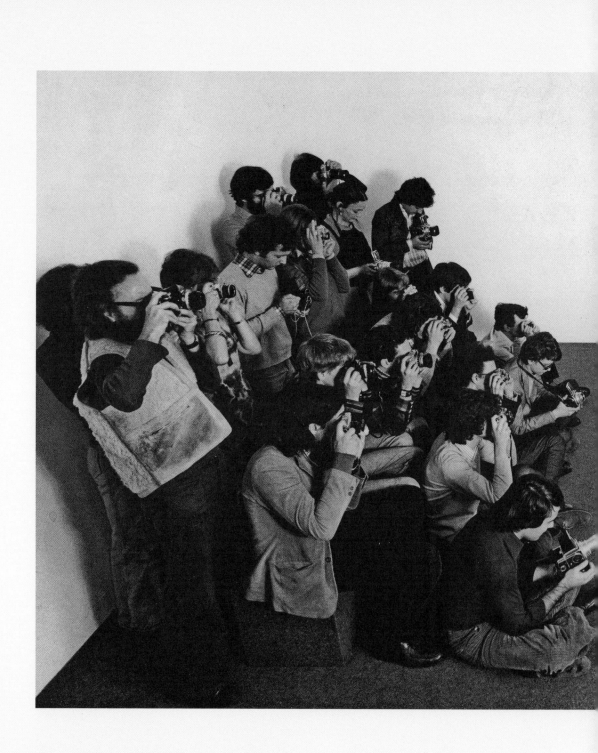

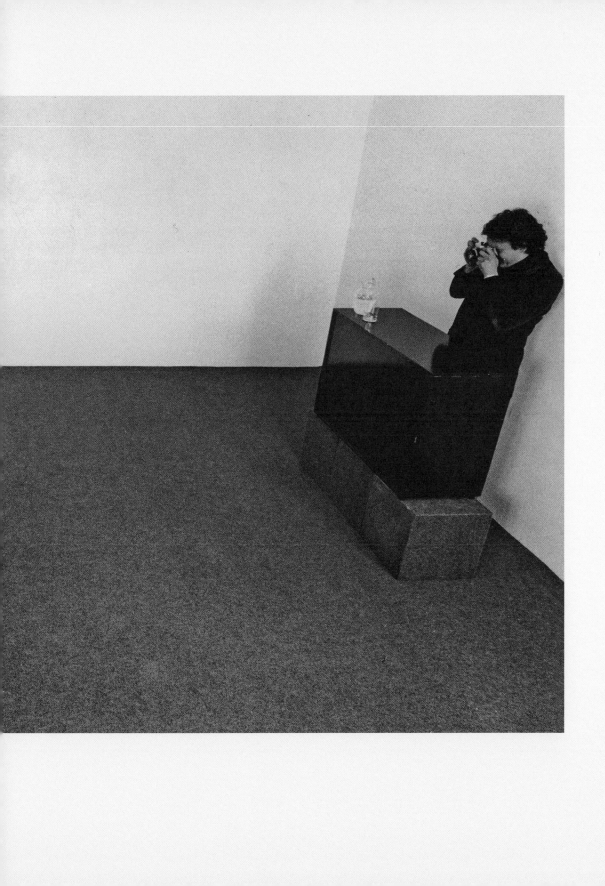

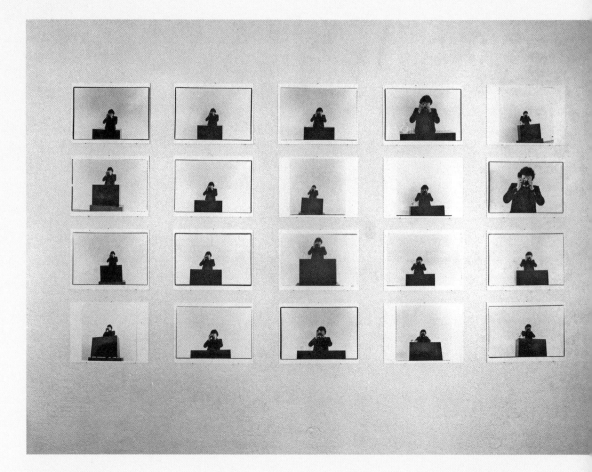

Preceding pages:
The Lecture,
photograph of the
action performed
at the Galleria
Christian Stein.
Turin, 1975.

The Lecture, 1975.
Photograph on
paper, twenty-one
elements, 30 x 40
cm each.

economic, and religious systems. As you see, it's not just a question of getting a pope to accept the nude figure, but of bringing about fairly major changes through art.

So art is necessary and is a form of peace because it travels, it's international. You're Piedmontese, but your works are all over the world and pass from hand to hand.
That's what happens.

Do you think like a farmer?
As a boy I was a farmworker for a while, during the war, and I learned many things in that short time. I learned to sow, to harvest, to irrigate, to fertilize, to prune and graft trees, to look after animals. The positive side of that terrifying time during the war was in fact that it gave me a chance to get really close to nature, to the true sense of the seasons, not just as a platonic observer, but also as an active participant. These things are still of use to me today. As is what I learned from my grandfather through my father—the significance of natural recycling.

I've always been struck by the fact that a successful artist has great power, because his work has great economic value. At the risk of sounding crass, some artists basically print their own money. As soon as you are able to pay for a meal by doing a drawing, it's as if your drawing were money. That gives you enormous power. It's true, though, that without the other's desire the exchange wouldn't take place.
Let's take the exchange that often takes place between the owner of a restaurant and an artist with no money. Between the two there is an exchange of desires, meaning appetites. The artist has a physical appetite; the man running the restaurant has a mental appetite. This is an example of how art functions in the broader dimensions of society. It's but a short step from need to desire, from physical need to intellectual desire. The artist desires something he doesn't have and obtains it through his act. In a sense the artist is a magician, because what he does looks like magic. Desire is like a magic spell—it's a phenomenon that the artist creates and stokes, but it's also the cause of financial

speculation. Desire is one of the main factors in human history. For the animal it's limited to the need for sustenance, while for human beings desire goes well beyond sustenance. There are two aspects to the economy: the most straightforward one, linked to simple necessity, and the one raised to the level of surplus. Simple economics is based on the principle of barter, complex economics responds to needs triggered and sustained by the feeling of desire. However, to understand where we stand today with economics, we should start with barter.

Let's go back to the example I gave before. Artists have often bartered their pictures for meals. Many of the world's restaurants are full of bartered pictures.
Exactly. Bohemian artists, for instance, live on barter. This system of exchange is as primitive as it is fundamental. I produce different things than you produce. I give you my product and in exchange you give me one of your products. It's inconvenient to trade objects directly, if for no other reason than it's difficult to carry them around. An easy means has been found to exchange many different kinds of articles and even time spent working, quantifying the goods conveyed numerically: money. A single, light, and handy medium. A unit that can be added up, subtracted, multiplied, and divided. But money has no fixed rules for the determination of value. In fact, the values assigned to objects and working time vary according to the circumstances. As a result, vast sums of money have been accumulated in the world in the face of immense poverty. The terms *rich* and *poor* are used for these opposites: on the one hand money has facilitated relations between people, and on the other it has made them very difficult. Time banks have been around for a few decades now, providing a service very similar to that of barter, in opposition to the monstrous financial speculation that has spread around the world. The economic office of Cittadellarte, run by Francesco Bernabei, has developed the theory of the "right to consumption" (not in the sense of consumerism), which proposes an even distribution of economic resources based on the basic needs of each person. But laying

down rules of equity by establishing the values of the things
in advance is almost impossible, especially in the current free
market system. Hypothetically, if product values were regulated,
the first offer of money driven by desire would undermine all
the rules. Art is said to have no price, precisely because its value
depends on desire and not on practical necessity. That is the
main reason those rules get broken. Paradoxically, art, preci-
sely as a result of having attained its maximum autonomy in
the twentieth century, has become the chief symbol of desire:
because of its total freedom, it represents the most tempting
conquest for those who have economic power. Art has become
so distant from practical life that it represents the highest of
all surplus values. With my work I try to bring art closer to the
practices of ordinary life, freeing its autonomy from subjection
to any power.

Desire is very important. It's the driving force of the world.
All the activities carried out under the sign of the *Third Paradise*
are aimed at sustainable progress in every area of the social
fabric. This artistic message is intended as a guide toward a new
direction of desire. The *Third Paradise* leads to a recognition of
glamour and luxury in responsible freedom and humanistic
aesthetics. The art of the *Third Paradise* drives toward new forms
of prestige and pride, no longer related to the perverse game
of the all-out exploitation of every human and environmental
resource. The avant-garde is no longer the unbridled freedom
that is so attractive to gamblers in the financial system, where
the life of humanity is at stake, but the expression of an indi-
vidual as well as interpersonal responsibility. Desire has to be
brought back to the basic needs of life again. It can be shared
if we recognize it in others, as well as in ourselves. Sharing
increases satisfaction, not the opposite, as many think. People
talk about "buying locally" and "short supply chains" where
consumer products are concerned, but the same ideas can be
applied to spiritual and social relations between people. Great
cultural, economic, and political movements can be formed
through cellular germination. Cell division can be translated in

social terms as "shared multiplication." So a social organism can be created that is structured in accordance with nature. The surplus value of art becomes a value of life, if desire identifies with the project of responsible transformation of society.

What is your desire? As far as I can tell it's not a desire for possession.
My desire is precisely to lead art to transform itself by transforming society.

What do you want to happen to your art?
My pictures are principles. Made available to the public through exhibitions, collections, museums, literature, and criticism, they can make ever clearer the meaning of the activities that I've developed in an interactive way on the social plane.

One of the sections of The Third Paradise, *the one on desire, refers to the overall desire illustrated by the* Third Paradise. *It joins the two extremes to create a more balanced world. So desire cannot be curbed, but it can be controlled.*
Yes, there is more than one kind of desire. Desire can become marvelously different from what has gotten us to this point.

There is a need in the human being to be an artist, ever since the most ancient times.
The first thing a child does is pick up a piece of paper and markers.

But not everyone can be an artist.
I drew my Art Sign and at the same time I offered to let anyone who wanted take part in some of the exhibits I staged, including some on the Internet, with Art Signs of their own—symbols, personal marks anyone could create. A lot of drawings were sent in, proving that an individual sign can be a key that opens the door to art for everyone.

Is a work of art's price determined by desire?
That's right. Desire comes into play—desire for things that

are not strictly necessary. It wasn't a desire to buy work that persuaded all the people who took part in the *Art Sign* exhibition to do so, but a desire to be involved in art.

Does Arte Povera have economic value?
Boetti was the exponent of Arte Povera who produced the largest number of two-dimensional works, pictures and tapestries that could be hung on a wall. This set him up for economic success, because people prefer work that can be hung on the walls in their homes and collections.

Before you were talking about moments in the life of an artist. Have there been times when the value of your work has changed?
Of course, there's always fluctuation. Desire is not a static phenomenon. In some cases it's a bit like movement on the stock market.

On the one hand there's the desire to create art, and on the other the critics, the market, and history see to it that some of those who do create art really become artists. The product of an artist is a product of the market and culture: unless it becomes a symbol, an absolute icon like the Mona Lisa, *it can lose its market value. Then there is this absurd phenomenon of people going straight to the* Mona Lisa *in the Louvre without looking at all the other masterpieces in the museum. The same is true for many other museums, like the Vatican Museums, where everyone rushes to see Michelangelo, barely glancing at Raphael's rooms as they rush past.*
People's desires are directed to a great extent. A guidebook is similar to a religious guide. In my view, this shows that artistic desire and spiritual desire coexist and coincide, but lend themselves to very varied speculation. That's how the markets of art and faith do their business.

There are three phases: an artist's work is very expensive and museums and collectors buy his work because they must have it; then it becomes too expensive and museums can no longer afford it; and finally the artist becomes iconic and his work is priceless.

Before we were saying that an artist's fame has its ups and downs. There is a bear market for art that is, I believe, unintentional, which makes it possible to buy a work in the hope that its value is going to go up. But there are also people who want to pay the maximum price, as a mark of prestige and power.

For example, as a young man the British art historian Denis Mahon collected the work of Guercino, which was then sold at auction in England before the war at very low prices. Today, a Guercino has a very different value. Have you ever bought back any of your work?
A few times, when I was particularly fond of the work. For a while my work was not going up in value. The prices were fairly low, but all it took was for some gallery owner to buy work from my early years on the market and show it and all my work would go up in price.

Desire is a very powerful motive.
Yes, and it can be contagious: there are epidemics of artistic desire. There is also a lot of emulation.

There comes a time when much desired works of art, like Leonardo da Vinci's Mona Lisa *or Botticelli's* Primavera, *do not even have a price, they don't have a market.*
Desire takes the purchase price to dizzying heights and the rise can be unstoppable, like ambition for power. Then there is induced desire, created by much of the art market, and there is the myth of the *Mona Lisa*. For some strange reason this happened to the *Mona Lisa*. Perhaps a reason can be found: the fact that it is a picture by an artist who was not just a painter but also a scientist, a man who is in a way a symbol of human genius. Now it is even said that there is more than one *Mona Lisa*: as well as the one in the Louvre there's another in the Prado, and perhaps more will emerge. Nonetheless it remains legendary. Think how many pictures of the Madonna there are, but this doesn't weaken the legendary quality of the Virgin Mary. On the contrary, the Catholic Church has propagated the legend through images and holy pictures.

Is there an icon in your work?
The *Venus of the Rags* is becoming one.

There's only one Venus of the Rags*?*
I've made several of them, but they're not all the same, although they're all based on the same template.

And where are they?
One is in the Tate Modern in London, one at the Castello di Rivoli, one in the Hirshhorn Museum and Sculpture Garden in Washington, D.C., one in the Toyota Municipal Museum of Art in Japan, one in a collection in Dallas, one in a private collection in Naples, one in a private collection in Frankfurt, one in the Kröller-Müller Museum in Otterlo, in the Netherlands, and one in Cittadellarte's collection.

Did you make them all at once?
I made the one at Cittadellarte in 1967, then three of them together immediately afterward and the others at different times. Each bears the date of the prototype and of its execution.

It's very important for an artist to have a work recognized as an icon.
When I made the sign of the *Third Paradise*, I declared straight-away that I'd designed a legend. I want it to be a legend.

Critics often say that one period of an artist is better or worse than another. It'd be very interesting to know what you think about it, and which you think are your most important works.
I've already told you, the *Mirror Paintings* represent a principle. Different moments and periods have sprung from this. When in 1985 I staged *Art of Squalor* at Giorgio Persano's gallery, I showed a black canvas on which I'd written, "Michelangelo Pistoletto— Fourth generation." I was my own child, child of an experience that becomes another experience, from which new generations are born. I've lost count now, probably today I'm at my tenth generation. So I am a child of myself.

Venus of the Rags,
1967. Marble and rags, 190 x 250 x 140 cm. Cittadellarte-Fondazione Pistoletto, Biella.

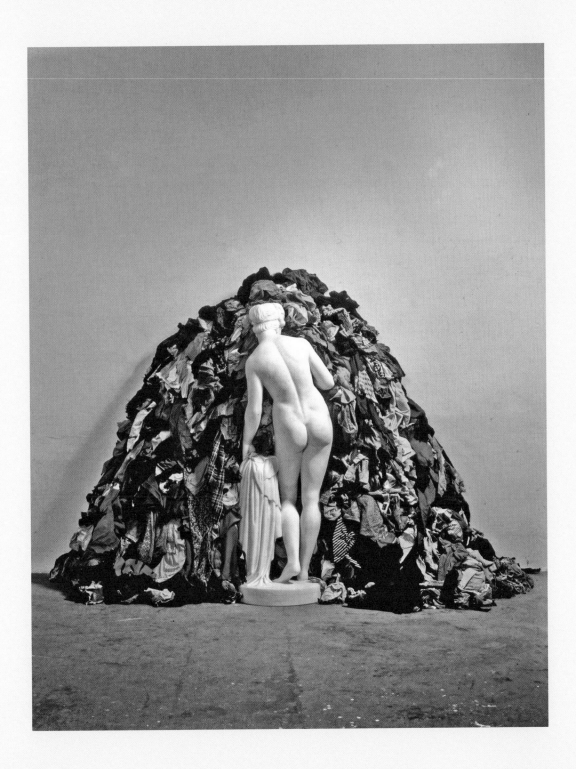

Yes, but there's a difference between possessing a Picasso from his Pink Period and a Picasso from the 1950s.
These are issues the artist can't decide. To me all my works are my children. I can't favor one over another.

I want to offer you an example: Alberto Moravia recounts how he made his debut at the age of twenty-two with The Time of Indifference, *a book that was a great literary success, and invented existentialism. Then it took him fifteen years to write his second book, but he didn't come up with anything important until over the space of a summer he wrote* Agostino, *another great success. Moravia told me that a book is good when it unwinds all by itself like a skein of wool, without effort. Then he continued with a series of ups and downs. In the end he himself acknowledged that, out of the fifty books he had written, there were ten that stood out from the others. The way you judge your own work is very significant; if you tell me that all your work is equal to you, I'll take your word for it. It appears to me, though, that the 1980s were a difficult time for your work.*
You're absolutely right. In the 1980s my work was interrupted and everything seemed a consequence of that. Looking back, I think I can view the period from 1981 to 1988 as one night, that is as a long sleep that began after *Year One* was performed at the Teatro Quirino in Rome with the residents of Corniglia and ended with the reawakening at the beginning of the *White Year*. Just like when you're asleep, my mind was pervaded by images that followed one another swiftly, interweaving in an incoherent way. They were fragments of monumental memory that I rapidly sculpted in polyurethane and then joined up or overlaid in an apparently rambling fashion.

Which work was the result of all this?
Those polyurethane sculptures. It's as if a whole load of three-dimensional images that pertained to sculpture suddenly emerged out of my memory bank early one night. As if a polyurethane parallelepiped contained all the work sculpted in the past. In practice it was a return to sculpture in its original sense: sculpture created by carving out material, by removing it, as

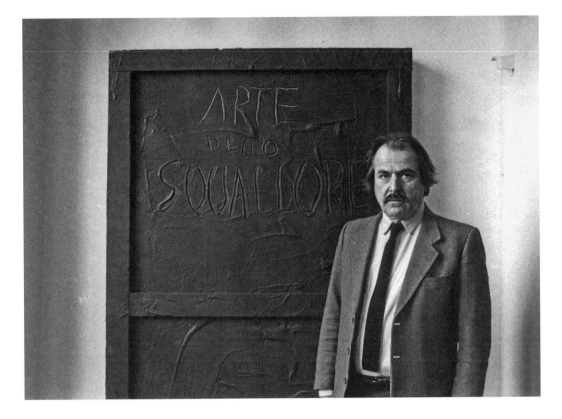

M.P. in front of *Art of Squalor—Fourth Generation.* The artist's studio, Turin, 1985.

Michelangelo explained. Removing mate-
rial to allow something to emerge, taking
it away to expose the image. Polyurethane
allowed me to do this almost at the speed
of thought; it was an incredibly soft and
light material that could be carved easily,
without effort; the same thing wouldn't
have been possible with marble. It was a
bit like giving a physical appearance, with
immediacy, to nocturnal images that came
almost instantaneously. The dream lasted
from 1981, when I exhibited at Ala's gal-
lery in New York, until 1984, the year those
sculptures were reproduced in marble on
a grand scale by Carrara sculptors, for the
exhibit at the Forte di Belvedere in 1985.
Then, in 1985 I moved onto the second
phase of the night and entered the torpor

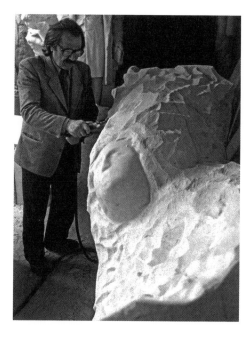

of deep sleep. What I called the *Art of Squalor* was created, and
I sank into darkness, into the black. In these works the dream
fades; the images vanish. All that remain are the volumes that
once contained the images. I acted on them with canvas and
color and other material that I would call nondescript. They
turned into blackish paintings swollen with voluminous sub-
stances. In these works, the paint envelops the volume, making
it dark and dull. The darkness of the night. I created shapes
but, at the same time, black holes. They were black volumes
that punctured the luminous space of the setting. Although one
could speak of sculpture, surface, paint, material, the ultimate
aim was the total absorption of light. In those dark works, the
black hole becomes a voluminous substance. They are extreme
coagulations of material. A nondescript material that absorbs
energy. They are concentrations of cosmic void. They are the
darkness of the sky solidified in the luminosity of the exhibit
space. That work was shown on several occasions. It took up a
whole floor of PS1 in New York, as part of my retrospective. I
worked on it until 1988, when I began the *White Year*. A blank

M.P. during the
execution of *Inchino
di rosa (Pink Bow)*,
1982–84. Studio
Nicoli, Carrara,
1984.

Facing page:
Il gigante (The
Giant), 1981–83.
White Carrara
marble, 600 x
150 x 120 cm.
Photographed at
the *Michelangelo
Pistoletto* exhibition.
Forte di Belvedere,
Florence, 1984.
Mario Pieroni
Collection, Rome.

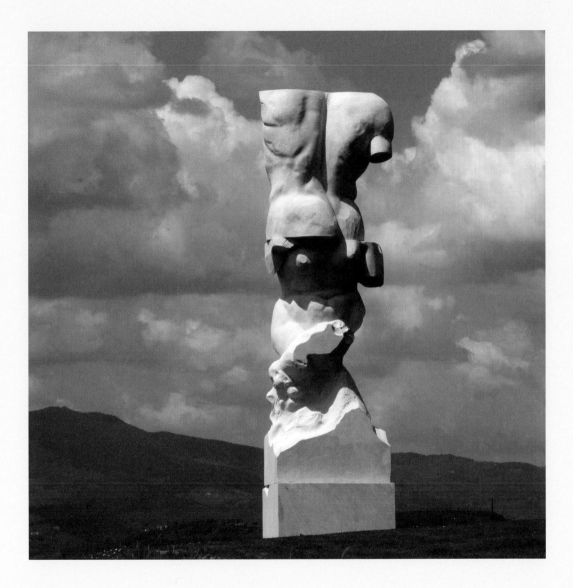

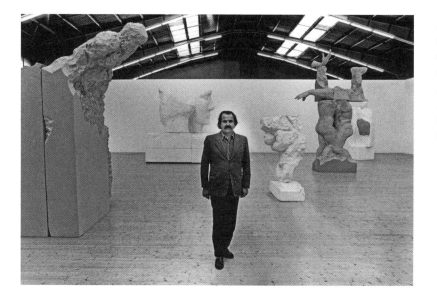

M.P. at the Centre d'Art Contemporain during the exhibition *Michelangelo Pistoletto: Sculptures 1981-1982-1983.* Geneva, 1984.

book open to the twelve months to come, ready to receive its salient images. As I told you before, at the end of that year the Berlin Wall came down—a genuine social, economic, and political Big Bang. During that period I made a number of slabs of poured white plaster that were then shaped by hand, like blank pages waiting for things to happen. At the end I showed a blowup of the Brandenburg Gate with the people of Berlin celebrating during the demolition of the Berlin Wall.

Where are those sculptures?
Some are in Naples, part of the collection of the Museo di Capodimonte, while others are in private collections. Now I'm preparing shows to draw attention to both the black and the white works, because many people, especially young people, aren't familiar with them.

You're an artist who ends something and begins anew. How do you decide that one period has finished and another one begun?
It happens because there is a need for renewal. When you've completed what you think had to be done, you move on to something else.

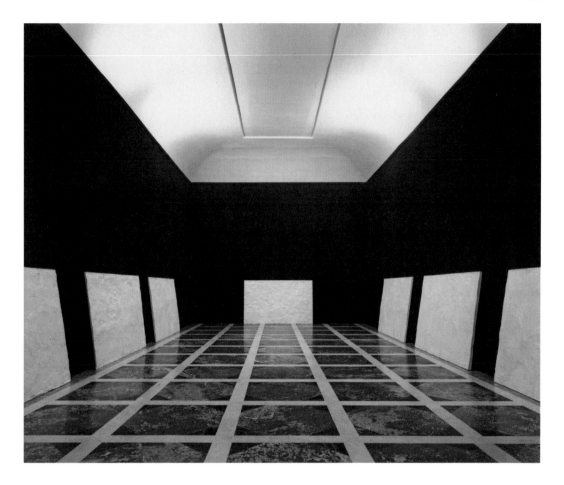

Sette rilievi (Seven
Reliefs), March
1989. Plaster, seven
elements of 186 x
290 x 5 cm each.
Work shown at
the solo exhibition
Seven Reliefs, Museo
di Capodimonte,
Naples, March
1989. Museo di
Capodimonte
Collection, Naples.

The only thing that always comes back is the mirror.
There is only one mirror, fragmented into many pictures,
and each mirror painting captures a moment in my life or the
events surrounding it. My motto could be "While there's life
there's mirror."

Which of your Mirror Paintings *are the standouts?*
Either all of them or none of them. The reflecting work, in its
slow technical transformation, captures different moments that
remain as historical documents: for example, I made *Vietnam*,
which couldn't have been done before the war, and I've done
work with the telephone that couldn't have been done later
because telephones are different now.

Is Vietnam *more important than a portrait of a woman?*
No, a portrait of a woman is also testimony to a moment in the
past that's brought back to life in the present of the person who
sees himself reflected in the mirror.

If I understand correctly, since 1961—when you were thinking of terror-
ism—you've believed that it's always necessary to take care that good
things don't turn into bad ones. That can be traced back to art, I'm
thinking of Clouzot's great film on Picasso, where we see Picasso pain-
ting a work, then correcting it over and over again, until he ruins it. So
there is a point when you have to stop. Has this happened to you?
Yes, it has.

There's also the idea that if we don't rein ourselves in, catastrophes like
wars can happen. I talk about the importance of recycling. But
there is also the recycling of wrongdoing, as well as the positive
recycling of nature. Evil is recycled using good. For instance, the
idea of peace has been used for its opposite, for war. It's stan-
dard practice to say that you can't make peace without having
war first. Or that you can't build without destroying first. The
economy of speculation profits both from destruction and from
reconstruction.
So desire has to be controlled.

I look back to the Renaissance concept of balance, which is achieved in a horizontal direction, while the medieval and Gothic idea was to create a vertical balance by constructing the spires of cathedrals. Verticality corresponds to the flight upward in search of a heavenly paradise; horizontality corresponds to the search for a paradise on earth. We have to consider balance a polarization of energy. In nature, lightning sets fire to forests and houses. Lightning has been captured and fed into the electric system, which lights the bulb and charges the cell phone. In this way we have turned wild energy into civilized energy. Now it is a question of managing the relationship between extremes to produce and ramify civilized energy in the overall development of society, at the economic, political, and even spiritual level. Art offers a diagram of this system of energetic equilibrium. In any case, we see how all the opposites already coexist perfectly in the mirror painting: chaos and order, the absolute and the relative, life and death, presence and absence, the past and the future, and so on. Creativity is bipolar, too. The same effort can be used to develop a destructive or constructive creativity. The sign of the *Third Paradise* leads creativity toward a conjunction of polarities never before practiced.

Your work is a civilized work?
Yes. Cittadellarte is a civilization of art.

What about your own work, which you've been traveling the world to talk about since the 1970s?
The manifesto "L'arte assume la religione," from 1976, implicitly also comprised the idea that art takes on politics. Religion shapes the mind, which then commands the body. The spiritual mind guides the body politic. To change politics, it's necessary to overhaul religious systems.

You've never wanted to scandalize, lambaste, or rail against something with your work?
No, I'm not interested in breaking things just for the sake of breaking them. If I'd wanted to do that, I wouldn't have followed

the concept of the coexistence of opposite signs. I break and construct simultaneously. When I discovered the principle of the balance of opposites through the *Mirror Paintings*, I started to work on putting that theoretical observation into practical effect.

Has your work ever suffered setbacks?
The years of sleep I told you about.

That long night was very important. You finally did what the practitioners of Arte Povera had asked you to do: stop and reflect.
Yes, there was a slowdown, or rather, a digression.

Was it a lack of inspiration, a desire not to repeat yourself, or fear of making a mistake?
Why not call it a poetic parenthesis? The reference to sleep seems appropriate to me when I think back to those years, because I have the impression that they went by extremely quickly, just like when you're asleep. You don't have the sensation of time passing. You go to bed at night and you wake up in the morning as if no time has gone by. You fall asleep, then you wake up, and all that remains is an impression of your dreams, but then you remember nothing.

Yes, but whereas before you made your own avant-garde or even anticipated those that were to come, as in the case of Arte Povera and conceptual art, that wasn't the case then.
In reality I allowed myself the pleasure of sculpting things by hand, something I'd never done. I'd been buying wooden sculptures ever since I was a kid—I put the first in one of the *Minus Objects*. But the desire to sculpt myself remained unfulfilled. In the second part of the night I felt myself really sinking into a dark void, but a void dense with material, a sensation on the verge of being unbearable. In the text that accompanied these works, titled "Poetica dura" (Hard Poetics), I wrote: "Art of squalor, parasitic art, art of mortification. Surface of desolation, obtuse surface. A repulsive art that represents nothing. Repressed art, like the countries where there is no art. Art that

removes, art that crushes, livid art, squalid art, a squalor that is only in art. Squalor of things without art, art that removes, art that makes the eye and the mind hard. An immobile, viscous, worn-out art. Grayish, blackish that tends toward yellowish. Mass of triturated ideas, of pulverized objects, of meanings that are smashed, rotten, softened, and compressed. Fragments of instruments and concepts; stellar dust, cosmic foam, meteorite lava, sidereal ice." Communism was collapsing, the Berlin Wall was about to fall, and we were coming to the end of a long nightmare: the terror of American and Russian nuclear bombs. But we didn't know it yet. We would find out waking up in the *White Year*.

But, paradoxically, in the meantime you went skiing.
Yes, of course. The role of the existentially tormented artist doesn't suit me. The world can come crashing down, but I go skiing. And I've always been someone who enjoys good food. I've never lost my taste for life. Just as I've always bought fast and beautiful cars. In my view the aesthetics of the automobile have been an extraordinary element of our time. Now I'll tell you about some of the other pleasant things that are part of my life. When I walked into Walter Bordese's car showroom, at the height of the economic boom, in the mid-1960s, I could at last afford to buy myself my dream car. I was wearing clogs and blue jeans and had a beard and long hair—the typical hippie. I said, "I'd like to buy a very nice car, if possible secondhand." They sold Rolls-Royces, Ferraris, Jaguars—that kind of car. This clearly astonished gentleman came to meet me—I found out later that he and his father were die-hard Fascists—and showed me a Mercedes Pagoda and I told him, "I'll take it," even though it wasn't exactly what I wanted. And then I asked him to look for one that was a bit special and to call me if he found one. He stared at me in amazement, doubting that I had the money to buy that car. He asked me what I did and I explained that I was an artist, but he didn't relax completely until I gave him the check. I told him, "I'll come and pick up the car the day after tomorrow," to give him time to cash the check. Later he sold me several

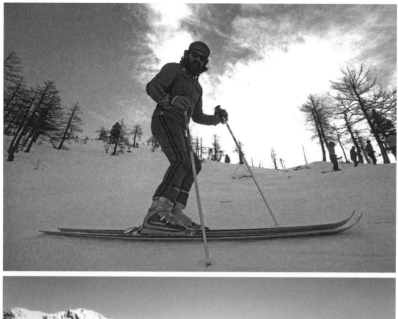

M.P. skiing in
Sansicario.

M.P. in Sansicario
with friends. From
left: unidentified
person, Paolo
Genta, Vittorio
Meazzini, M.P.,
two unidentified
people, Armona
Pistoletto, Francesca
Marzotto, Giorgio
and Filippo Ferraris,
Cesare Furno and
his daughter Beba.
Seated, Gianni
Bella. Sansicario,
1998.

automobiles, Jaguars, Maseratis, an Iso Grifo. Beautiful cars and very fast. Walter became a friend, started to take an interest in art, and bought a ski house in Sansicario. Not a Sunday went by that he didn't come to see me and go skiing. He wanted his home in Turin to be decorated by a designer. An architect friend of mine renovated the apartment. The encounter with art changed his life. The saying "you can't judge a book by its cover" turned out to be spot on both for me and for him. The same thing happened in Corniglia. Maria and I had been going to Vernazza, in the Cinque Terre, since 1968. Corniglia was a nearby village that we had never visited but that we saw from the mountains as part of the panorama. One day I bought a plot of land in the mountains above Vernazza. There were terraces and the remains of a building on it. I paid a deposit and then we went to the notary to sign the contract and discovered that the last time there'd been a registered owner of the land had been in the late eighteenth century. The current owner said that, even though he had never registered the transfer of property, everyone knew that it was his. A handshake had always been enough for such agreements. In short I couldn't buy the land—the paperwork would have been too complicated and taken too long. I was fairly irritated, and with Maria and my daughter Cristina, who was eight years old, I decided to go take a look at Corniglia. Me with long hair, Maria dressed in black from head to toe and with a large bundle over her arm (a black piece of cloth—the type old women used to knot and slip over their arms to carry their things). We went to the village and tried to order a something to eat at a café, but they looked at us in bewilderment and said that there was nothing for us. We went a bit farther and in the small central square of the village found a little trattoria that was just opening. We asked the owner, "Can you give us something to eat?" And he said, "Yes, yes, take a seat." The fish was excellent. When we'd finished I asked him, "Do you have any Sciacchetrà?" That's a typical Cinque Terre wine. The owner answered, "No, Sciacchetrà is a wine that we make only for ourselves or for special occasions," and he went away. Then after a while he came back and said to me, "I think you must be somebody, so I have a bottle

of Sciacchetrà and I'd like to offer it to you." After drinking the
bottle, we said to each other, "What a fine place is this!" in part
because Sciacchetrà is sweet and fairly alcoholic and makes you
feel pretty good. So I asked the owner, "Do you know of a house
for sale around here?" And he answered, "Yes, the professor
died, so maybe his house is for sale." He called out to Orazio, his
builder brother who lived above the trattoria, and Orazio came
down and took us to see the house. It needed a gut renovation,
but it had a wonderful view of the sea and two terraces. We liked
it at once. I asked him what he thought they would want for
it, and he told me, "Well, Signora Elvira is asking four million,
but if you were to offer her cash I'm sure she'd let you have it
for three." He took us to Signora Elvira and I asked her, "How
much do you want for the house?" "Four million," she said, and
I replied, "Wait a minute." I was following the advice the builder
had given me. I said to Maria, "Open your bundle." She opened
her bundle and it contained the money for the contract we had
been planning to sign that morning. Maria took out the money
and I said to the woman, "Here, signora, will three million do?"
And we closed the deal in a few minutes. We stayed there chat-
ting cheerfully for a while. On our way back, we walked through
the village again and everyone we encountered in the street
greeted us with a smile. They had already heard that Maria
had been carrying millions in her bundle, and so we were an
instant legend.

Isn't that a contradiction in terms?
A marvelous contradiction in terms. We made friends with
Orazio, who restored the house for us, and the next year we
spent nine months there with the Zoo and did theater, gradually
involving the inhabitants of Corniglia.

*Ultimately, there you found your new and somewhat Tolstoyan voca-
tion for instructing uncultivated people, for creating multidisciplinary
and multireligious centers along with symbols that you design as an
artist. On one of the buildings at the Mercati Generali at Porta Palazzo
in Turin, there are neon signs that illustrate that concept. Above and*

beyond the Third Paradise, *you believe in religious plurality, in cultural diversity.*
It's my belief that art can change things, can make possibilities reality. In reality, anything is possible. There is a need for change, and art can bring it about fairly rapidly but not in an abrupt way.

At a certain point you need other people.
I need others to change things, because many people working together can make changes that are impossible for a single person to effect.

Yes, but you need to change things not just with rags and mirrors, but with action, too.
I also used rags as stage props in the Zoo performances. Rags and mirrors helped bring me out of my solitude.

Everything you did before you were able to do alone. At the end of the 1960s, though, you started to have this need for others that continues to this day. What happened? Was it that in the years when you traveled and talked about your work, when you traveled back and forth from Vienna to Biella, you evolved beyond your role as a mere artist?
That's what I've always been. I opened up my studio to other artists with the idea that together we would be able to produce multimedia forms of art. Over time the different sectors of the social fabric were added to the different languages of art. At the academy in Vienna, in addition to new media I introduced activities related to food, clothing, manufacturing, the market, communication, and other spheres of civil life. At Cittadellarte all this has developed with the University of Ideas and with the activity of the departments that connect art with politics and production—that is, with social responsibility as a whole.

You believe in chance. Do you think it's possible that in the future you'll come up with another idea and go back to being an active artist?
Yes, I hope I keep on getting new ideas, but I can't speculate about the future. For the moment I can say that I've set in motion a

machine that stimulates and produces new ideas by itself. There's always a new utopia, but now we are realizing our utopias of yesterday. In 1994, when I presented "Progetto Arte," in which I described what I thought the destiny of art and society would be, everyone said it was pure utopia. Today no one says that to me anymore, because with Cittadellarte the project has started to turn into reality. The situation of humanity in the world concerns me greatly. All my activity is driven by that concern. But I'm not alone any longer and neither is Cittadellarte. There are many initiatives like it now, and they are growing in number.

Would you like to work with someone like Cattelan or Jeff Koons? They come to mind because you've mentioned them as friends or pupils, or in any case people who have been inspired by your work.
No. Beuys did that with Warhol and it was a failure. He didn't get anywhere by attaching himself to someone else's name. I have no desire to team up with artists like them, unless they start taking an interest in the area in which I'm engaged.

Do you think eventually you'll say, "Now I'm going to make a series, not of thirty-four objects, but of thirty-four drawings," simple drawings without a mirror, without rags? In other words, will you go back and find yourself again?
At this time it would just be a sightseeing trip for me.

Why?
Because I'm engaged in the activity of social change. I can't permit myself a sightseeing trip. I can't let myself be distracted while I do this work, but I'm not shutting the door on any possibilities. For the moment, doing something outside the art that I'm practicing would be a pure digression.

Would you like to do it anyway?
If you look closely at the different versions I've made of the *Third Paradise* symbol, you'll realize that in addition to being a message for the world, each one is a work of art in its own right. The point is that I don't sell that work. The only one I sold was

the first one, traced in the sand. I sold that one to Salvatore Ala, but the others I offer to everyone and everyone can do his or her own work with this sign.

How much room is there for friendship in such a busy and creative life? What does friendship mean to you?

I've never seen the concept of friendship as an issue. When I was young my friends were the people with whom I went dancing or skiing. Then, as I embarked on my work, starting with encountering the world of modern art, my friends were Renato Rinaldi and Aldo Conti, who were with me at Testa's school. Armando Testa himself became a friend, as did the critic Tommaso Trini and his brother Clino, the sociologist Giuliano Della Pergola, whom I only see in the summer at Corniglia and with whom at the bar, in the village square, I defined the concept for "Love Difference—Artistic Movement for an Inter-Mediterranean Politics." Many friends from the past and the present are portrayed in my *Mirror Paintings*. The architect Giorgio Ferraris, for example. We've done theater together and still go skiing together. I have many friends—new ones come along and I lose touch with others. For me the people of Corniglia with whom I've worked and still work are friends. The relationship with them has been very intense, so that now we're like family. Parents, children, and even grandchildren are friends. It's very important, in friendship, to do something together. Now with Cittadellarte and the *Third Paradise* the number of friends I have is growing; with a smile, I could say ad infinitum.

Have you ever been betrayed by friends?

Attraverso la rete, lei e lui (Through the fence, him and her), 2008. 250 x 125 cm. Luhring Augustine, New York.

Rather than betrayals, I'd say there may have been moments of tension with a few friends in the Arte Povera movement. But even in situations of conflict and disappointment I never give up on the possibility of reconciliation, which is what has almost always happened. Times change and so do people, so the cause of the conflict can be overcome.

Have you ever been afraid of dying?
I think fear of death is a human thing, shared by everyone. It's a fear that makes me look for a way to overcome it. All the work I do is aimed at overcoming the fear that stems from the sense of the unknown. I try to do this with understanding. And then for me, even in the worst moments, it's important to have an underlying feeling of joy; this gives me strength in life. All of life should be fun. The real commitment is to having fun. The mountaineer makes great effort and takes risks, but he doesn't see that as a sacrifice because he gets joy and fun out of it.

Have you made sacrifices in your life?
Some people might call them sacrifices, but I call them pleasures and even duties. Duties do not necessarily have to be imposed on you. Duty is like sacrifice: if you do it of your own will, you're happy to do it. If duty is imposed when you don't feel it, then it becomes a sacrifice. Personally, I take on a duty in relation to my engagement in my work and my life, public as well as private.

What about money?
As far as I'm concerned, all it's good for is exchange. It's important to the extent that it helps me do what I intend to do.

You've never been afraid of running out of money?
The fear of running out of money is always present. I've even come very close to being completely broke, but with determination I got through those times by thinking about how to present my work to the world.
You're a very well-known and highly rated artist. Has that made

you rich?

I'm very rich because I don't run after money. I don't seek wealth from money. Money is another kind of wealth. The success of the change I'm trying to bring about is wealth. The very process of my life is wealth to me. Perhaps if I hadn't had a chance to develop this activity that allows me to have something more than money, I'd have stopped at the money and would be, without knowing it, much poorer.

Are you ambitious?

Yes, I'm ambitious because I'm always trying to achieve something. For me ambition means aspiring to a satisfactory result, desiring to bring about change. It's setting yourself a goal and working to reach it. In my life I've always set goals and targets for myself. Success for me is obtaining a result after seeking it via a process. My greatest ambition now is to contribute to the rebirth of the human world and an environment that is in danger of collapse.

What do you think about fame and recognition?

All forms of recognition are very welcome. But the end is not the recognition itself, but how it can help me keep going.

Do you think you've managed your career as an artist well?

The way I see things, yes. For example, in 1992 a director from Paris, Pierre Coulibeuf, was making a film about my work called *L'Homme Noir*. He followed me from Austria to France and Germany and to Cittadellarte, which was just getting started. In the film I say, "My legacy will be an empty space." That's it, I manage the economics and the artistic recognition with the aim of making space for new possibilities.

Why did you feel the need to set up Cittadellarte?

If I want to get other people to understand what I intend to do, I have to understand it myself by working with others. So it's an ongoing workshop. Cittadellarte allows me to understand by doing things, not only for myself but with others and for others. *You couldn't stay alone with your wife in an apartment in Turin*

any longer?
Perhaps I could have. Maybe at a certain point I'll need to shut myself up in an apartment and end my life knitting socks. But I don't think that will be my fate.

What do you do in the evening before you go to bed?
I used to go to the movies, but today I watch television. I watch the odd interesting film, but above all I follow the news and politics. They make me think.

What do you think of the country we're living in, the Italy of today?
I find it not so much a comedy as a tragedy: the dramatic events of daily life often come to a tragic end.

Have you ever thought about leaving Italy because of what goes on here?
No. My vision is not limited to this country. Through my work I continue to unite a local perspective with a universal one. Achille Bonito Oliva once called me "an unlimited liability artist." But even someone with unlimited liability has to respond to the sometimes narrow limits of the local and the everyday. So Italy for me is a place that I compare with the rest of the world. And then I have to say that I love Italy.

How do you feel about going abroad?
I'm fine anywhere an authentic cultural life exists. There was a time when the political and cultural delegates who came to represent my country at openings of my shows abroad embarrassed me. They were such petty, ignorant, obtuse, self-important, and incompetent people that I felt truly ashamed. They were people who had no ambition, at least none worthy of the name, only political arrogance. I have to say, and this is something worth thinking about, that I've noticed a considerable change since the end of the so-called First Republic, in the years following the demolition of the Iron Curtain. Since that time I have encountered some cultural representatives of Italy with qualities I can appreciate.
Was there any difference in the way you were treated at the exhibit of

your work at the MAXXI in Rome and the one in Philadelphia?
No. Carlos Basualdo was the curator for both and did a very
good job, and I received excellent and highly professional treat-
ment at both museums.

*What do you think of museums today? Do you prefer a standard
museum that focuses on modern or contemporary art, or a museum
like the Metropolitan [Museum of Art, in New York] where you can find
everything? Does it matter?*
I think a museum can contain everything. But there is a differ-
ence between art that is already viewed in a historical perspec-
tive and what is being produced now. In museums of modern
art we now find work by new artists as well as the work of
historically endorsed artists. This means that the idea of the
museum is moving toward new concepts. I believe interaction
between art and society will represent a new transition.

*When your work is exhibited, are you involved in setting up
the exhibitions?*
Often, yes, but in some cases my participation is limited.
In Philadelphia and Rome, I only handled arrangement of
the *Minus Objects*. In any case, museums are now responsible
for the cultural management of the work.

How do you prepare an exhibition?
It depends. For an exhibition in which there is a creative side to
the display design, the artist obviously has to be involved, but
when it's a matter of re-presenting works or displays, the inter-
pretive skill of the curators is very important.

*Have you ever mounted a retrospective only to find that you're not sure
about one of your pieces?*
That doesn't happen, because the work for retrospectives has
already been selected some time in advance. However, depend-
ing on the interpretation, you choose the work best suited to the
specific case.
How do you feel about the idea of holding a retrospective at the Louvre,

M.P. and curator Carlos Basualdo during the mounting of the retrospective *Michelangelo Pistoletto: From One to Many*, 1956–74. Philadelphia Museum of Art, Philadelphia, 2010.

M.P. with Carlos Basualdo and Timothy Rub, curator and director of the Philadelphia Museum of Art, respectively, during the *Walking Sculpture* action in the streets of Philadelphia.

Timothy Rub, director of the Philadelphia Museum of Art, Michael Nutter, mayor of Philadelphia, and M.P. during the *Walking Sculpture* action in the streets of Philadelphia.

which is perhaps the world's most famous museum featuring the art of the past?
It's an extraordinary opportunity, insofar as the history of the world recounted through art and myth is on display there, so all that remains for me to do is to mirror it in the rooms of the Louvre. In addition, I will be presenting the sign of the *Third Paradise,* which I've created as a new myth for the future. The title of the exhibit is *Année Un—Le Paradis sur Terre* (Year 1: Earthly Paradise).

How is the exhibition organized?
The preparation of the exhibition has entailed very close cooperation between me, the then-director, Henri Loyrette, and the curator, Marie-Laure Bernadac, with the participation of Galleria Continua. The work on display in the rooms of different sections of the Louvre establishes a direct relationship with the work in the museum's collection and with the presence of visitors. It combines three time periods: the historical past, the unfolding present, and the foreshadowing of the future. It traces an ideal line between past and future, between the reappraisal of what has been and the prediction of what will be. The retrospective part of the exhibition directly reflects the view of history offered by the matchless collection of the Louvre, but includes present-day life through the immediate mirroring of the people present. The future part emerges with the symbol of the *Third Paradise,* realized on a monumental scale amid the work of great sculptors of the past. Past and future are represented in the same symbol. In fact, it sums up the two eras through which humanity has passed, first natural paradise and then artificial paradise, leading us now into a new era founded on the union between nature and artifice. Taken as a whole, the exhibit makes us unequivocally aware that we are in a time of epoch-making transition. December 21, 2012, seen in the popular imagination as the day the world will come to an end, becomes the universal day of rebirth: *Rebirth Day* is the symbolic celebration of entry into the *Third Paradise.* At the Louvre, there will be a theatrical performance *Year One,* created and staged in 1981 with the

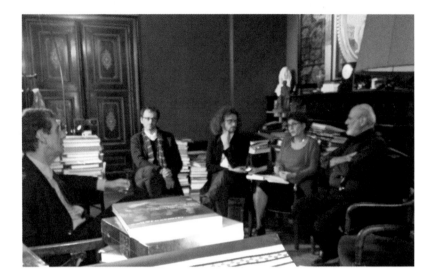

From left: Henri Loyrette, then-director of the Louvre, Paolo Naldini, director of Cittadellarte, Lorenzo Fiaschi of Galleria Continua, curator Marie-Laure Bernadac, and M.P. Musée du Louvre, Paris, 2012.

inhabitants of Corniglia, there will be a selection of films documenting participation in *Rebirth Day* in different parts of the world.

Today, all these years later, what happened to the fun you had with the Zoo?
It goes on with the intention of changing things. Although I wouldn't want the word *fun* to be interpreted as distraction. By "fun" I mean joy, pleasure, and enthusiasm in the work done to bring about the re-evolution of society.

Acknowledgments

We would like to thank Maria Pioppi, who was an invaluable presence and voice in the conversation and in the course of the creation of this book. Our gratitude also goes to Caterina Pellion di Persano for attending our meetings and transcribing and editing the text of the interviews.

Index of Names

Credits